W9-AGL-014

FRIDA.

THE STORY OF HER LIFE

VANNA VINCI

FRIDA

THE STORY OF HER LIFE

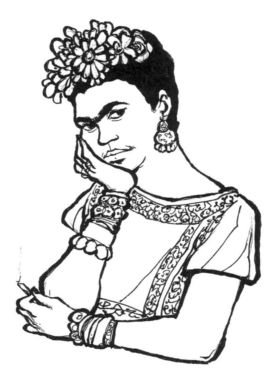

PRESTEL

MUNICH · LONDON · NEW YORK

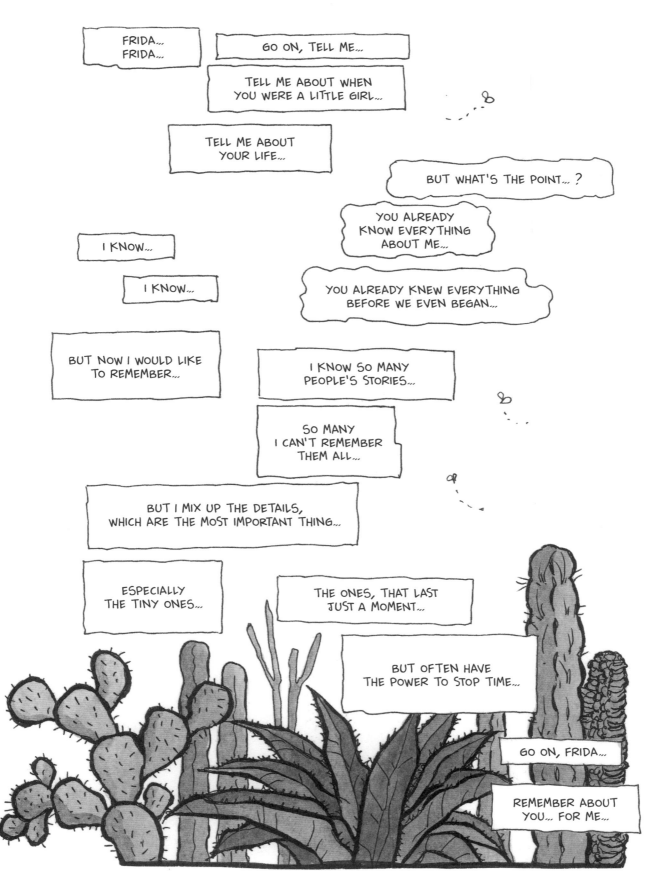

FRIDA...
FRIDA...

GO ON, TELL ME...

TELL ME ABOUT WHEN
YOU WERE A LITTLE GIRL...

TELL ME ABOUT
YOUR LIFE...

BUT WHAT'S THE POINT... ?

YOU ALREADY
KNOW EVERYTHING
ABOUT ME...

I KNOW...

I KNOW...

YOU ALREADY KNEW EVERYTHING
BEFORE WE EVEN BEGAN...

BUT NOW I WOULD LIKE
TO REMEMBER...

I KNOW SO MANY
PEOPLE'S STORIES...

SO MANY
I CAN'T REMEMBER
THEM ALL...

BUT I MIX UP THE DETAILS,
WHICH ARE THE MOST IMPORTANT THING...

ESPECIALLY
THE TINY ONES...

THE ONES, THAT LAST
JUST A MOMENT...

BUT OFTEN HAVE
THE POWER TO STOP TIME...

GO ON, FRIDA...

REMEMBER ABOUT
YOU... FOR ME...

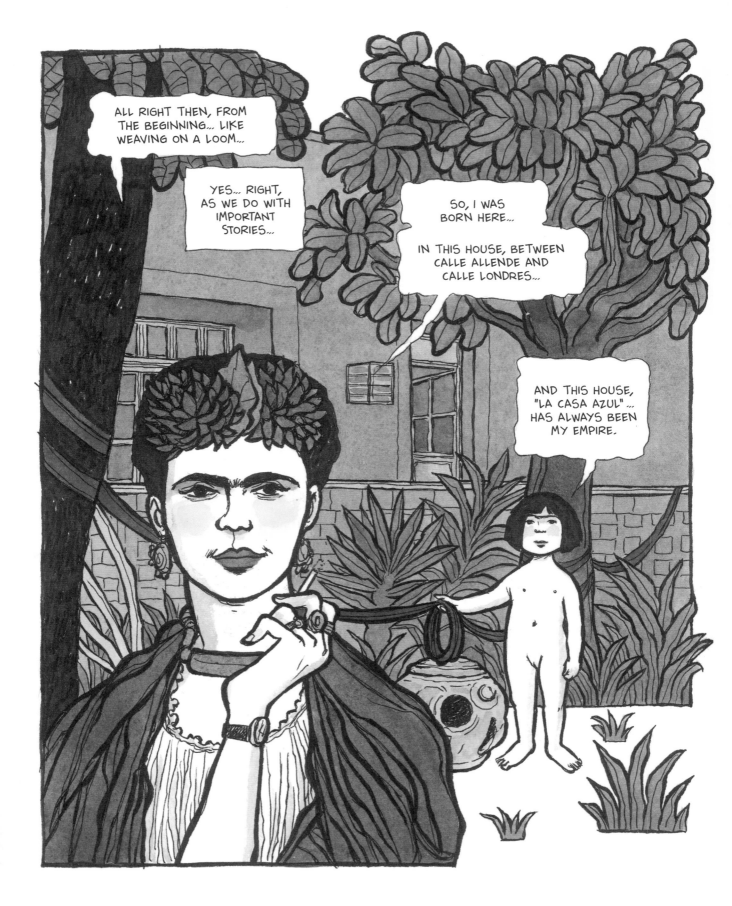

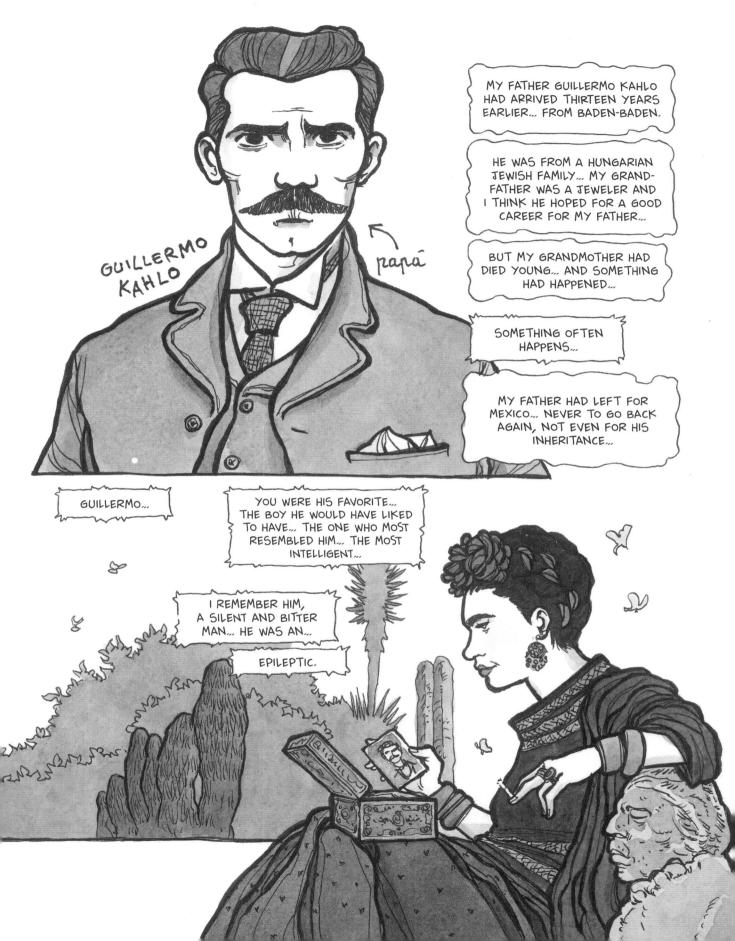

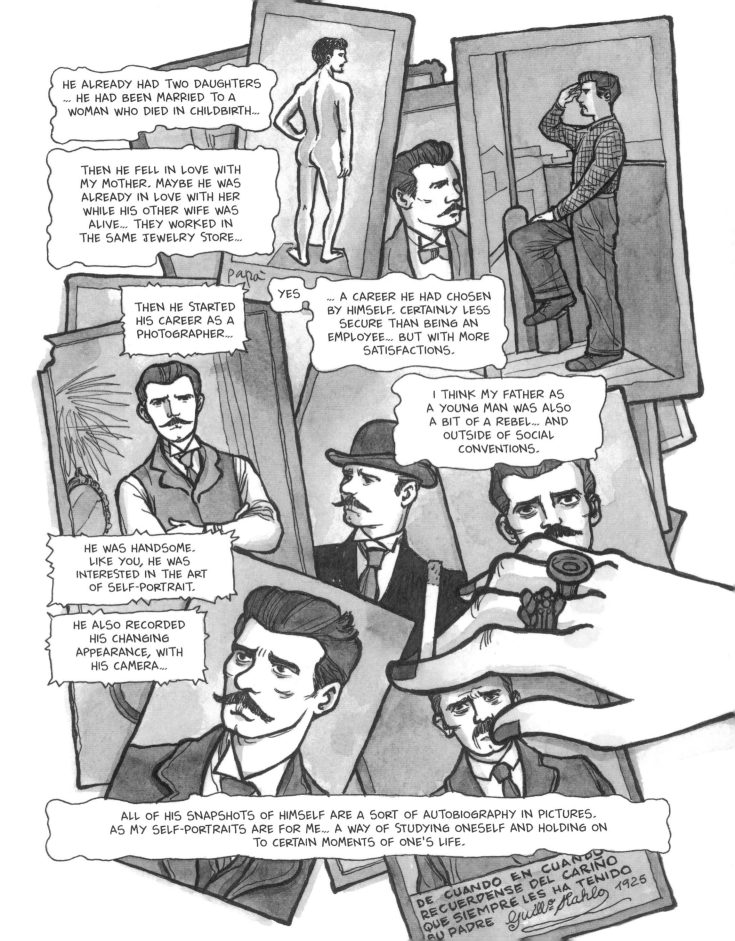

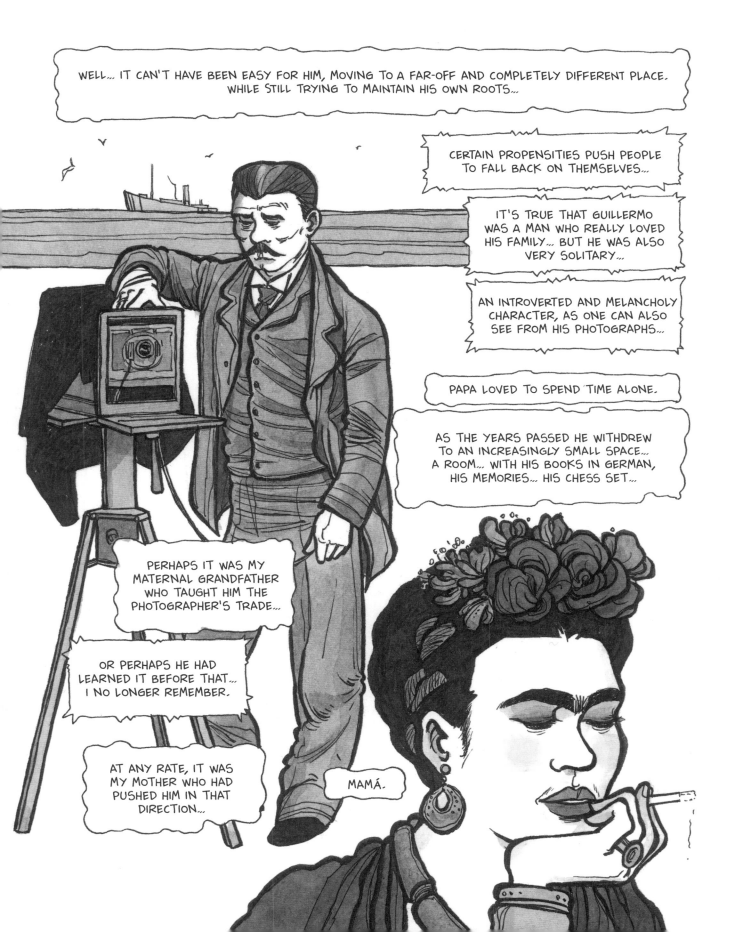

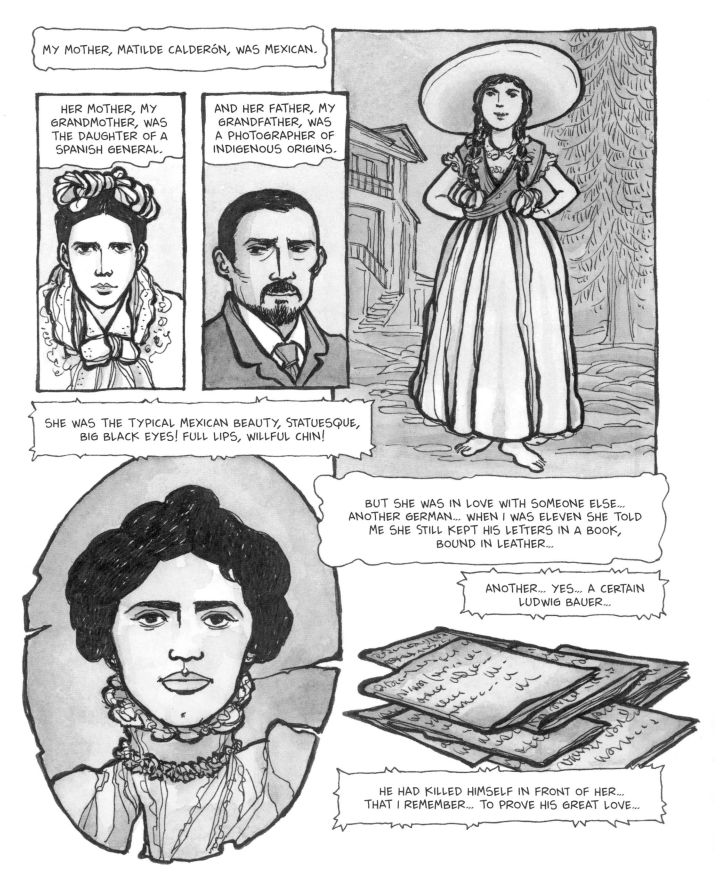

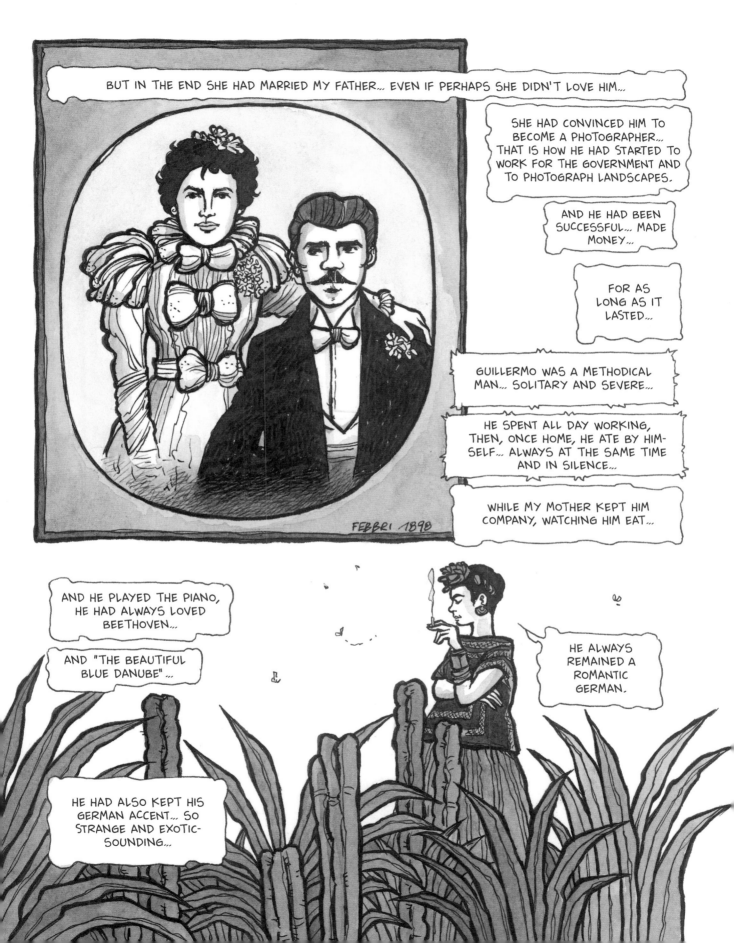

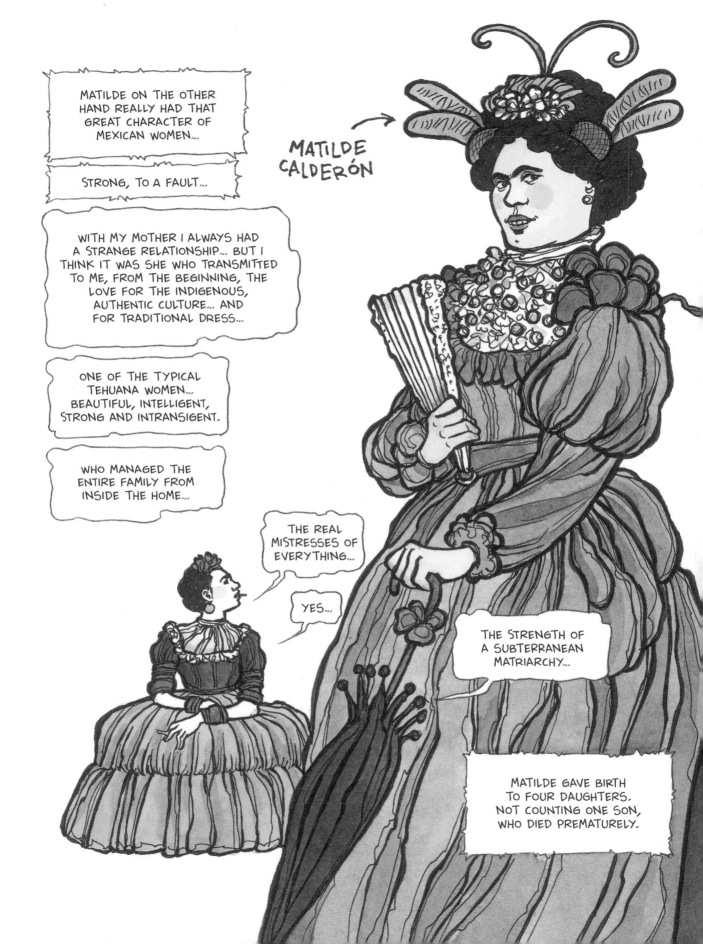

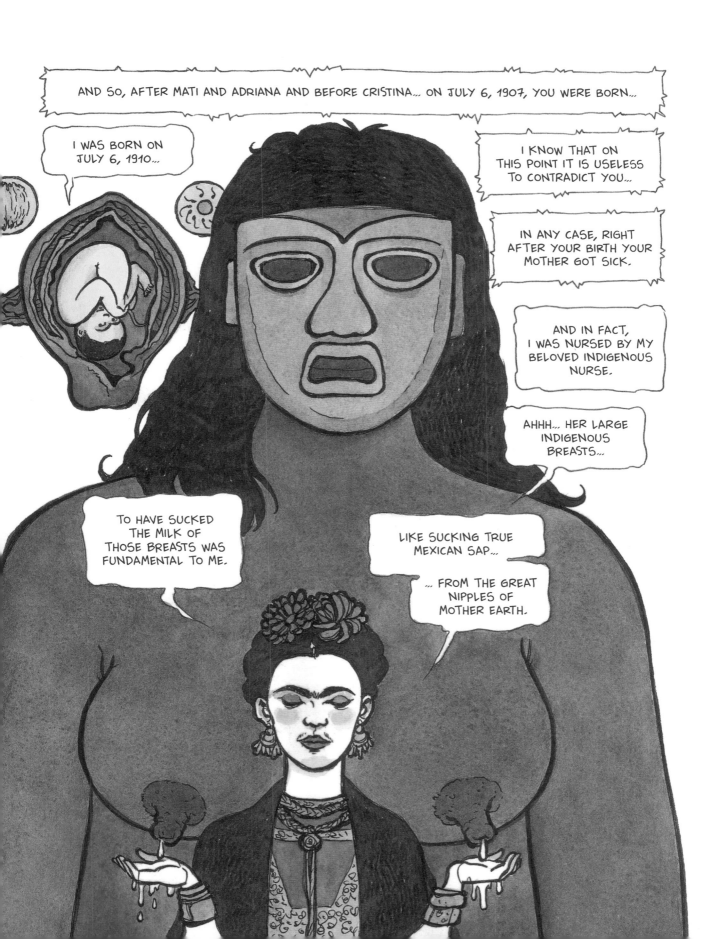

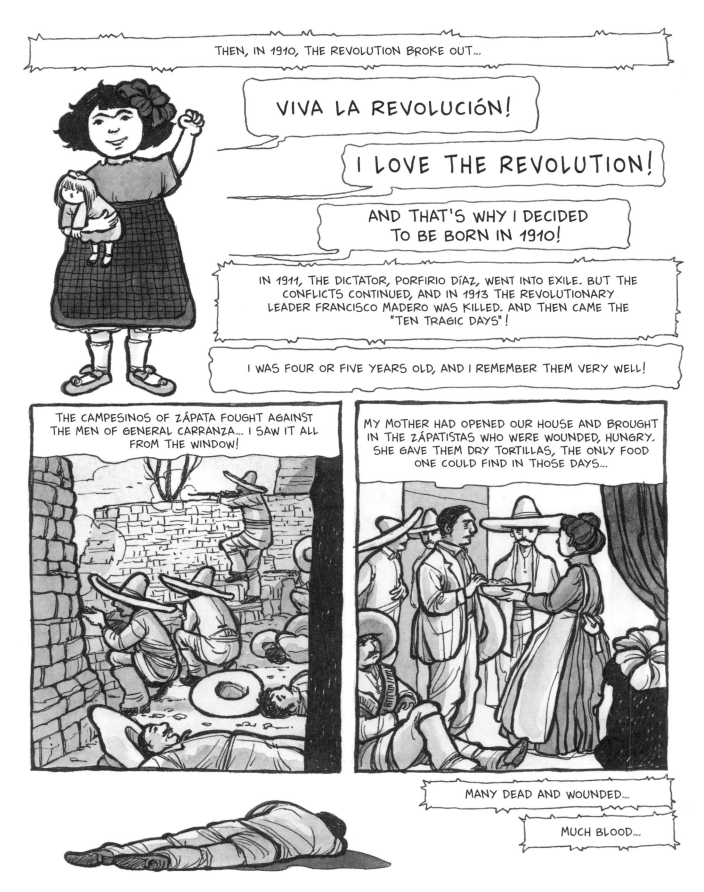

THEN, IN 1910, THE REVOLUTION BROKE OUT...

VIVA LA REVOLUCIÓN!

I LOVE THE REVOLUTION!

AND THAT'S WHY I DECIDED TO BE BORN IN 1910!

IN 1911, THE DICTATOR, PORFIRIO DÍAZ, WENT INTO EXILE. BUT THE CONFLICTS CONTINUED, AND IN 1913 THE REVOLUTIONARY LEADER FRANCISCO MADERO WAS KILLED. AND THEN CAME THE "TEN TRAGIC DAYS"!

I WAS FOUR OR FIVE YEARS OLD, AND I REMEMBER THEM VERY WELL!

THE CAMPESINOS OF ZÁPATA FOUGHT AGAINST THE MEN OF GENERAL CARRANZA... I SAW IT ALL FROM THE WINDOW!

MY MOTHER HAD OPENED OUR HOUSE AND BROUGHT IN THE ZÁPATISTAS WHO WERE WOUNDED, HUNGRY. SHE GAVE THEM DRY TORTILLAS, THE ONLY FOOD ONE COULD FIND IN THOSE DAYS...

MANY DEAD AND WOUNDED...

MUCH BLOOD...

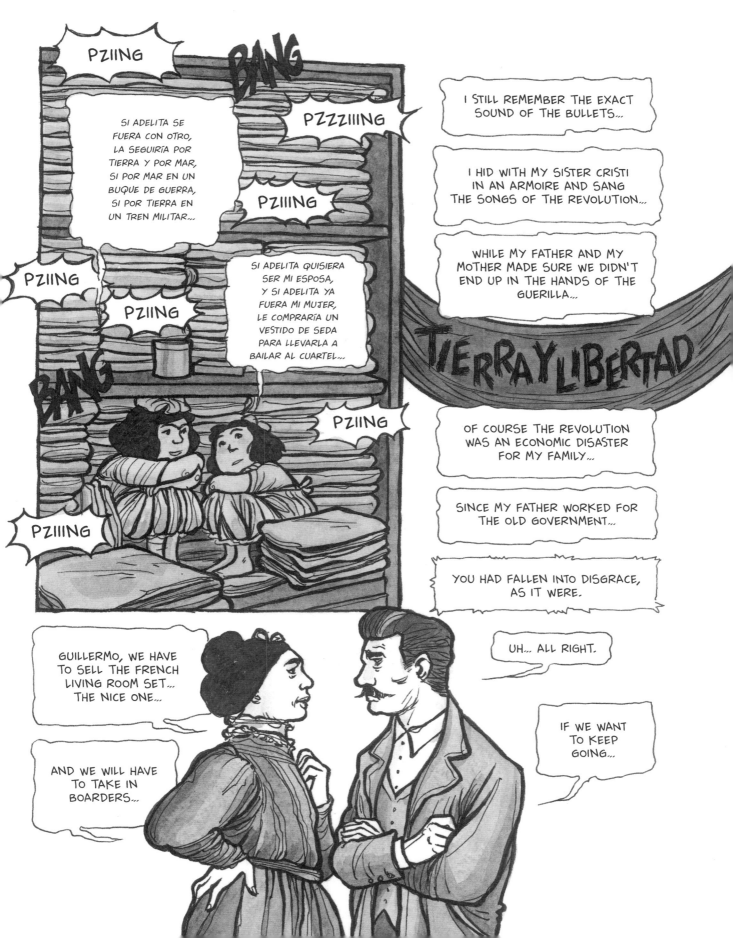

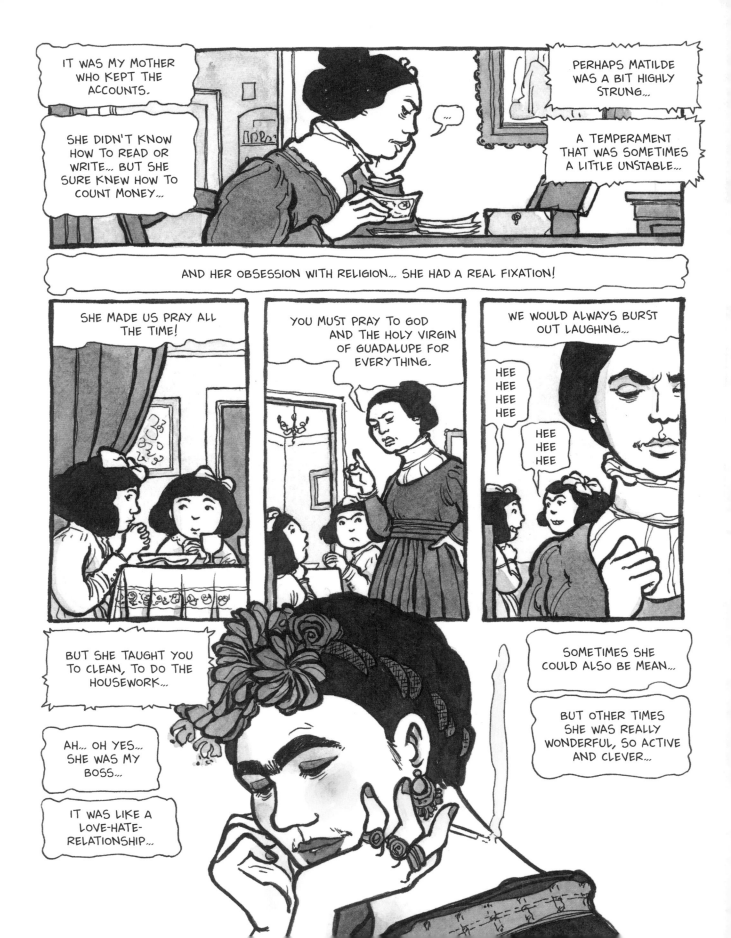

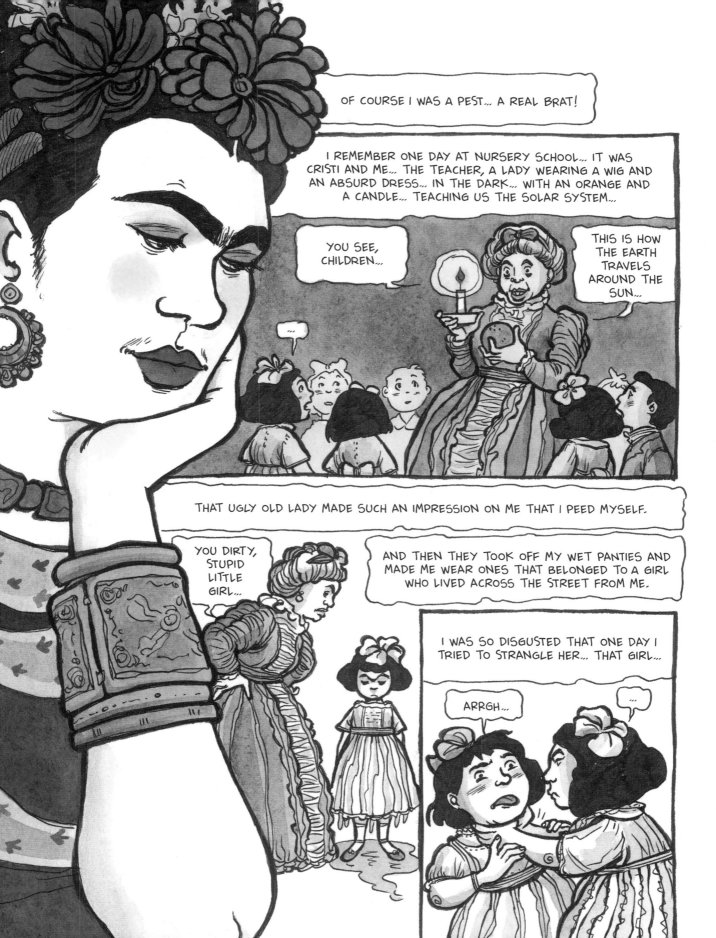

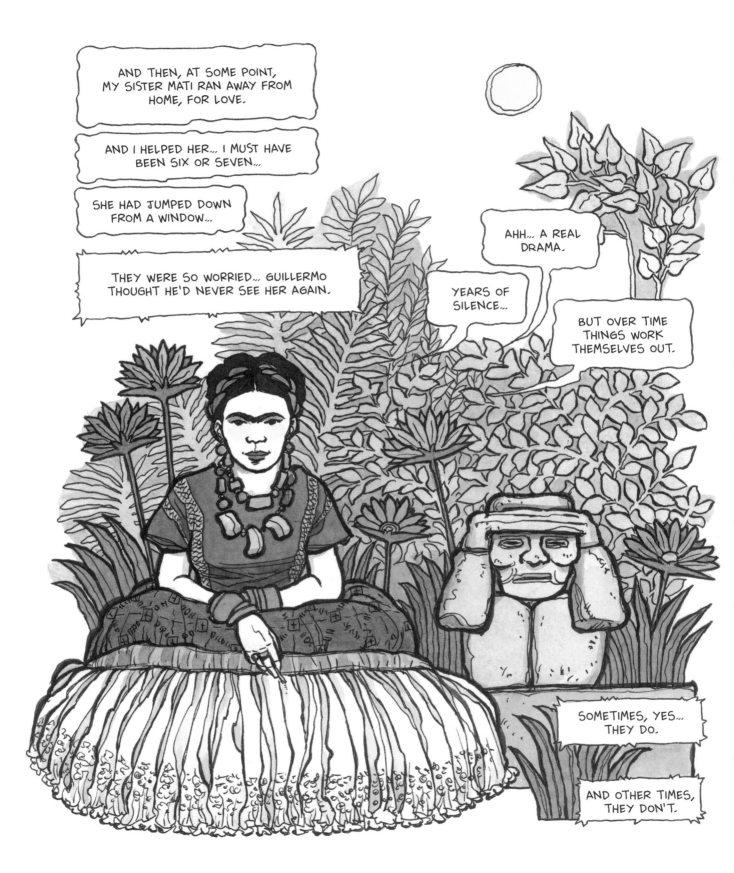

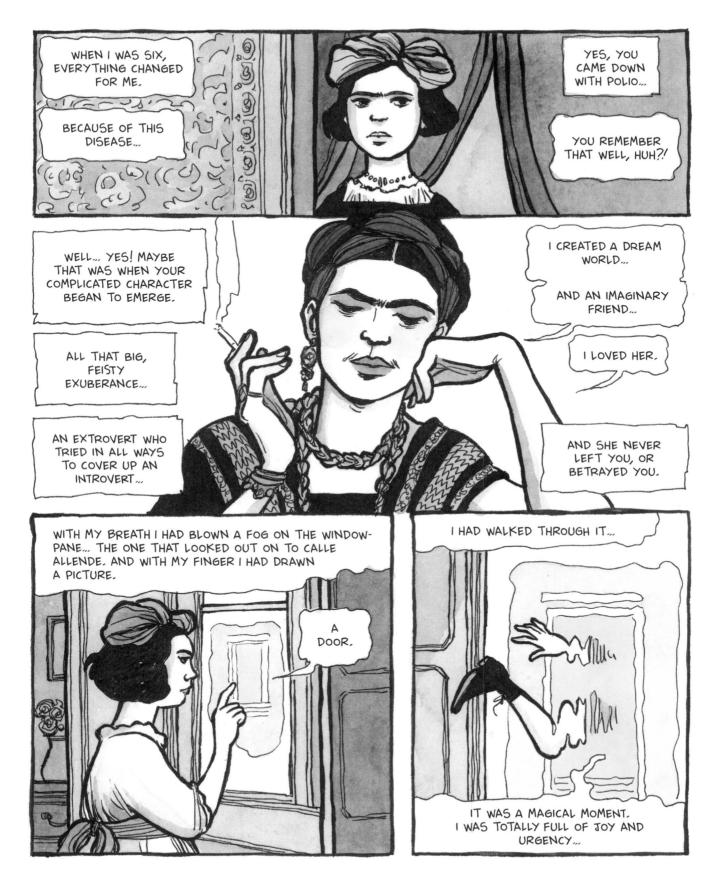

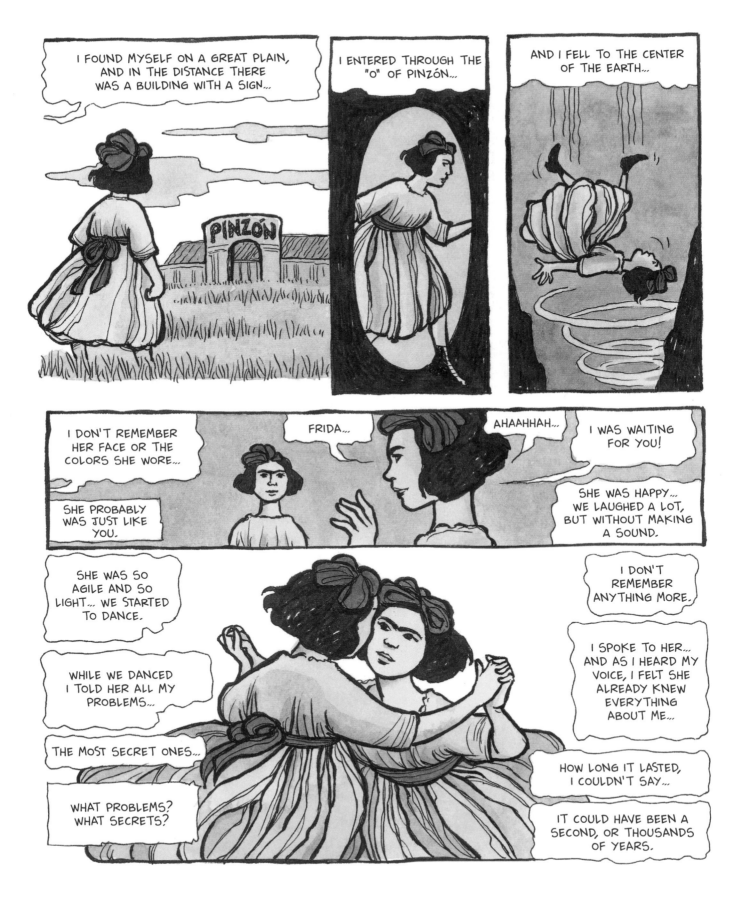

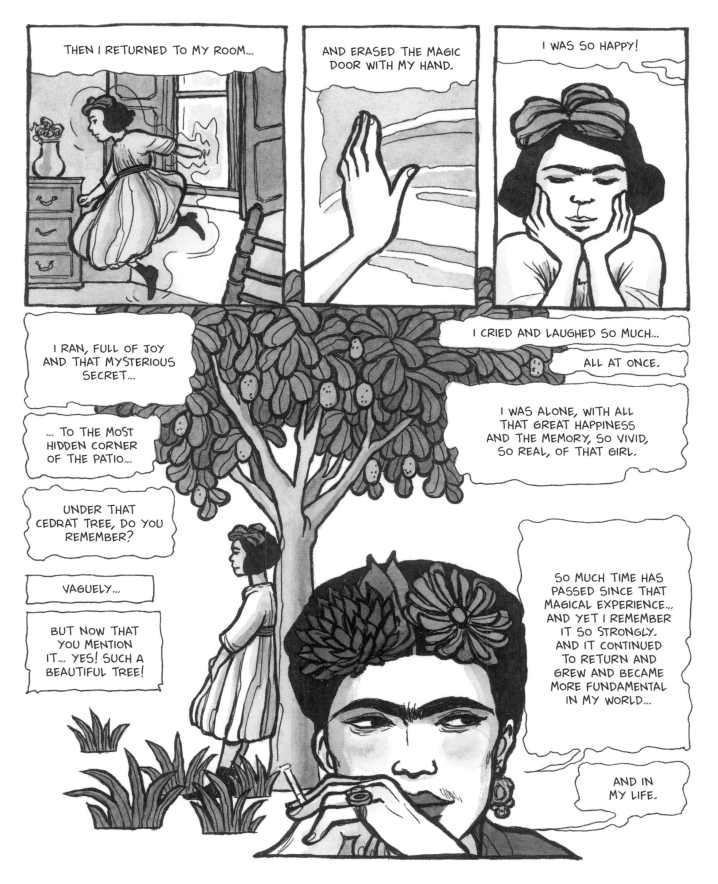

THEN I RETURNED TO MY ROOM...

AND ERASED THE MAGIC DOOR WITH MY HAND.

I WAS SO HAPPY!

I RAN, FULL OF JOY AND THAT MYSTERIOUS SECRET...

... TO THE MOST HIDDEN CORNER OF THE PATIO...

UNDER THAT CEDRAT TREE, DO YOU REMEMBER?

VAGUELY...

BUT NOW THAT YOU MENTION IT... YES! SUCH A BEAUTIFUL TREE!

I CRIED AND LAUGHED SO MUCH...

ALL AT ONCE.

I WAS ALONE, WITH ALL THAT GREAT HAPPINESS AND THE MEMORY, SO VIVID, SO REAL, OF THAT GIRL.

SO MUCH TIME HAS PASSED SINCE THAT MAGICAL EXPERIENCE... AND YET I REMEMBER IT SO STRONGLY. AND IT CONTINUED TO RETURN AND GREW AND BECAME MORE FUNDAMENTAL IN MY WORLD...

AND IN MY LIFE.

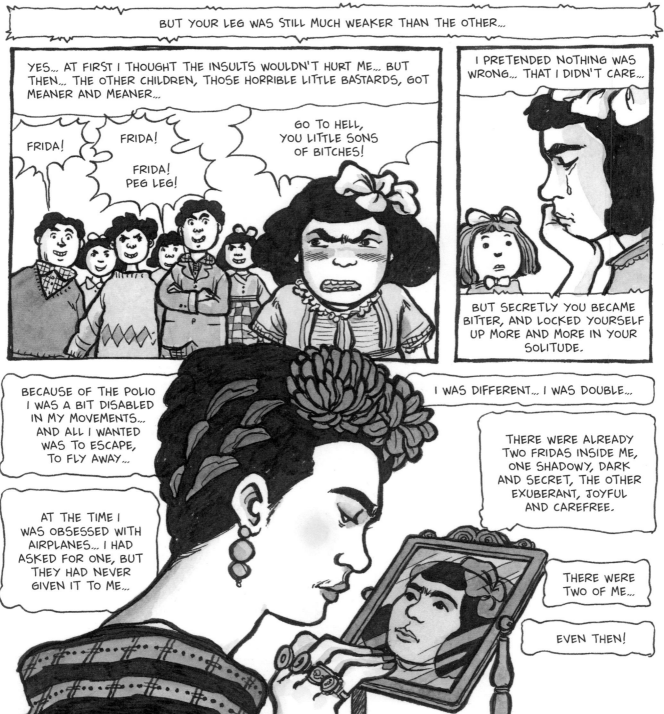

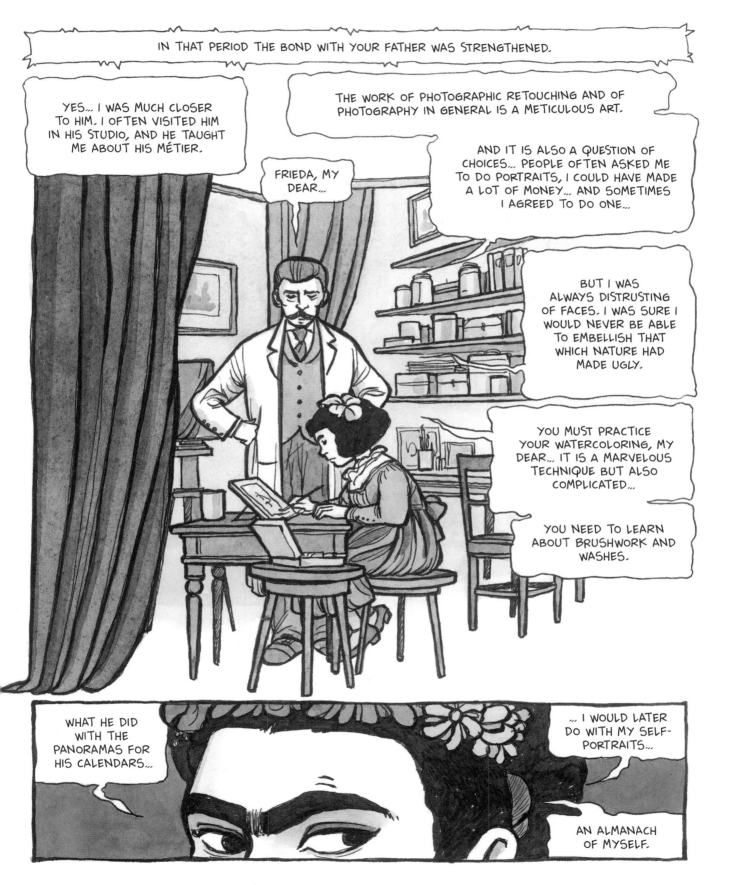

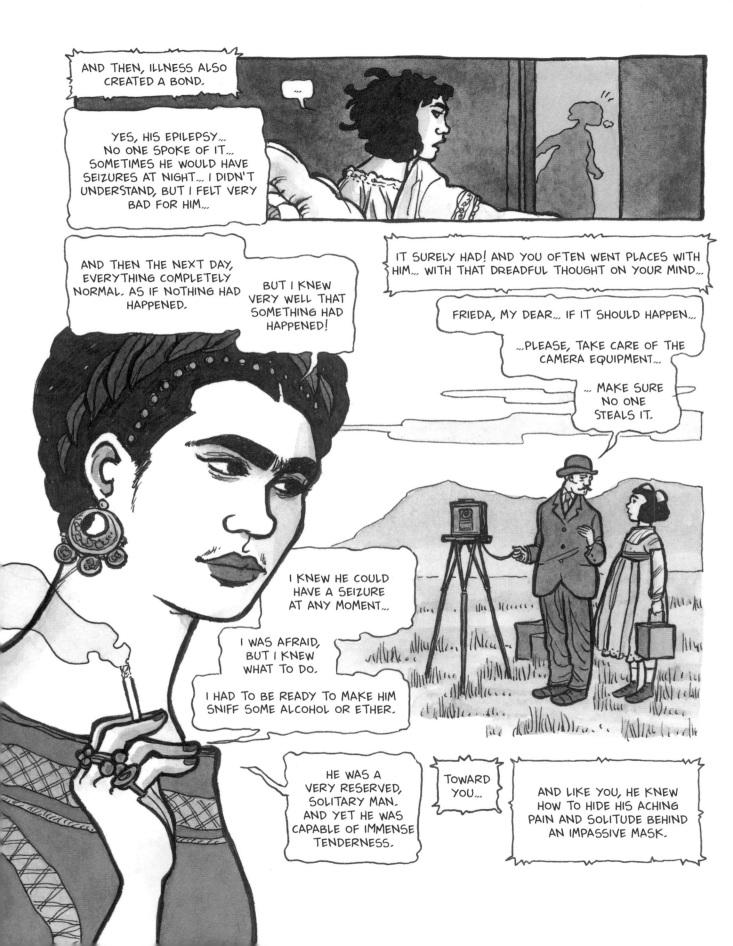

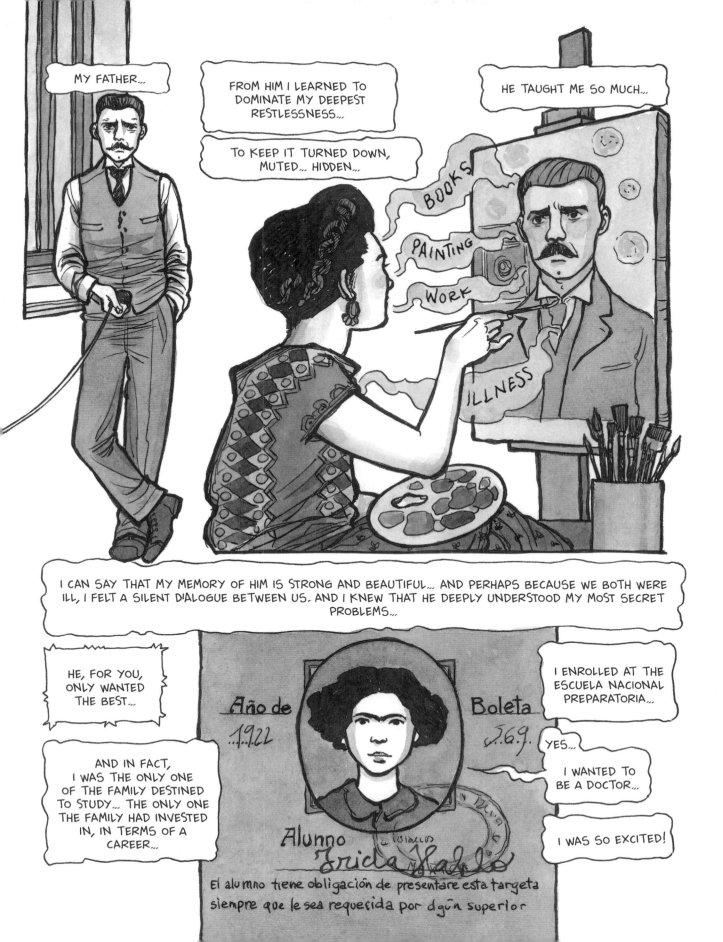

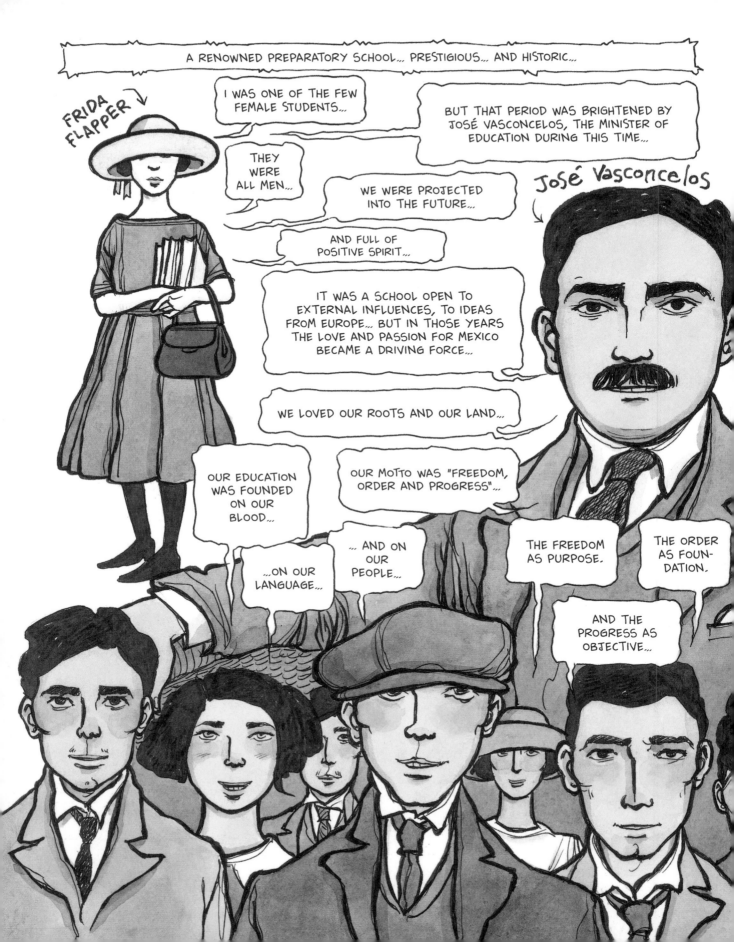

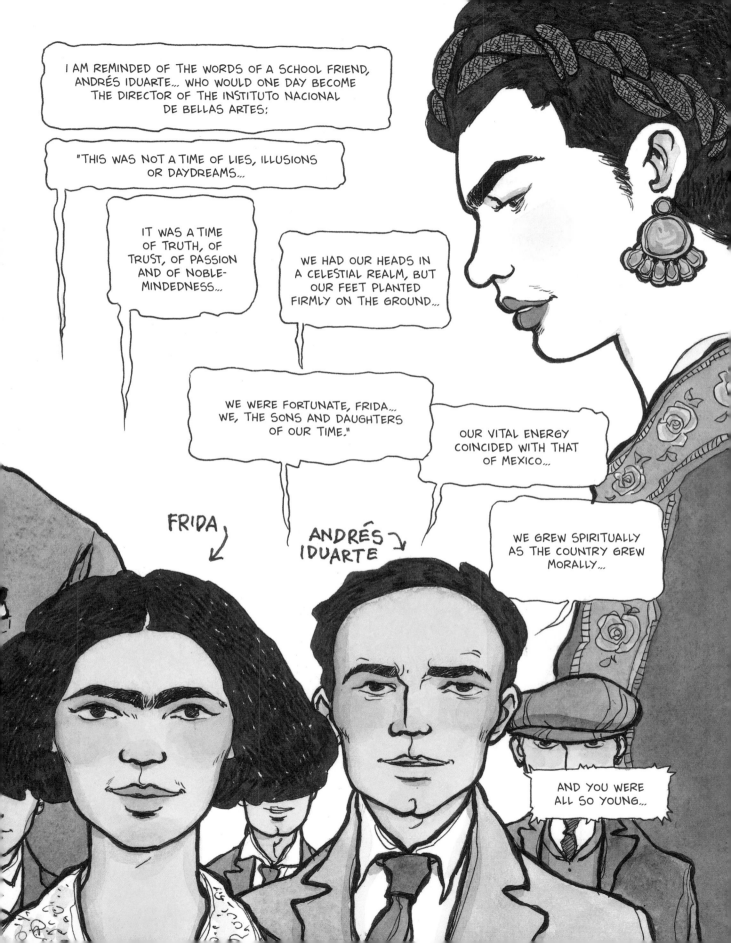

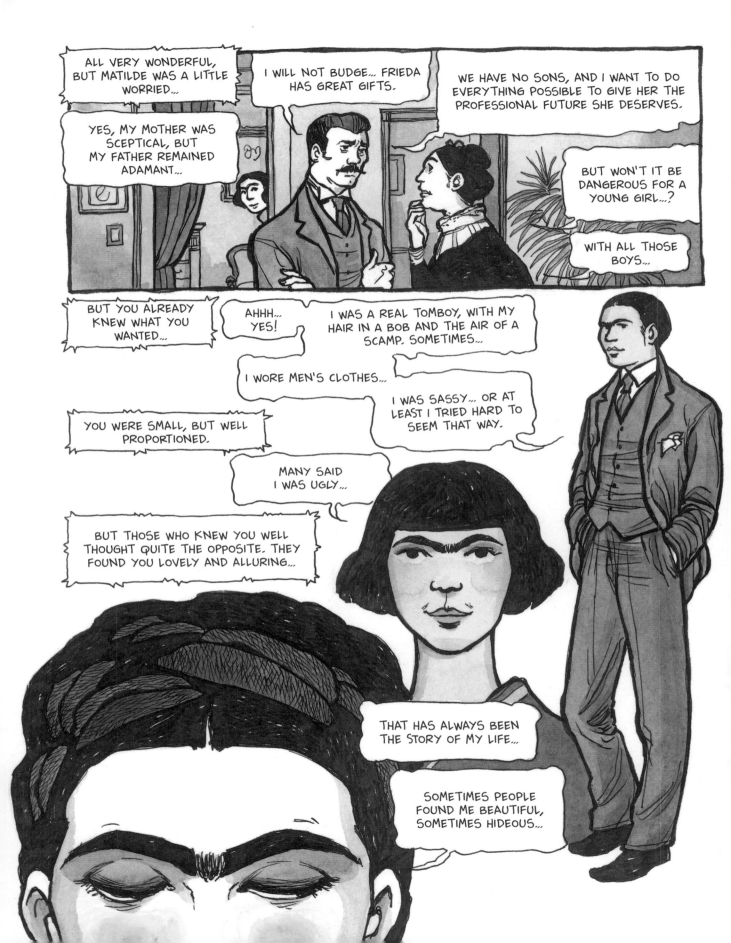

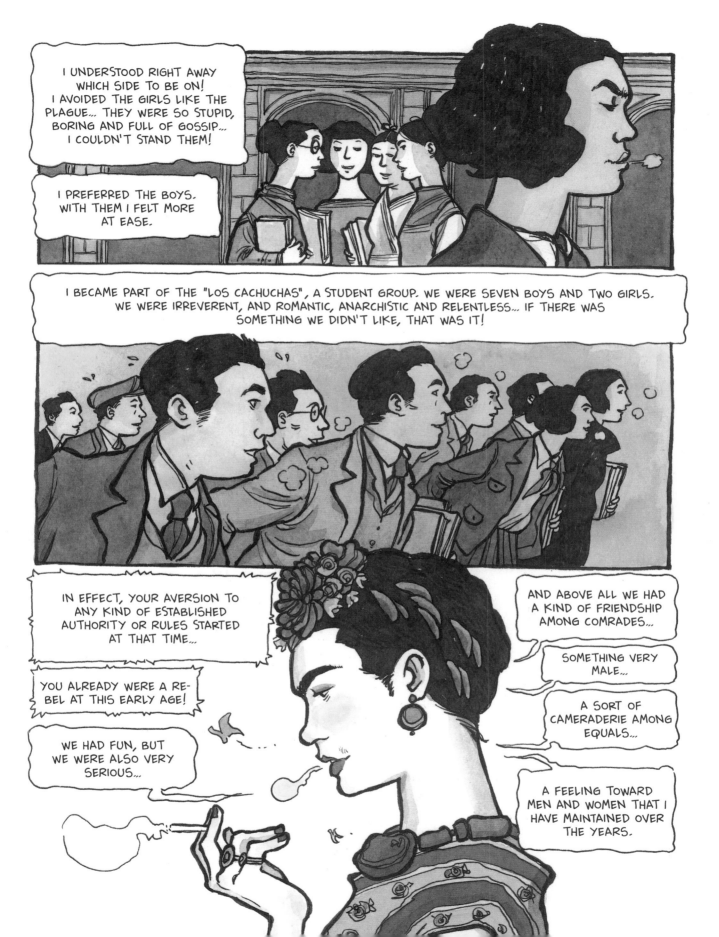

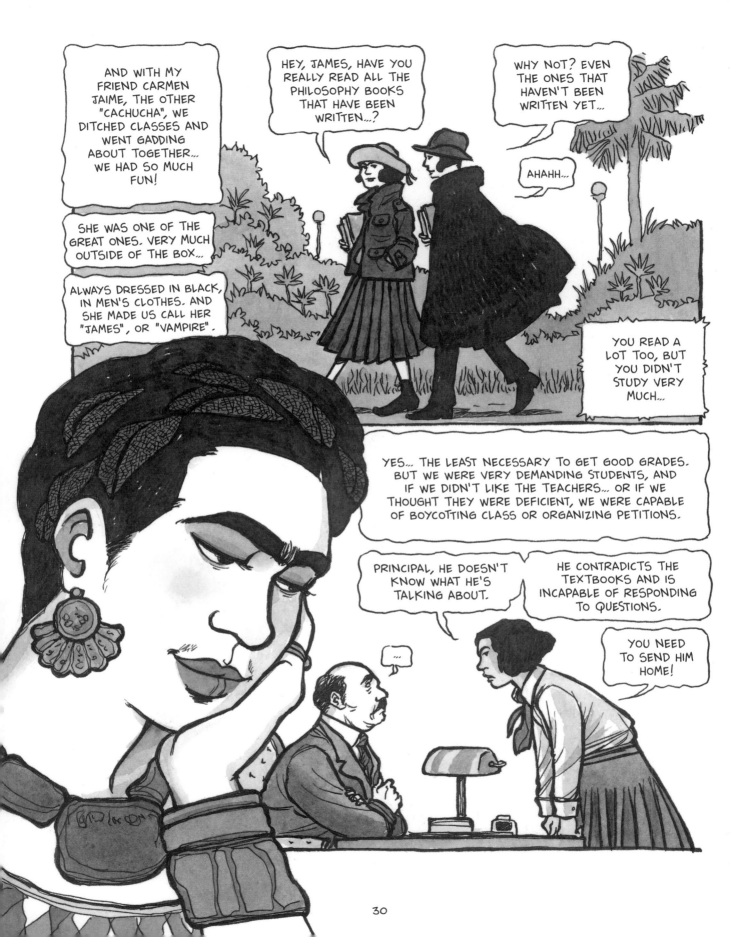

AND WITH MY FRIEND CARMEN JAIME, THE OTHER "CACHUCHA", WE DITCHED CLASSES AND WENT GADDING ABOUT TOGETHER... WE HAD SO MUCH FUN!

HEY, JAMES, HAVE YOU REALLY READ ALL THE PHILOSOPHY BOOKS THAT HAVE BEEN WRITTEN...?

WHY NOT? EVEN THE ONES THAT HAVEN'T BEEN WRITTEN YET...

AHAHH...

SHE WAS ONE OF THE GREAT ONES. VERY MUCH OUTSIDE OF THE BOX...

ALWAYS DRESSED IN BLACK, IN MEN'S CLOTHES. AND SHE MADE US CALL HER "JAMES", OR "VAMPIRE".

YOU READ A LOT TOO, BUT YOU DIDN'T STUDY VERY MUCH...

YES... THE LEAST NECESSARY TO GET GOOD GRADES. BUT WE WERE VERY DEMANDING STUDENTS, AND IF WE DIDN'T LIKE THE TEACHERS... OR IF WE THOUGHT THEY WERE DEFICIENT, WE WERE CAPABLE OF BOYCOTTING CLASS OR ORGANIZING PETITIONS.

PRINCIPAL, HE DOESN'T KNOW WHAT HE'S TALKING ABOUT.

HE CONTRADICTS THE TEXTBOOKS AND IS INCAPABLE OF RESPONDING TO QUESTIONS.

YOU NEED TO SEND HIM HOME!

...

30

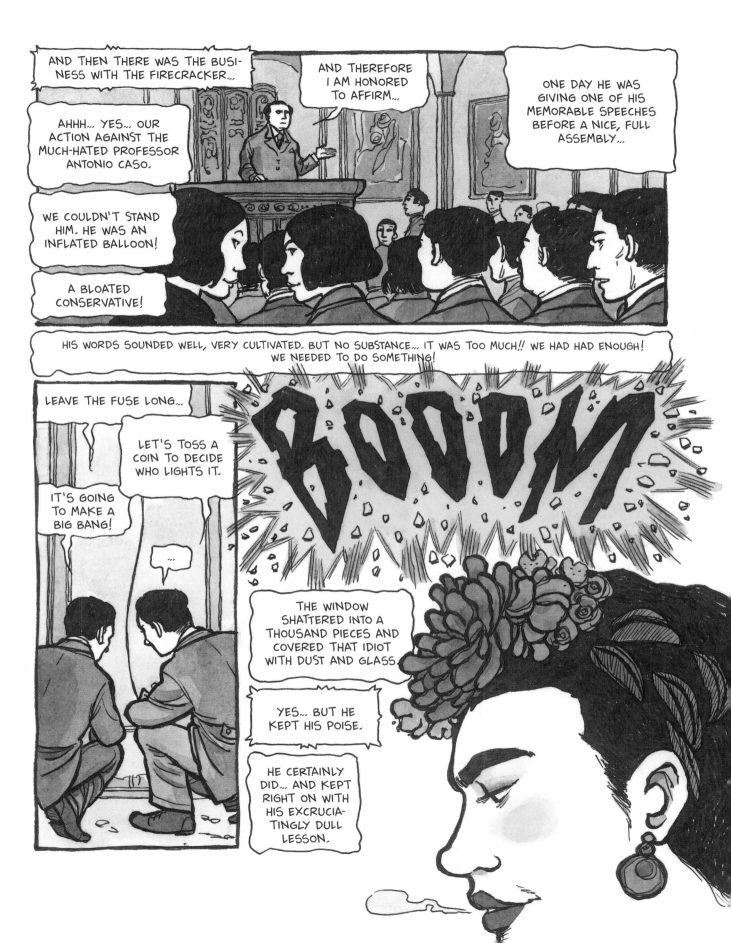

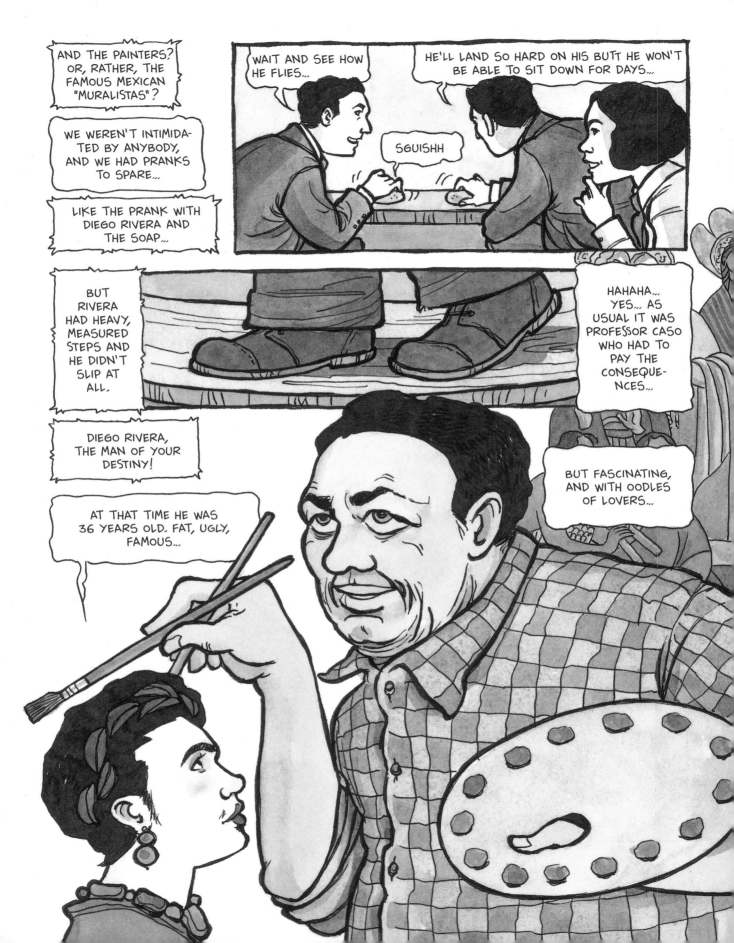

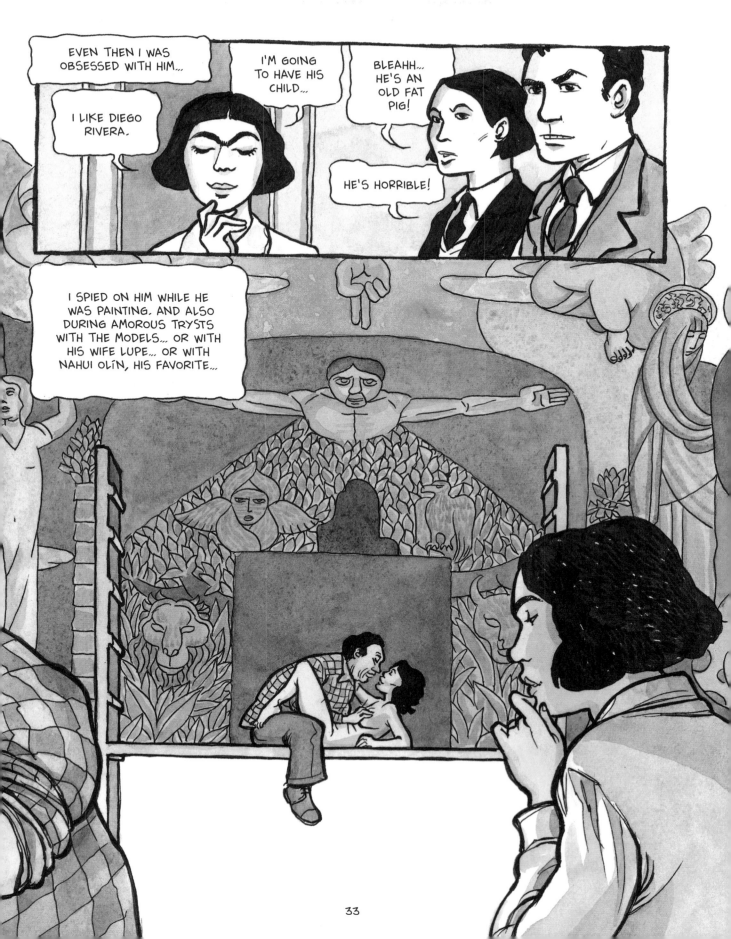

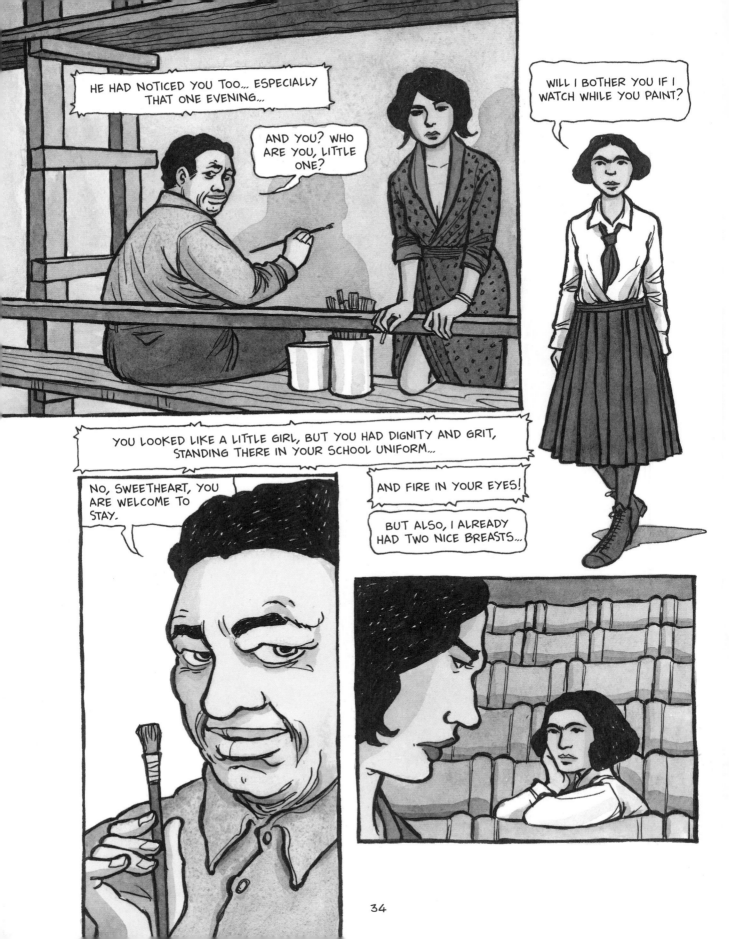

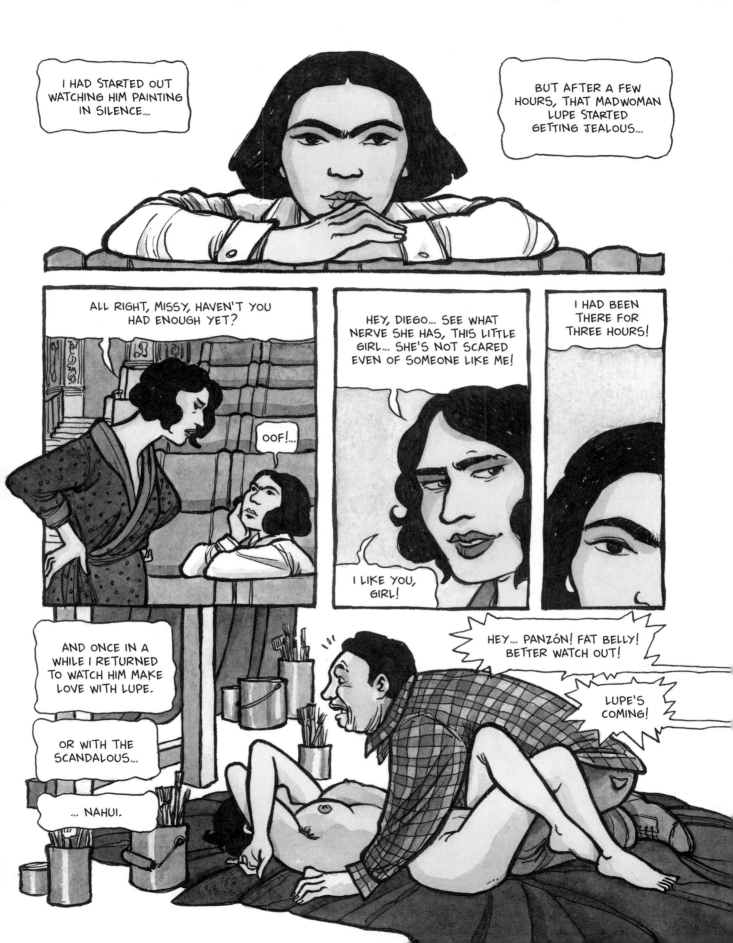

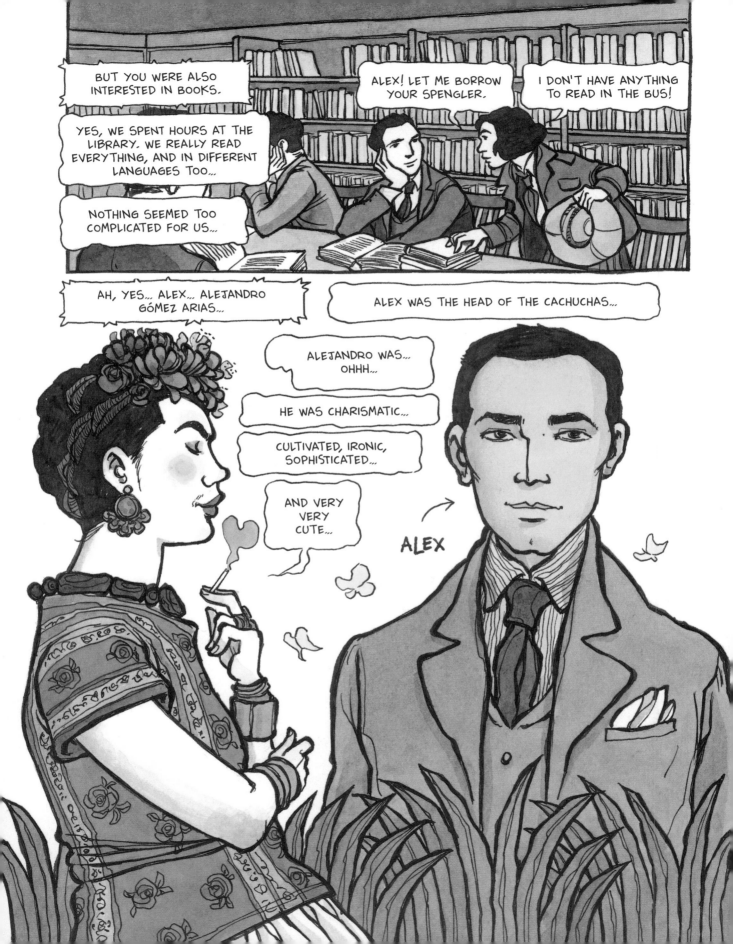

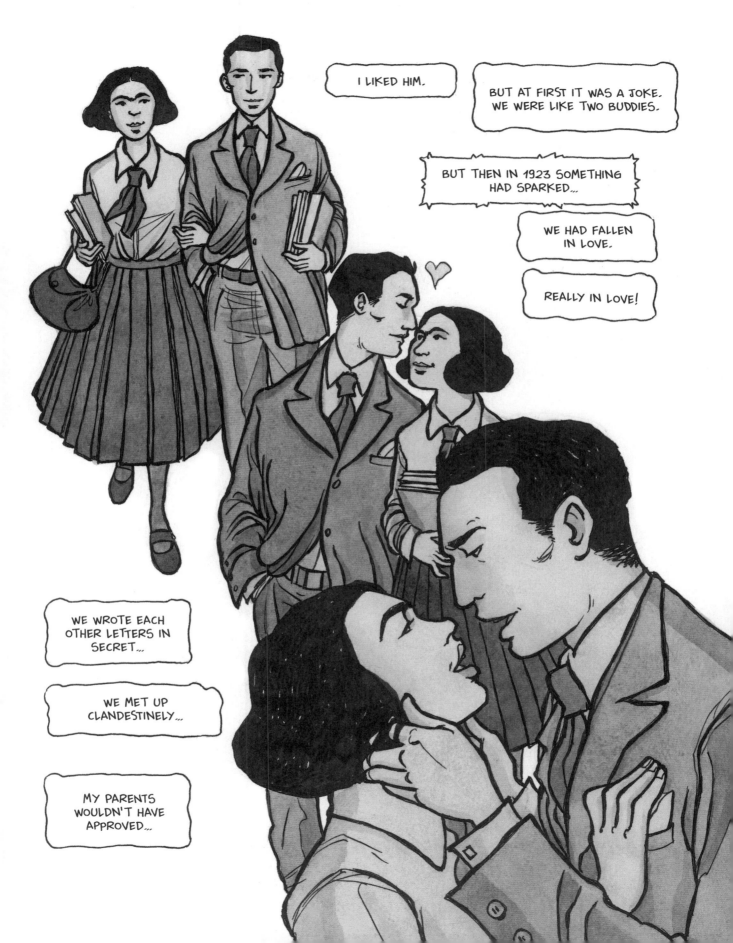

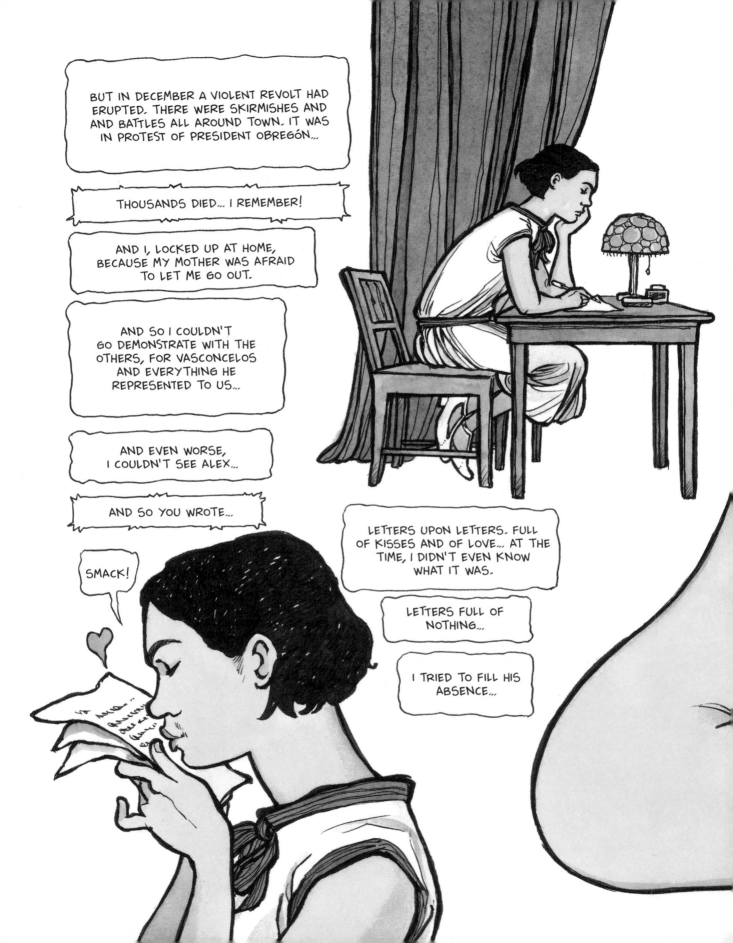

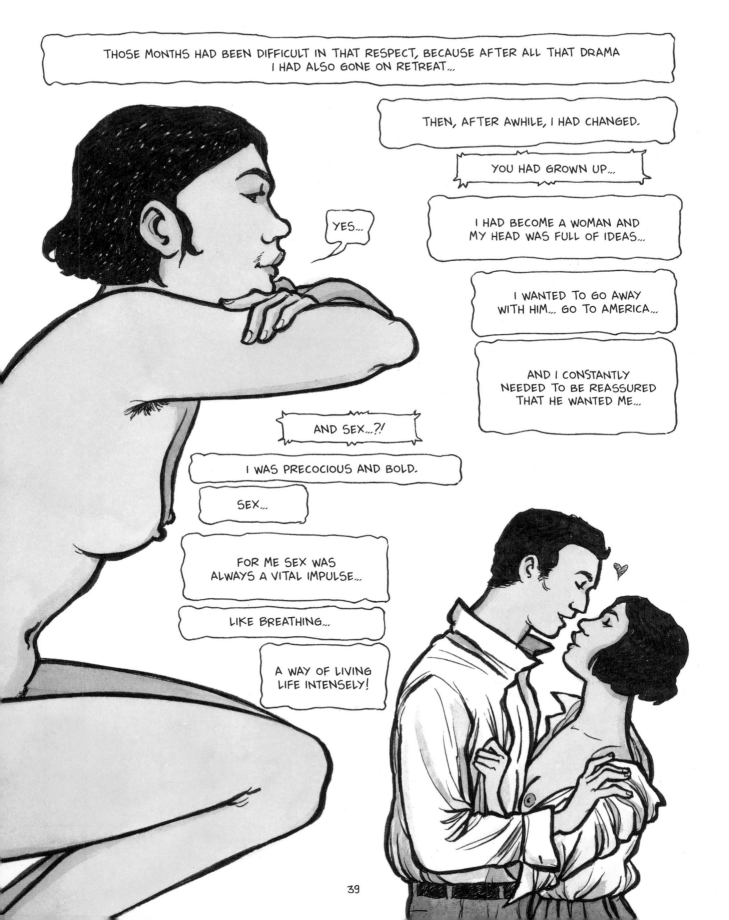

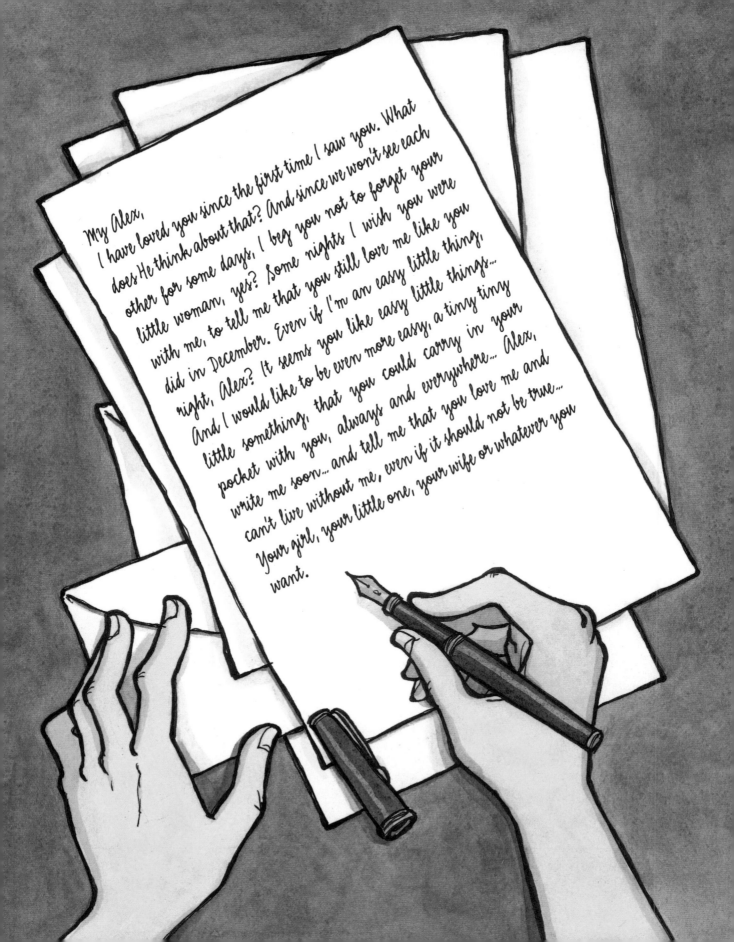

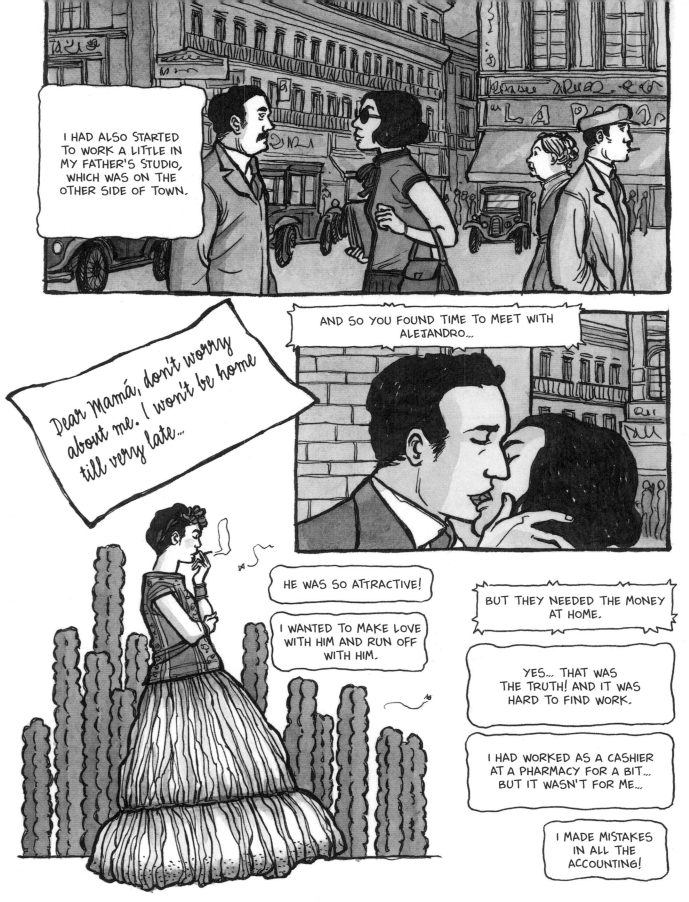

41

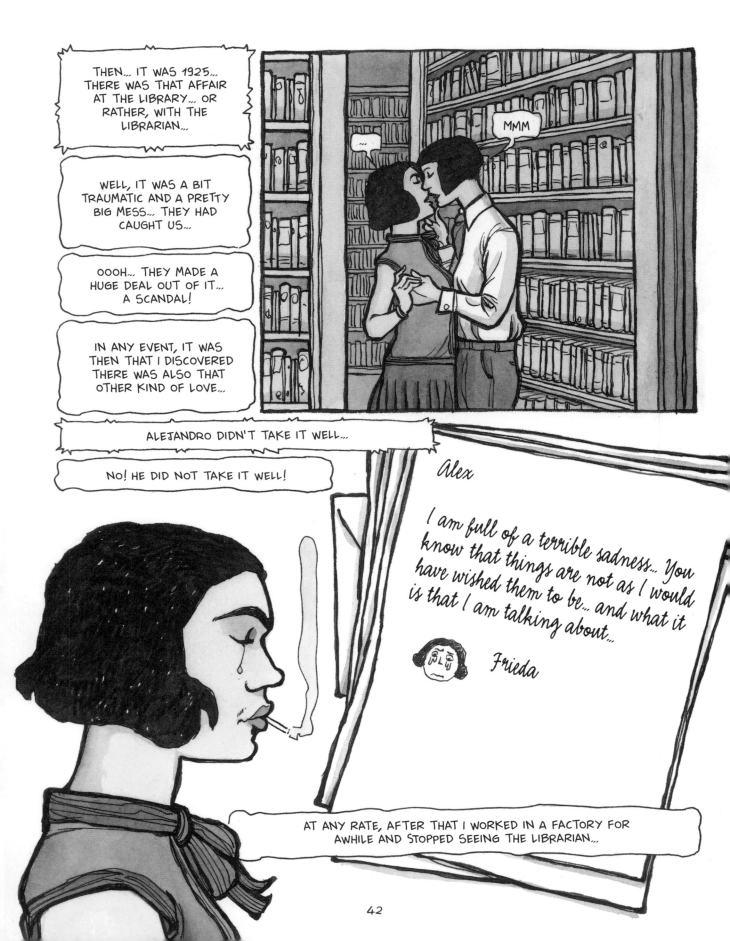

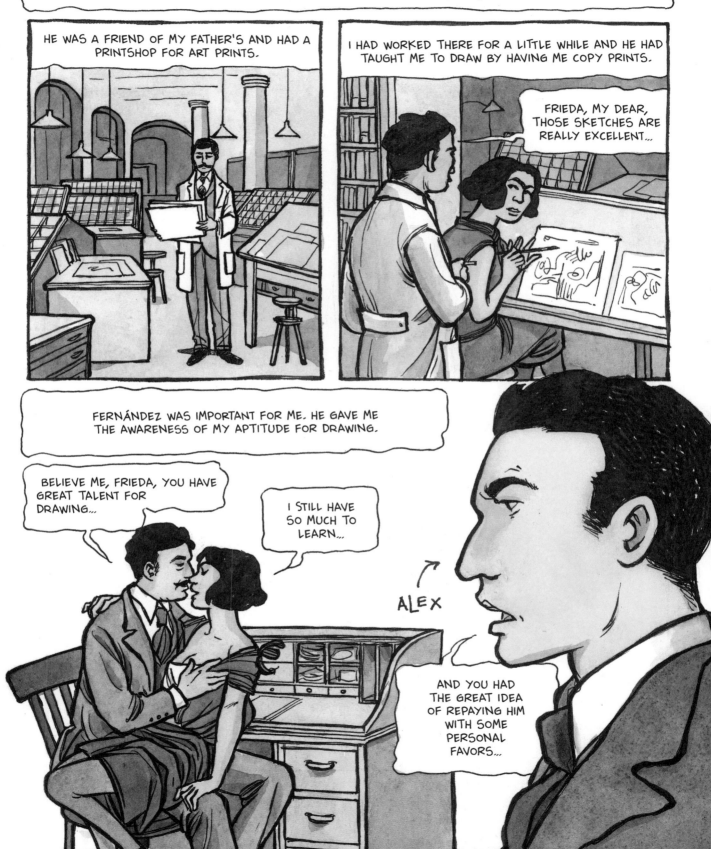

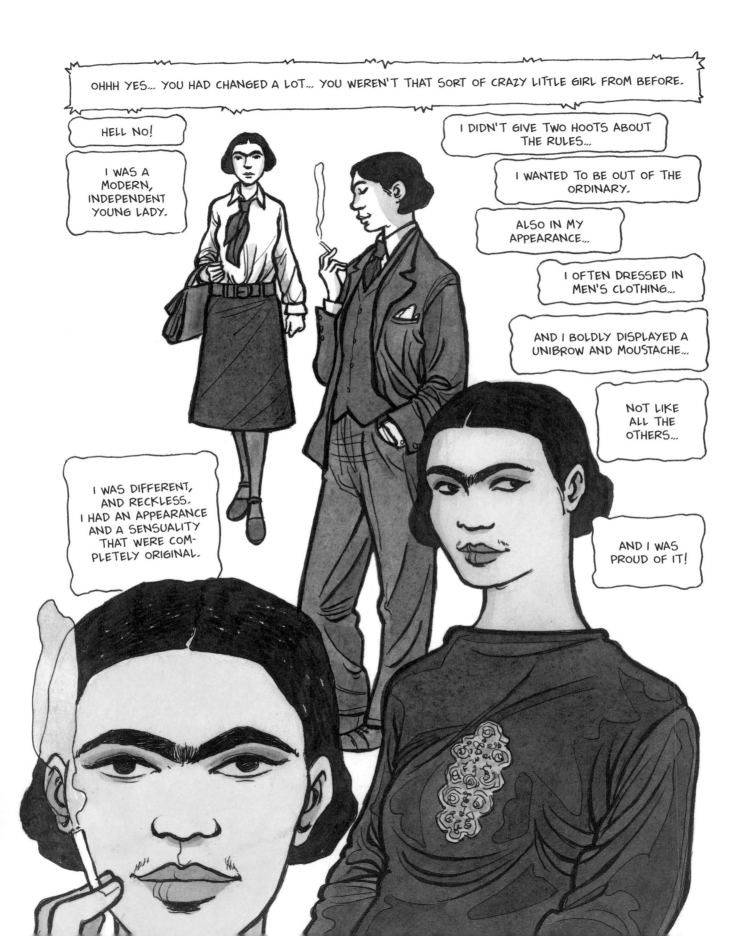

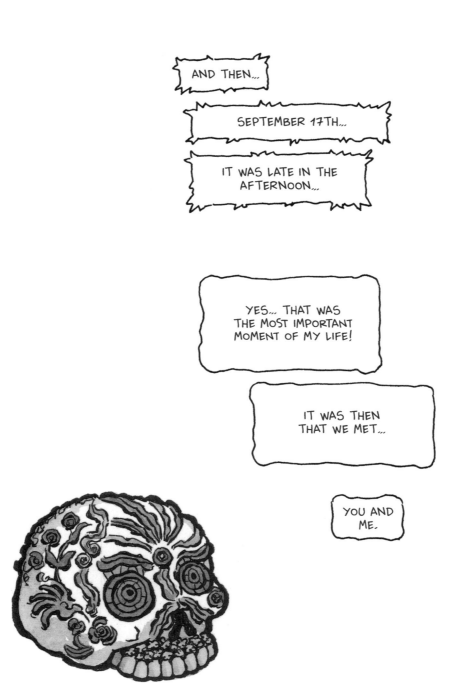

IT WAS SEPTEMBER 17, 1925.

IT WAS AFTERNOON.
IT HAD JUST STOPPED RAINING.
ALEX AND I WERE ON A BUS HEADED
TOWARD COYOACÁN. IT WAS
THE SECOND ONE WE TOOK. I HAD
LOST AN UMBRELLA AND WANTED
TO LOOK FOR IT.

WE HAD GOTTEN OFF ANOTHER
BUS AND GOTTEN ON TO THIS
ONE. IT WAS A NEW BUS.

IT HAPPENED IN FRONT OF
THE MERCADO DE SAN JUAN.
A STREETCAR WAS APPROACHING.
IT ALL HAPPENED VERY SLOWLY.
THE BUS WAS DRIVING SLOWLY,
BUT THE YOUNG GUY WHO WAS
DRIVING IT WAS NERVOUS.

I WAS A SMART GIRL,
BUT ALSO A LITTLE
CARELESS... DESPITE
THE GREAT FREEDOM I
HAD CONQUERED.

I THINK THAT'S
WHY I DIDN'T
REALIZE WHAT
WAS HAPPENING.

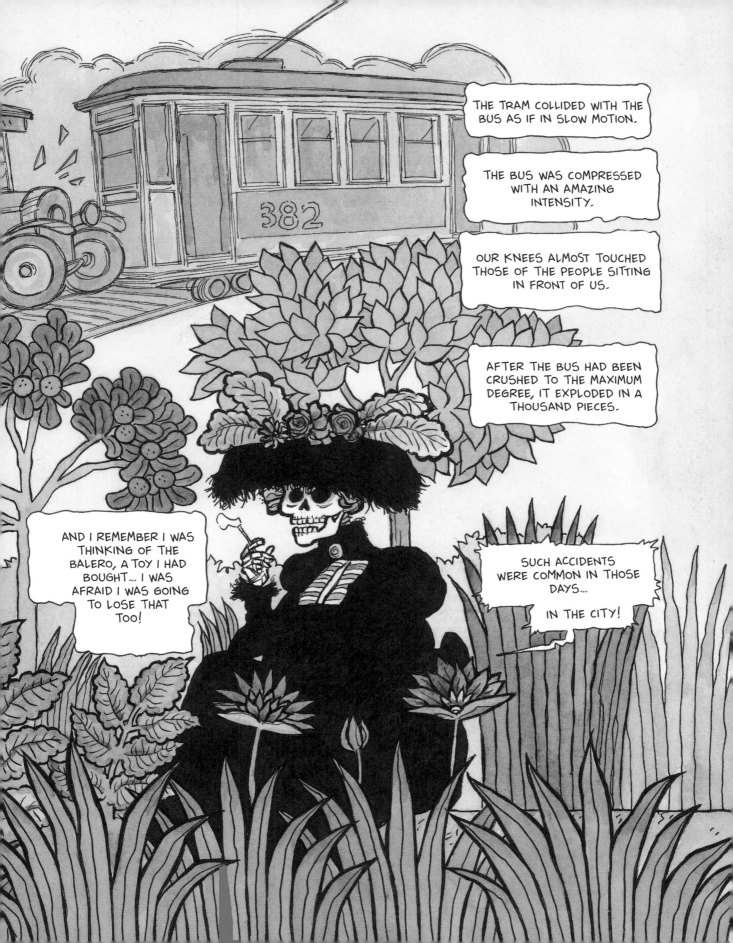

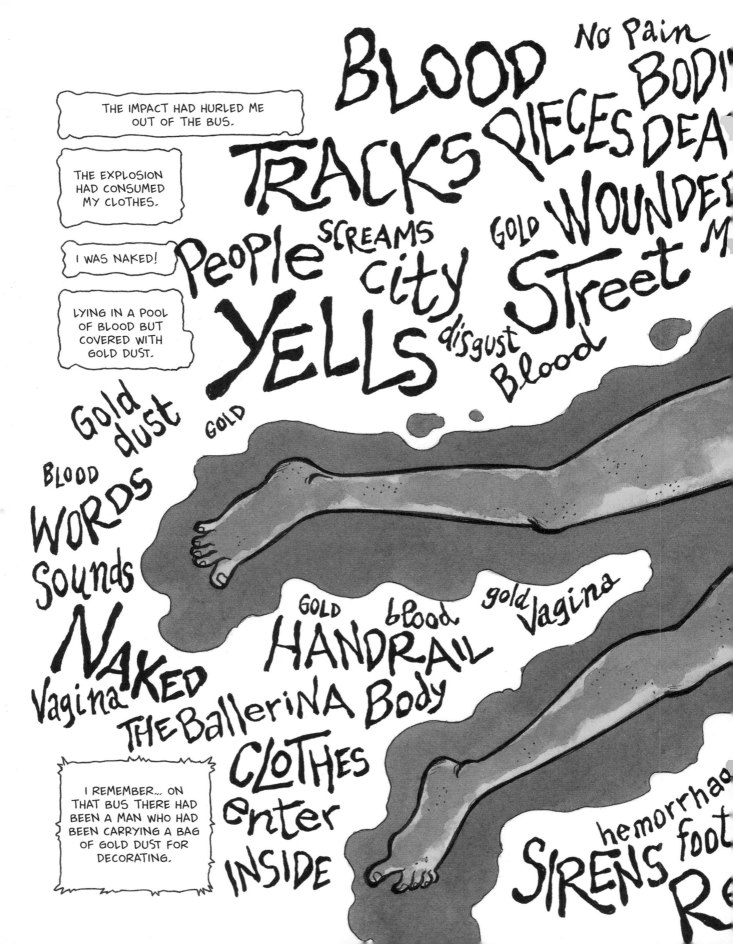

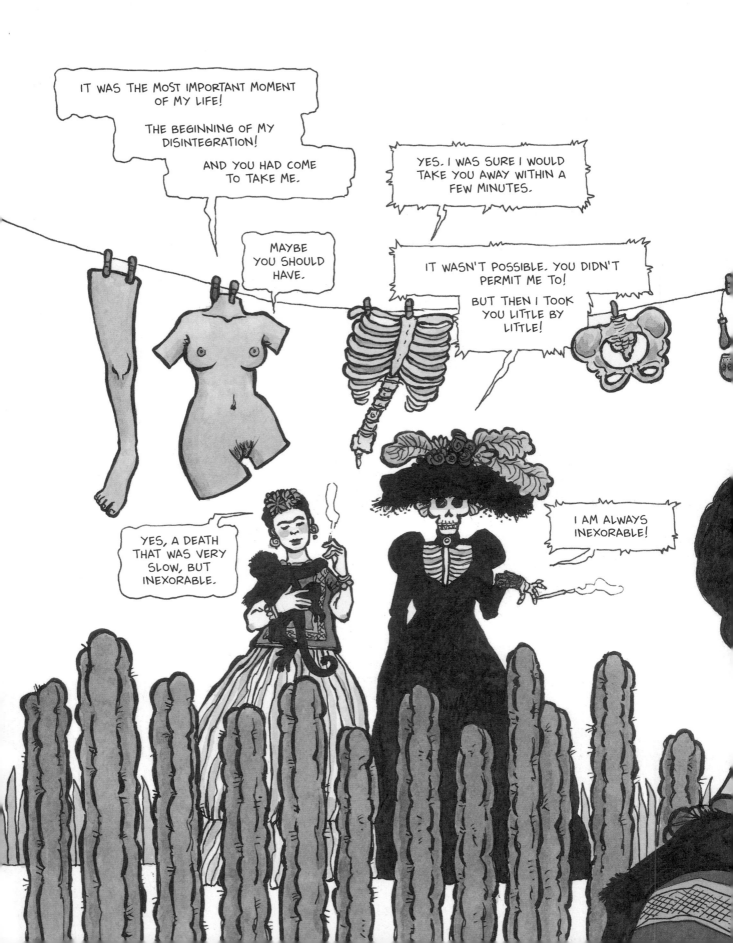

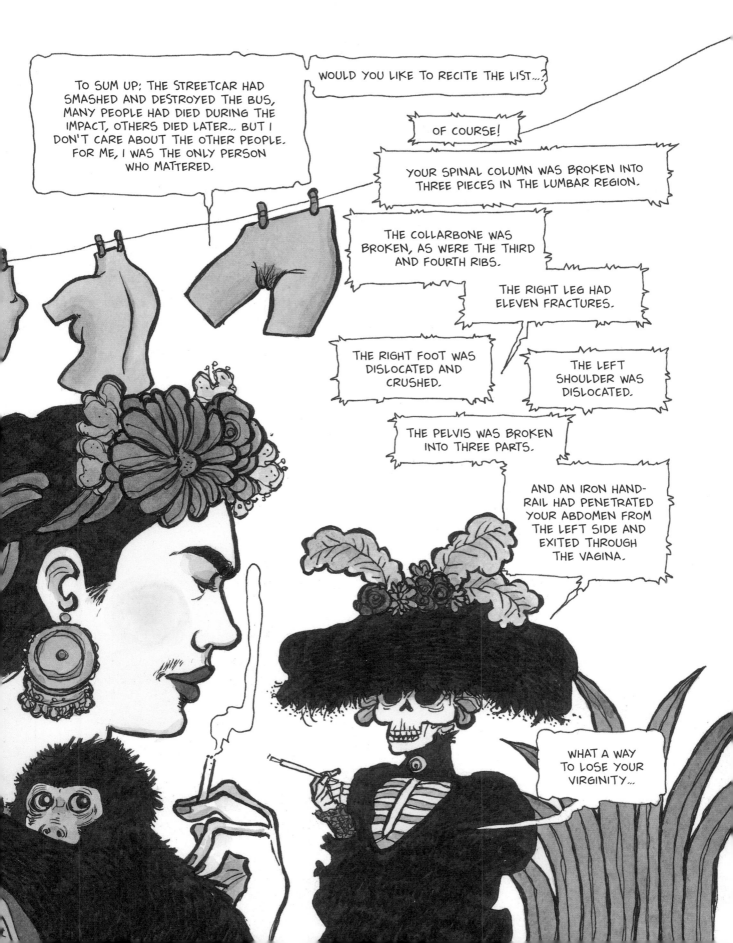

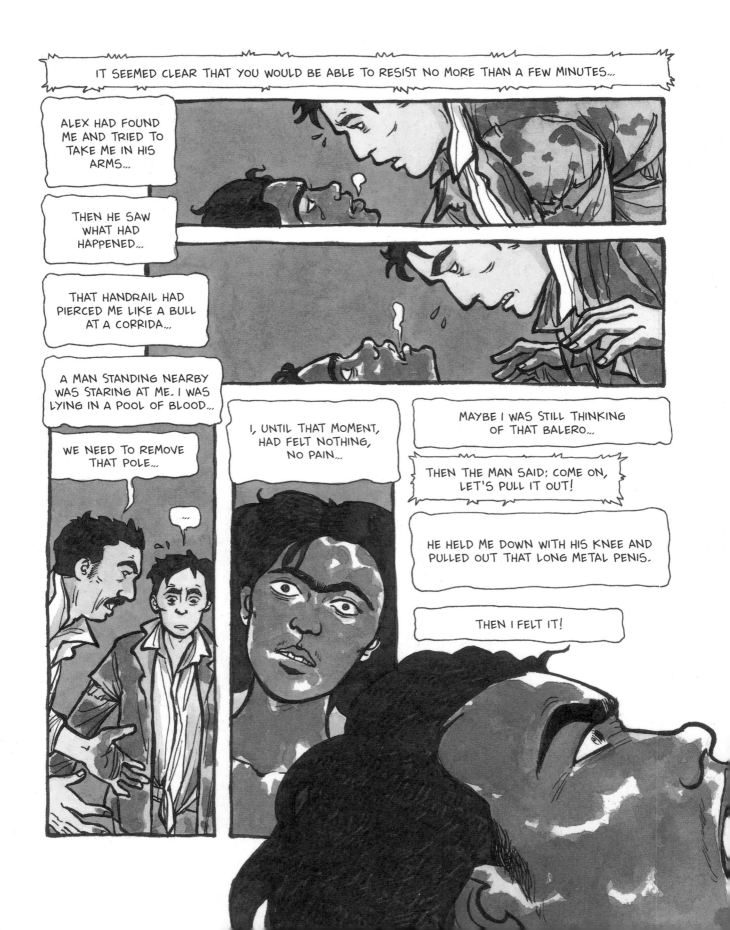

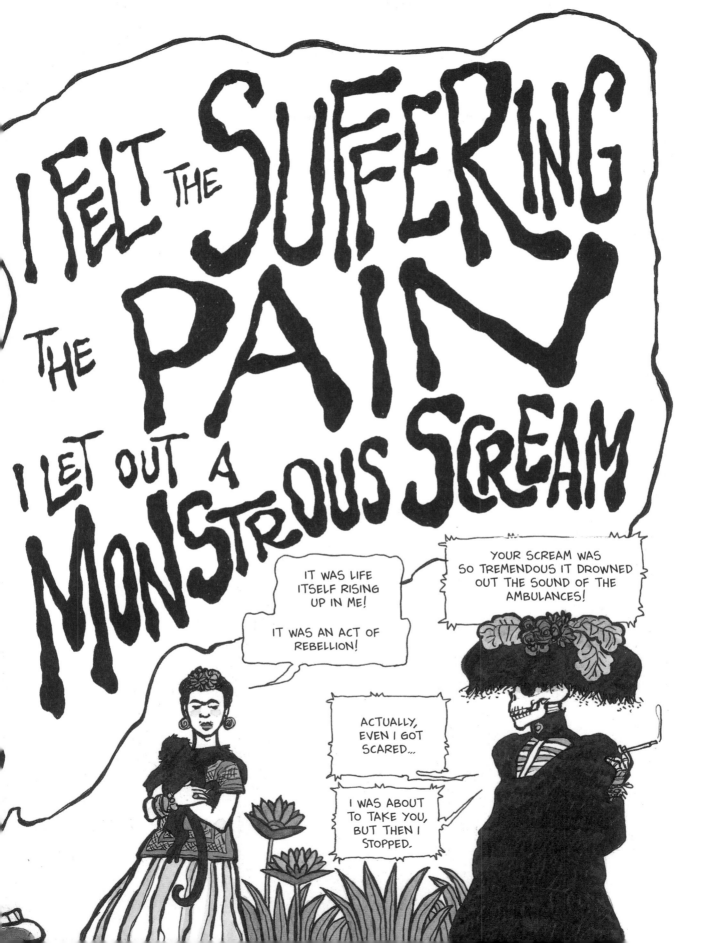

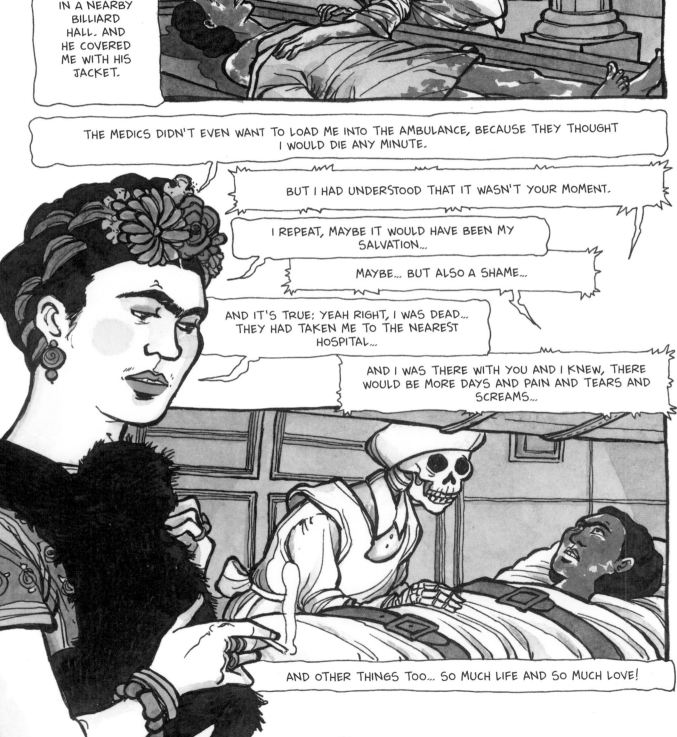

ALEX PICKED ME UP AND LAID ME, NAKED AND COVERED WITH BLOOD, ON A POOL TABLE IN A NEARBY BILLIARD HALL. AND HE COVERED ME WITH HIS JACKET.

THE MEDICS DIDN'T EVEN WANT TO LOAD ME INTO THE AMBULANCE, BECAUSE THEY THOUGHT I WOULD DIE ANY MINUTE.

BUT I HAD UNDERSTOOD THAT IT WASN'T YOUR MOMENT.

I REPEAT, MAYBE IT WOULD HAVE BEEN MY SALVATION...

MAYBE... BUT ALSO A SHAME...

AND IT'S TRUE; YEAH RIGHT, I WAS DEAD... THEY HAD TAKEN ME TO THE NEAREST HOSPITAL...

AND I WAS THERE WITH YOU AND I KNEW, THERE WOULD BE MORE DAYS AND PAIN AND TEARS AND SCREAMS...

AND OTHER THINGS TOO... SO MUCH LIFE AND SO MUCH LOVE!

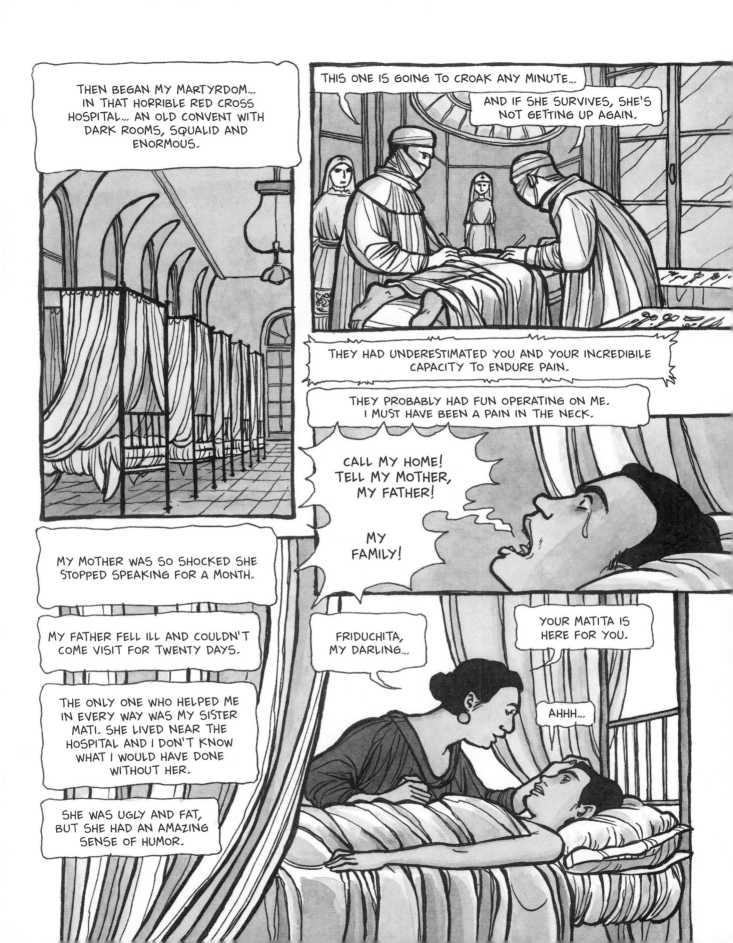

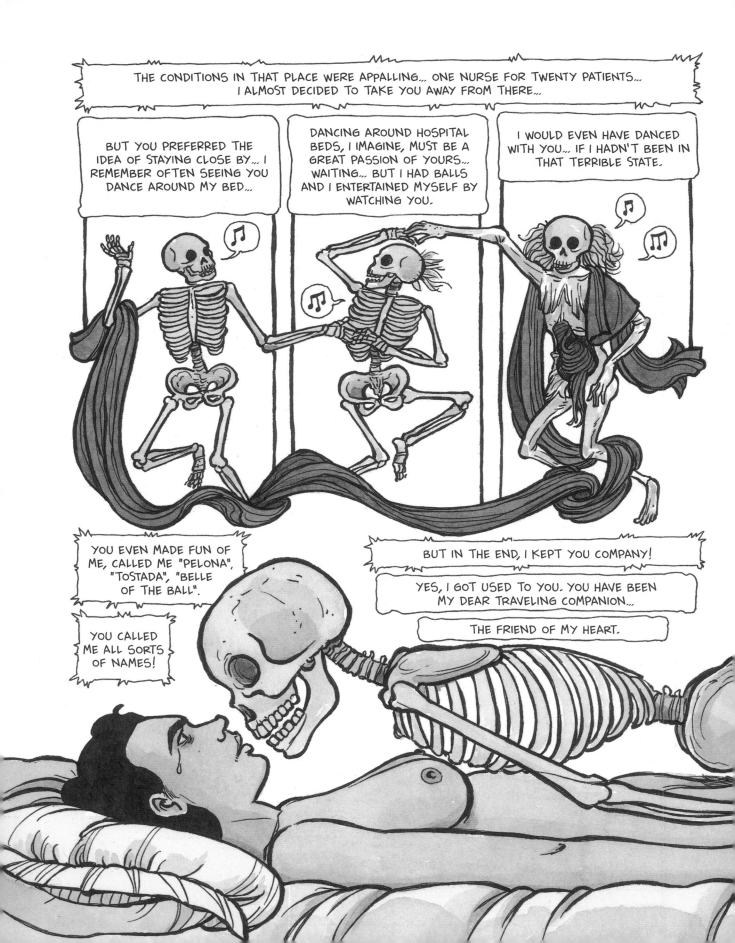

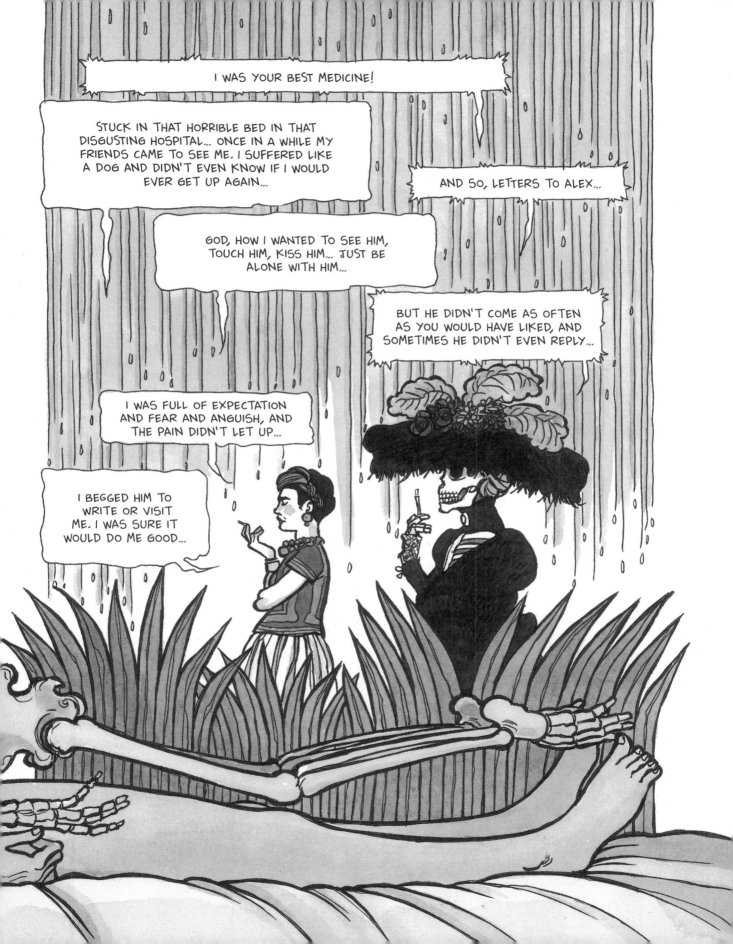

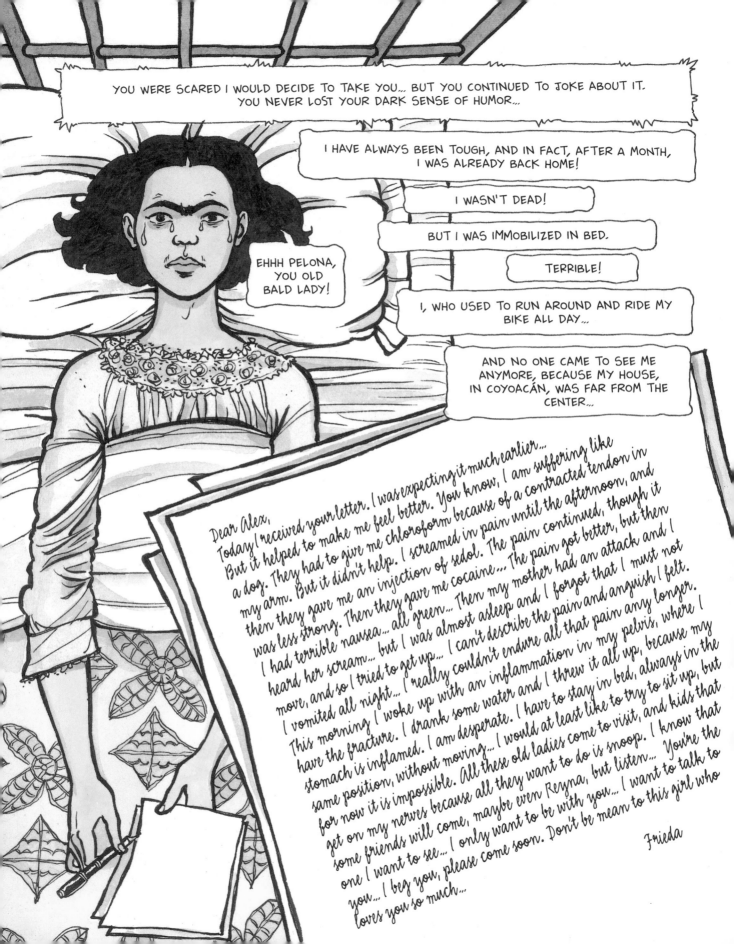

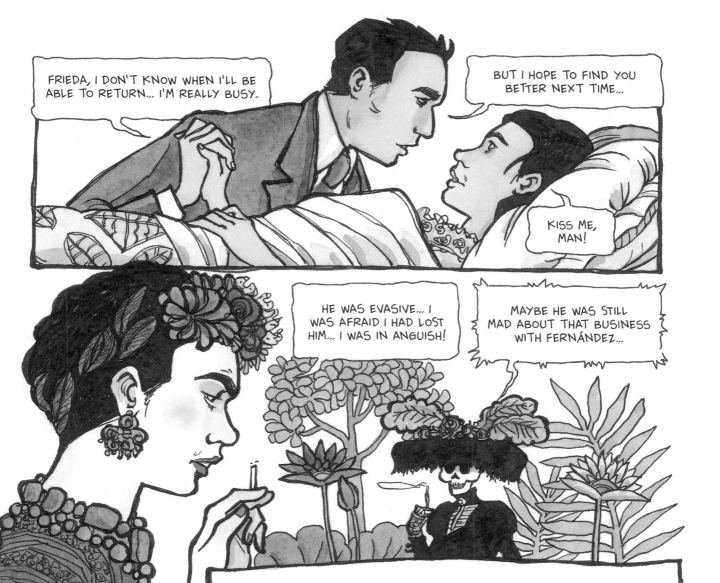

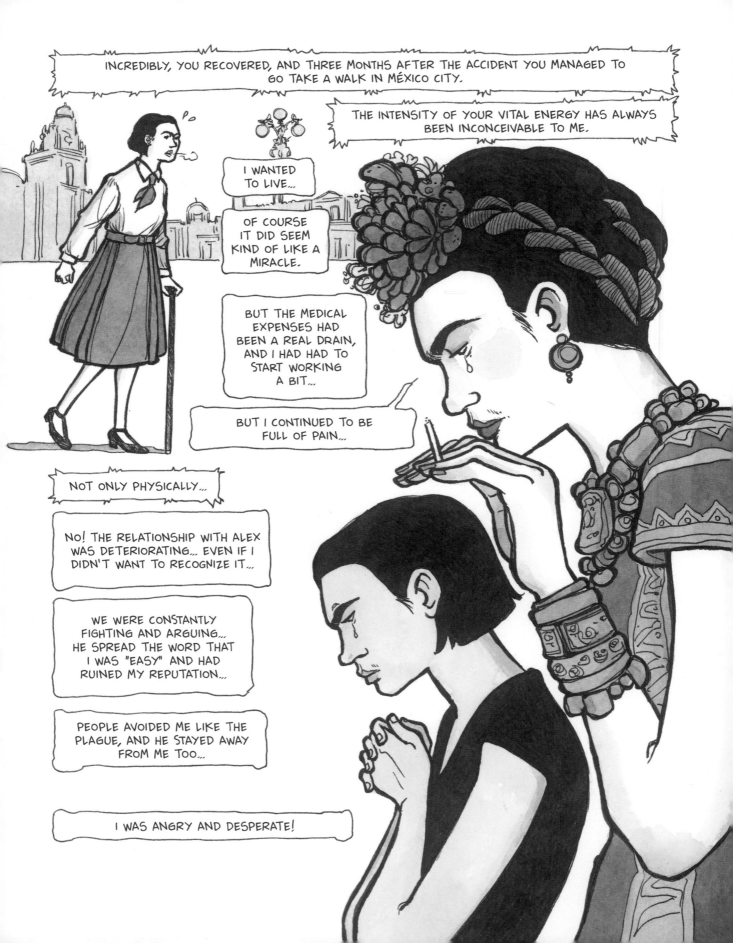

Yesterday I went to the city. I wanted to see you, I waited forever for you in the library and then I went to look for you at your house, but you weren't there...

You are going around saying terrible things about me, and I can't forgive your treating me as if I were Nahui Olin or one of those women... You insulted me, Alex, and at the same time you also hurt yourself...

All right! I won't be your Novia anymore, but I want to keep on seeing you and talking to you, because I love you more than ever before...
You have to believe me!

I WAS IN LOVE WITH HIM AND I COULDN'T TOLERATE THE THOUGHT OF LOSING HIM... BUT HE WAS LEAVING ME...

I'LL CHANGE... I SWEAR I'LL CHANGE...

BUT SOMETIMES YOU GOT MAD AND REBELLED...

You said I should go my own way, and that given the circumstances I don't show the least bit of shame...

You say that now I have nothing left to lose.

Well, I think I've already told you that even if I'm worth nothing to you, or to all those who once said they were my friends, to myself I am worth much more than all those girls who seem so perfect and exceptional...

And I like myself the way I am.

BUT I WAS WILLING TO DO ANYTHING JUST TO SEE HIM AGAIN.

THAT'S WHY YOU GAVE HIM YOUR FIRST REAL SELF-PORTRAIT...?

YES, IT WAS AS IF I WERE GIVING MYSELF TO HIM...

AN OFFER OF LOVE TO THE PERSON I MOST CARED ABOUT...

MY PORTRAIT IN THE STYLE OF BOTTICELLI.

A TALISMAN.

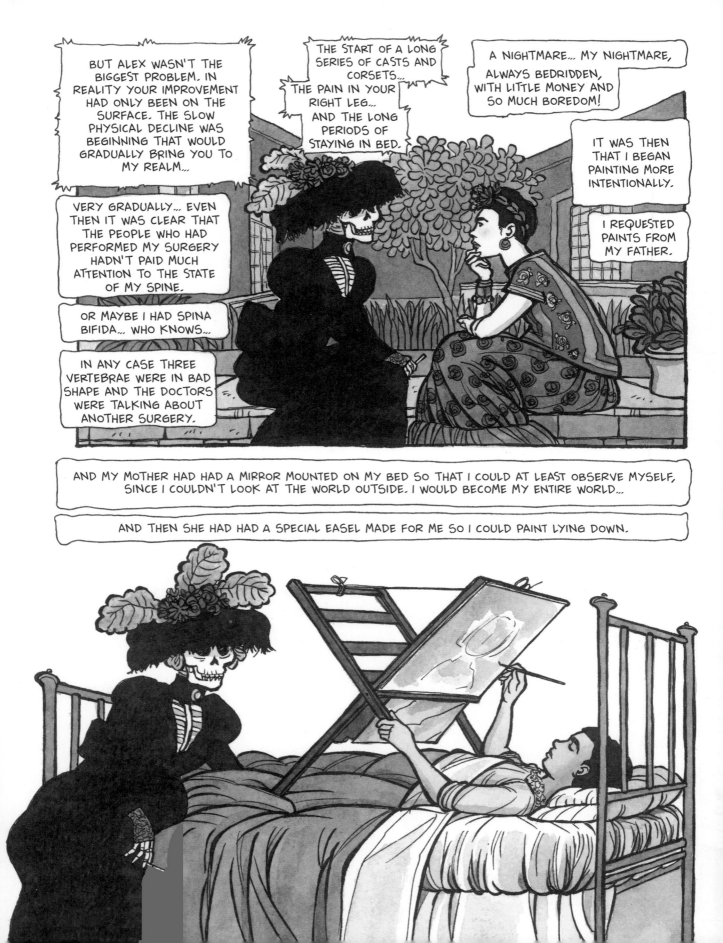

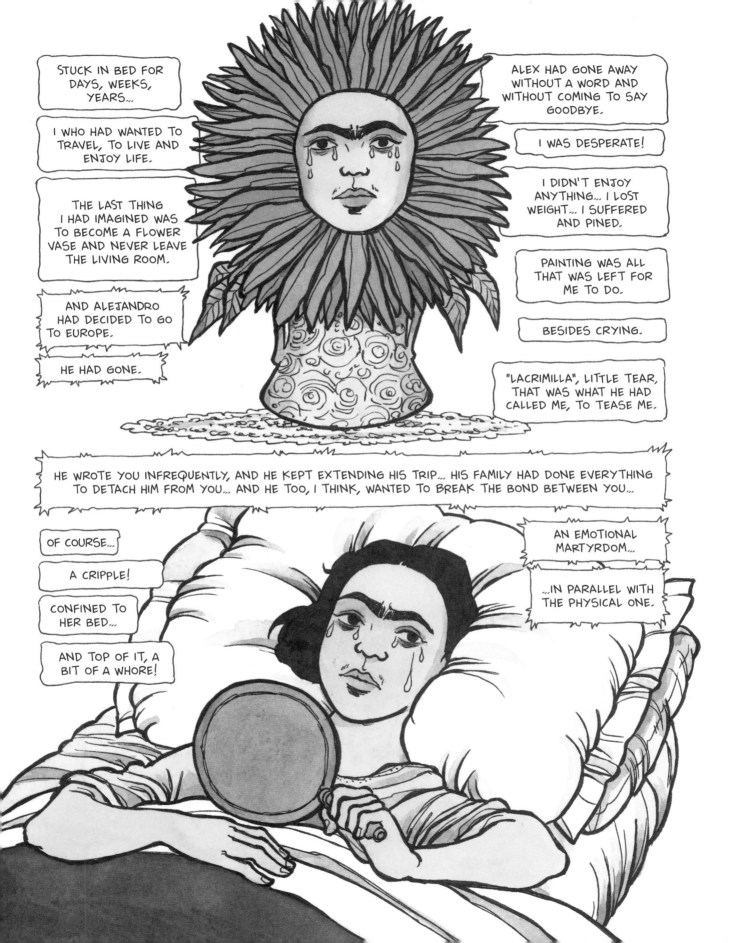

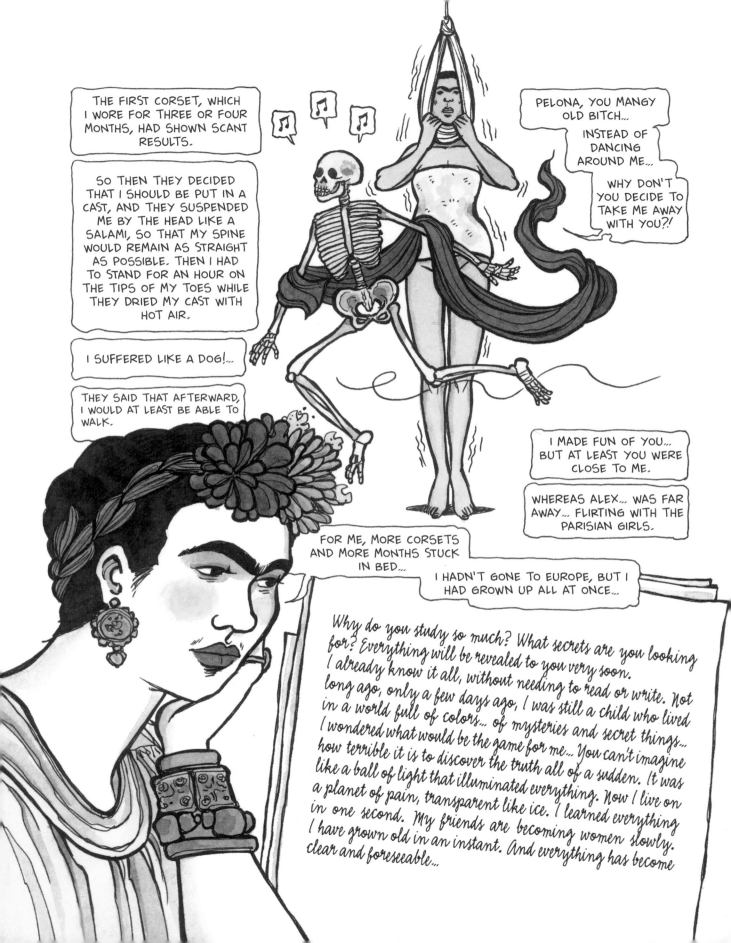

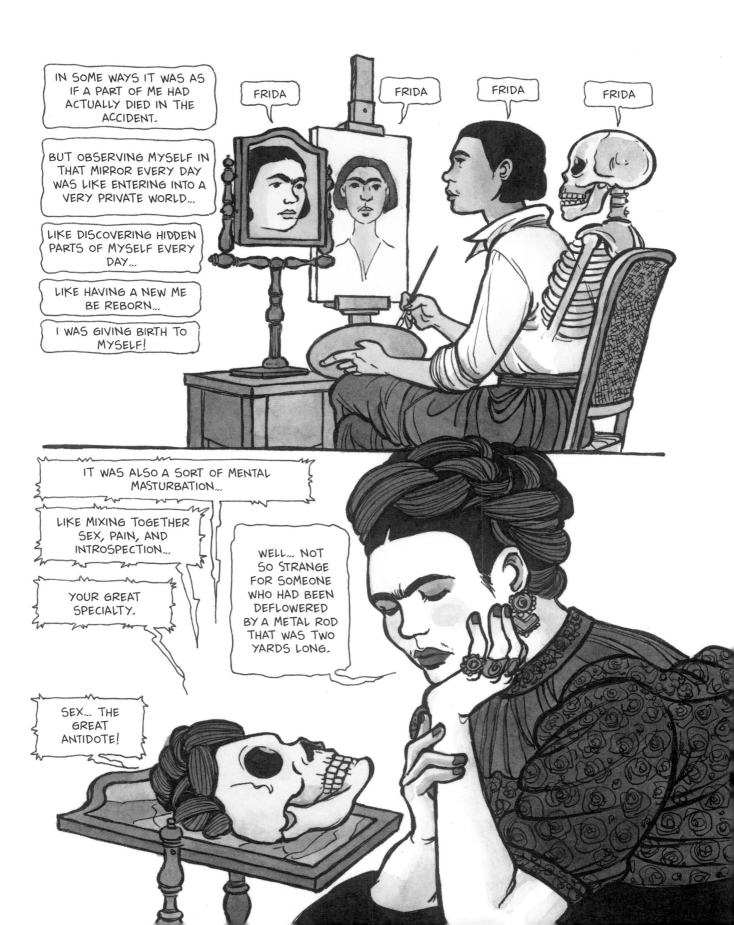

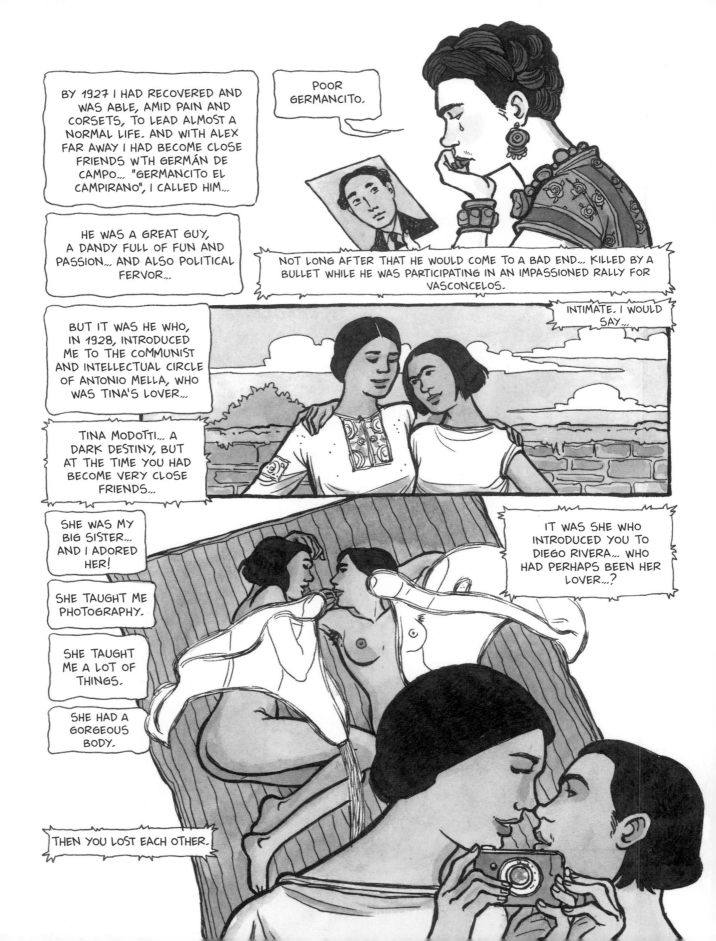

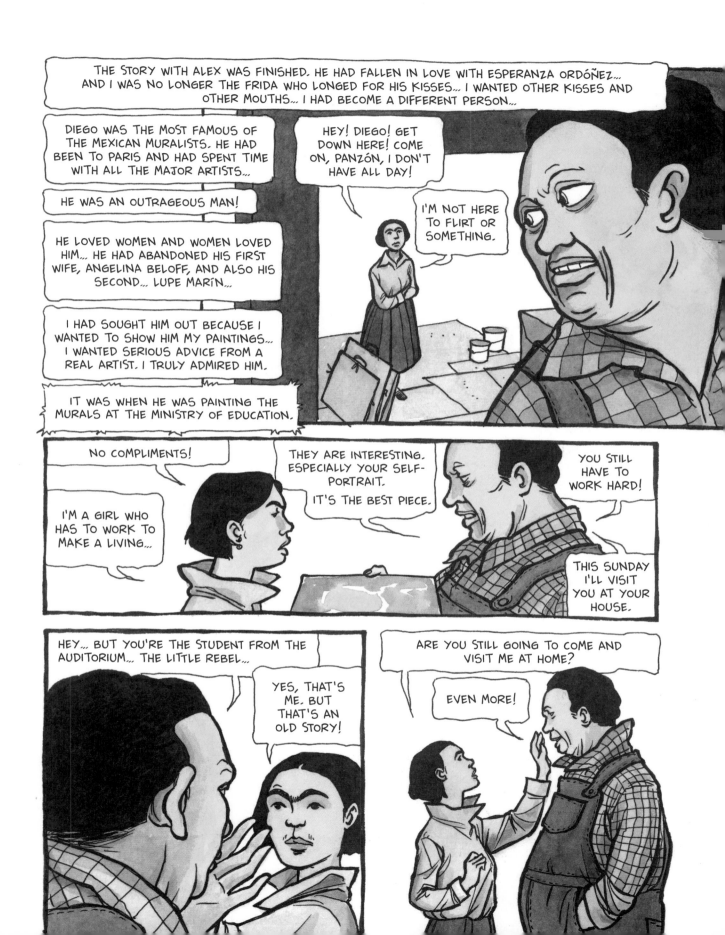

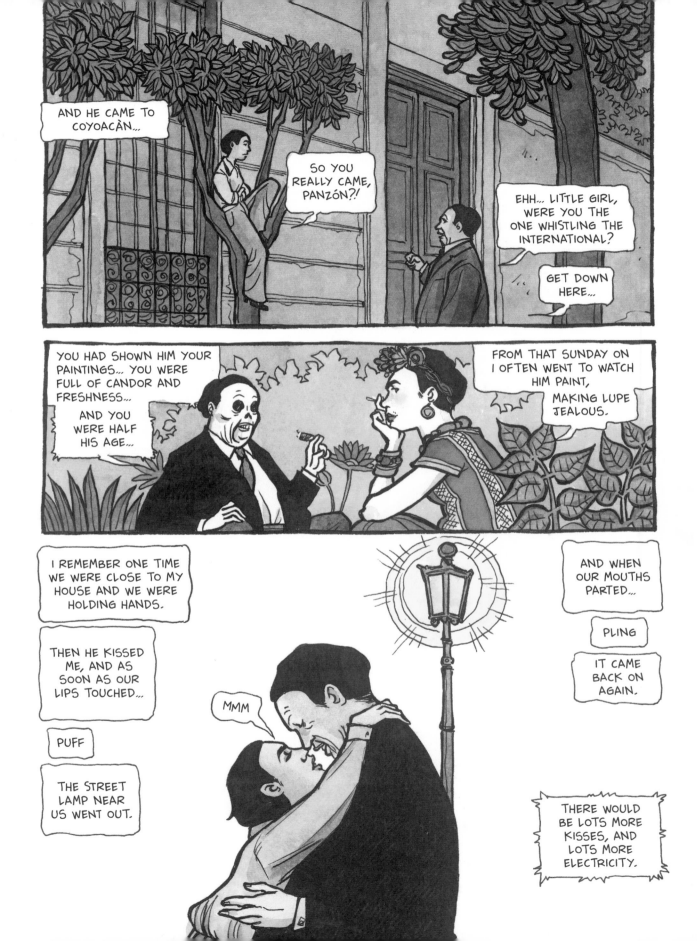

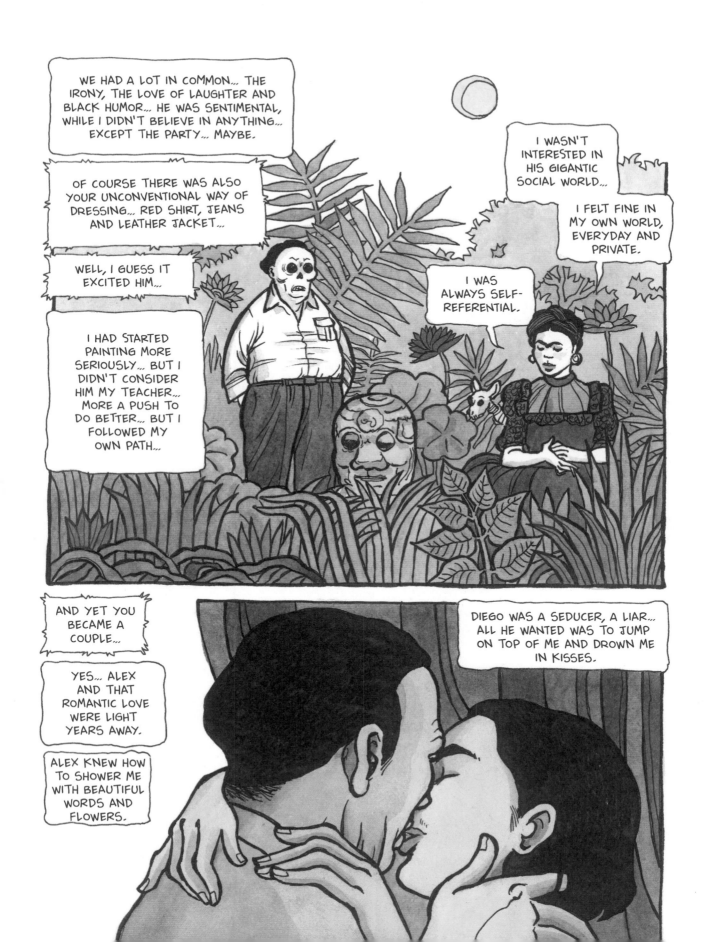

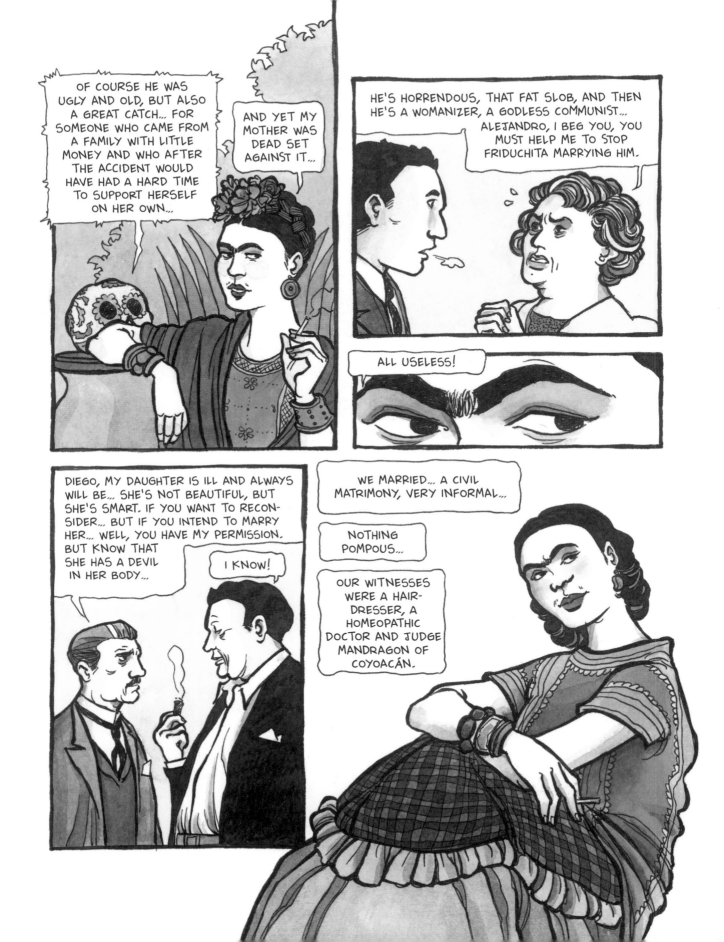

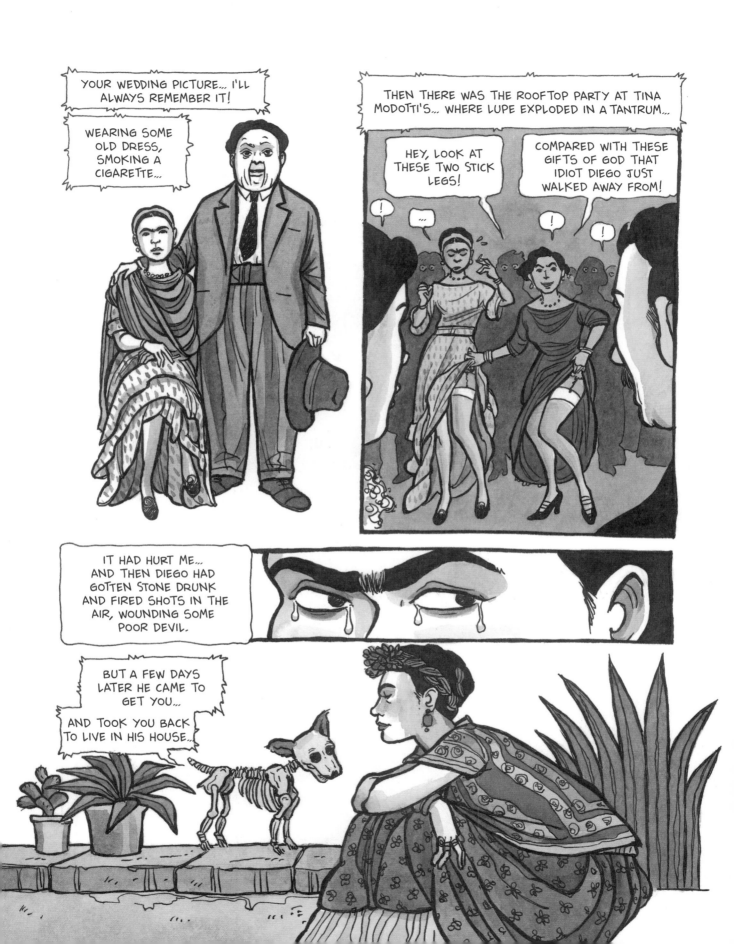

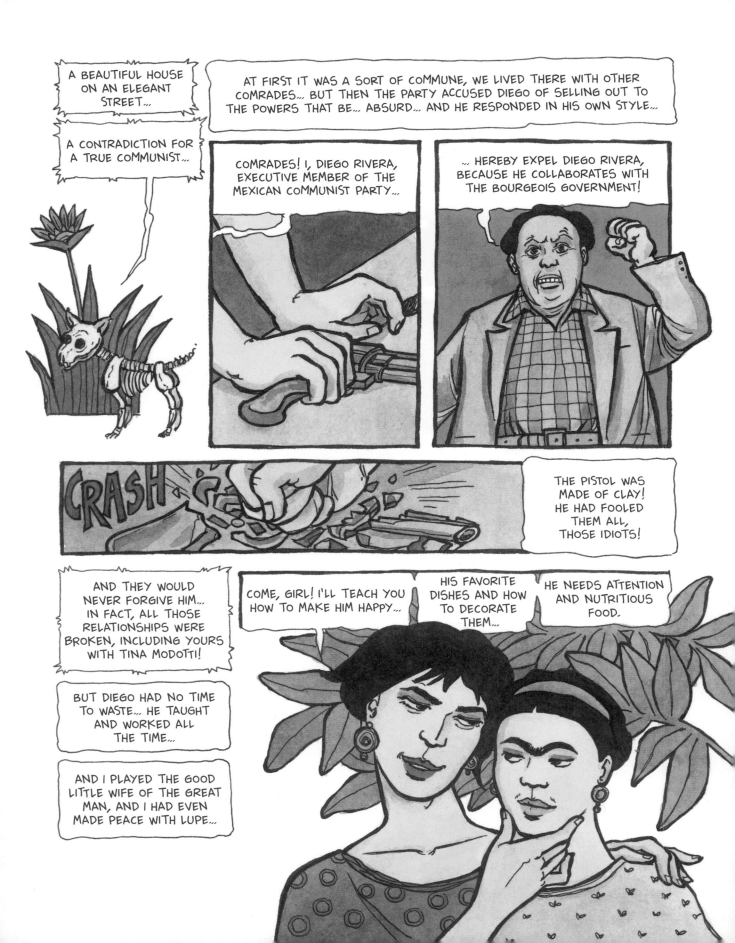

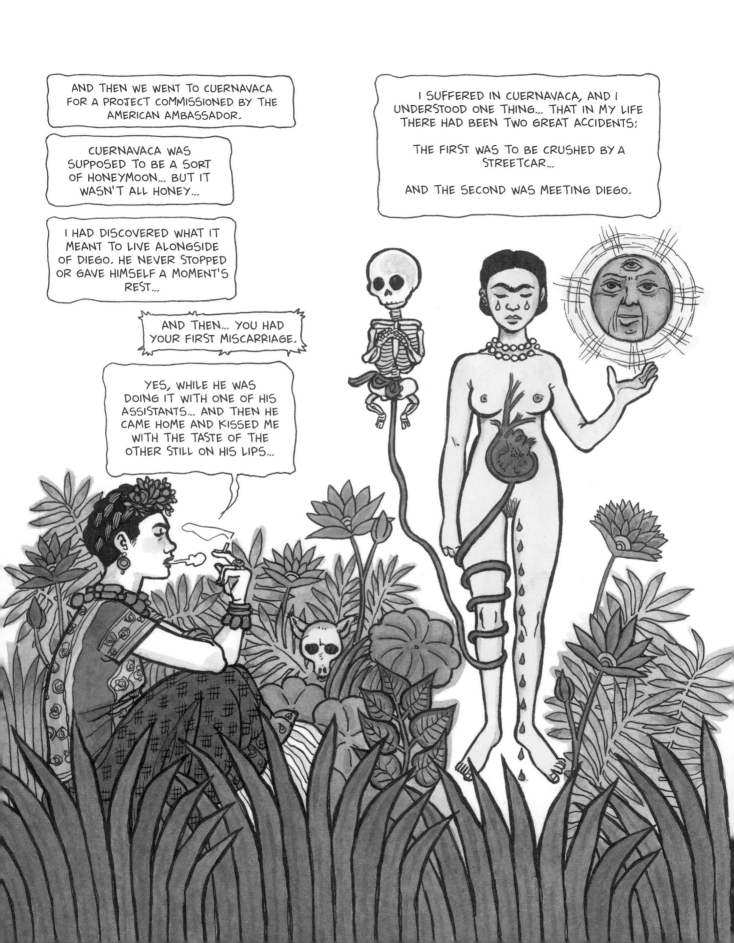

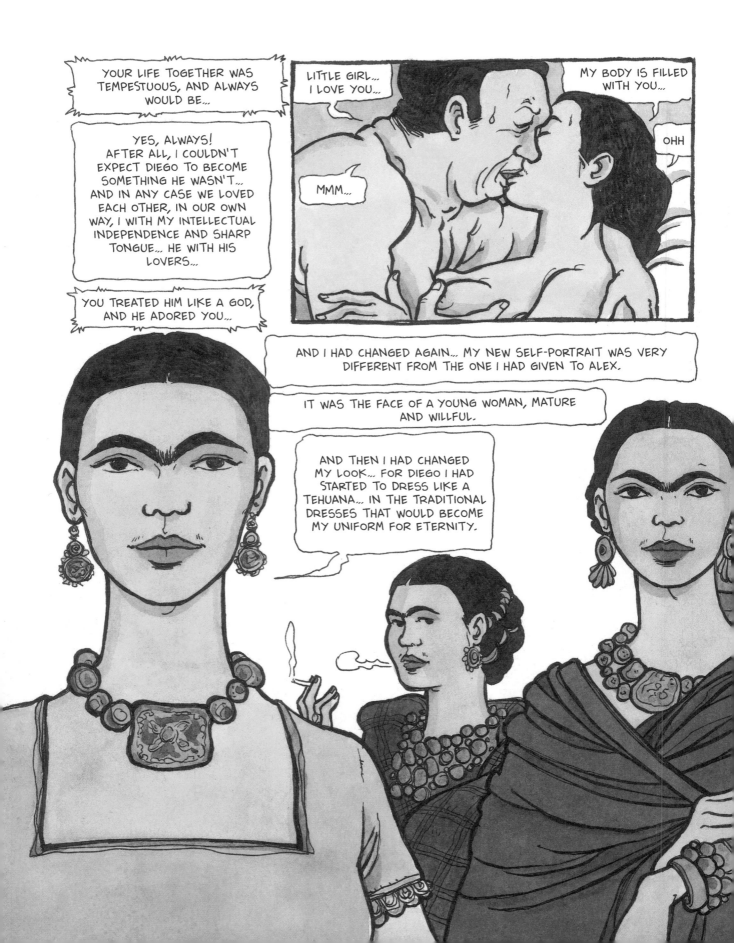

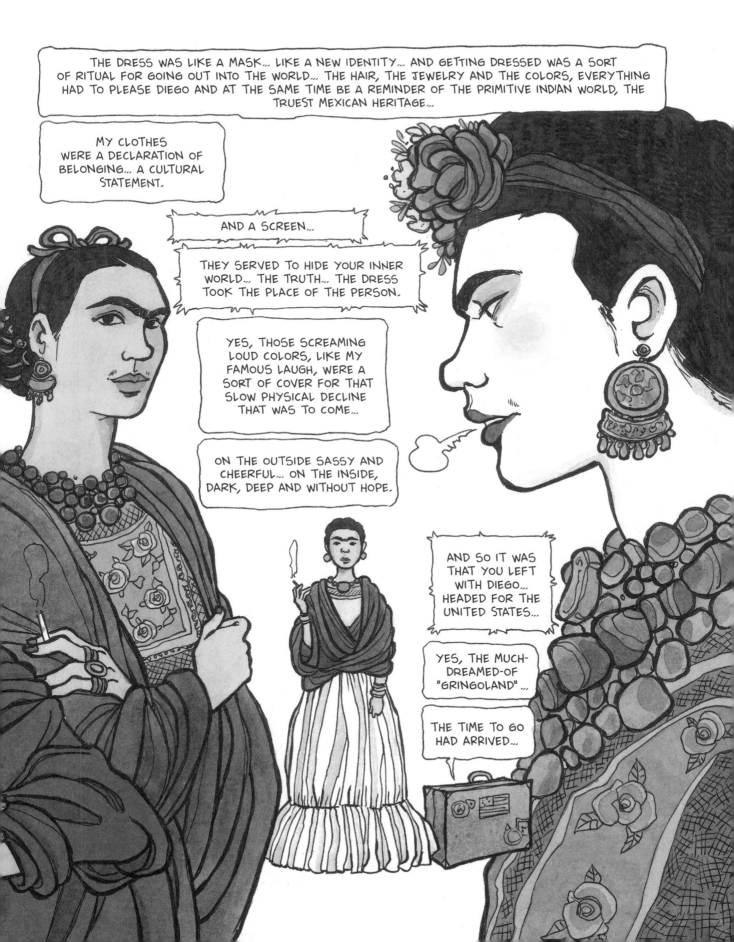

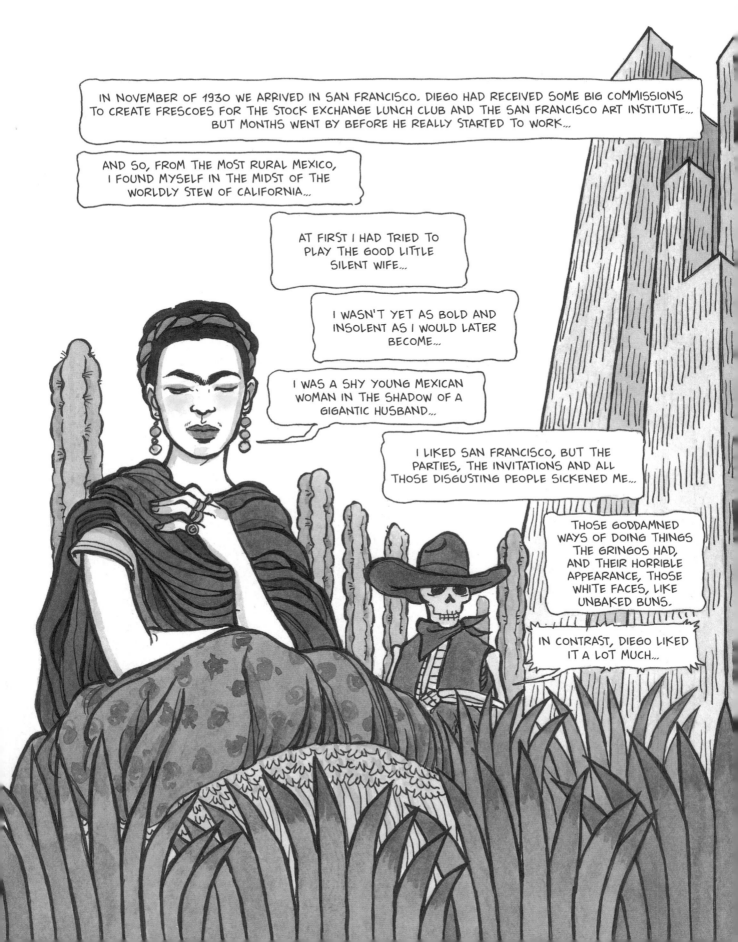

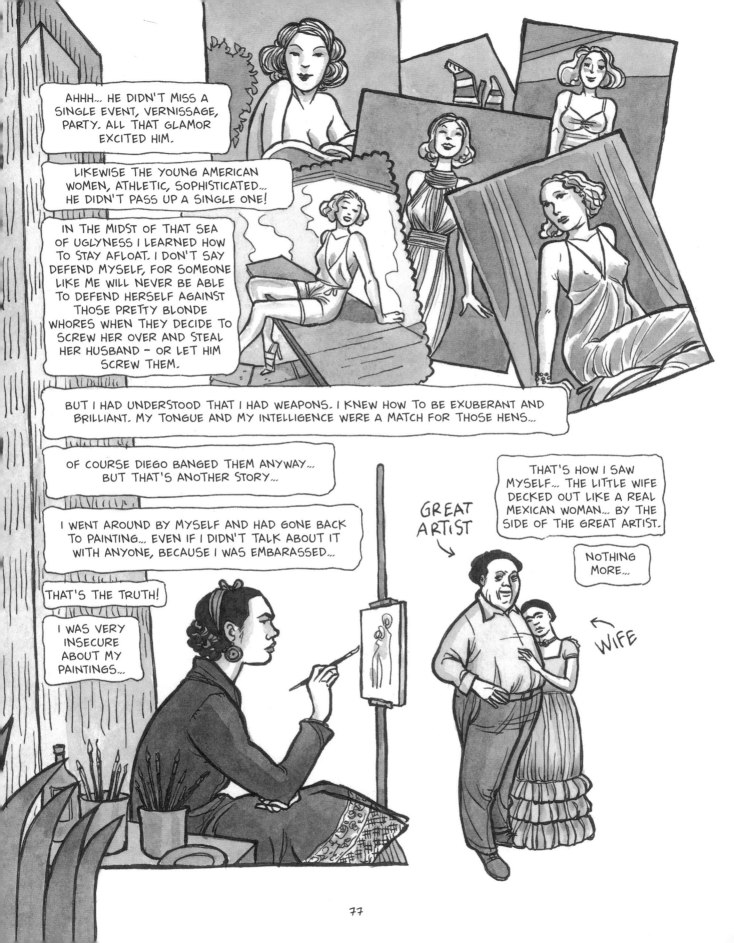

AHHH... HE DIDN'T MISS A SINGLE EVENT, VERNISSAGE, PARTY. ALL THAT GLAMOR EXCITED HIM.

LIKEWISE THE YOUNG AMERICAN WOMEN, ATHLETIC, SOPHISTICATED... HE DIDN'T PASS UP A SINGLE ONE!

IN THE MIDST OF THAT SEA OF UGLYNESS I LEARNED HOW TO STAY AFLOAT. I DON'T SAY DEFEND MYSELF, FOR SOMEONE LIKE ME WILL NEVER BE ABLE TO DEFEND HERSELF AGAINST THOSE PRETTY BLONDE WHORES WHEN THEY DECIDE TO SCREW HER OVER AND STEAL HER HUSBAND – OR LET HIM SCREW THEM.

BUT I HAD UNDERSTOOD THAT I HAD WEAPONS. I KNEW HOW TO BE EXUBERANT AND BRILLIANT. MY TONGUE AND MY INTELLIGENCE WERE A MATCH FOR THOSE HENS...

OF COURSE DIEGO BANGED THEM ANYWAY... BUT THAT'S ANOTHER STORY...

I WENT AROUND BY MYSELF AND HAD GONE BACK TO PAINTING... EVEN IF I DIDN'T TALK ABOUT IT WITH ANYONE, BECAUSE I WAS EMBARASSED...

THAT'S THE TRUTH!

I WAS VERY INSECURE ABOUT MY PAINTINGS...

THAT'S HOW I SAW MYSELF... THE LITTLE WIFE DECKED OUT LIKE A REAL MEXICAN WOMAN... BY THE SIDE OF THE GREAT ARTIST.

NOTHING MORE...

GREAT ARTIST

WIFE

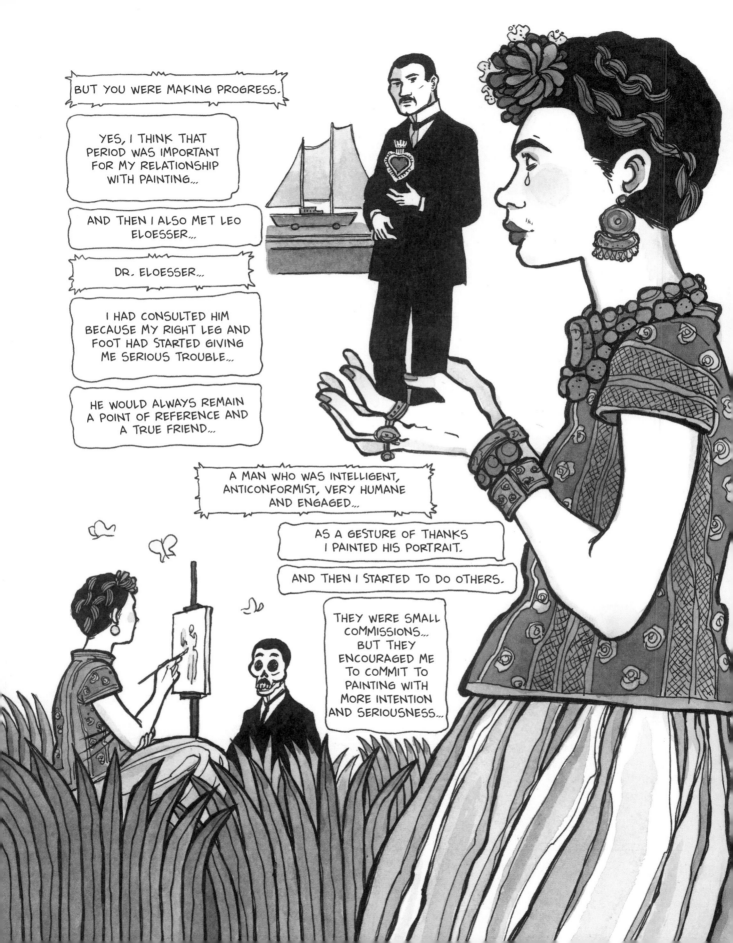

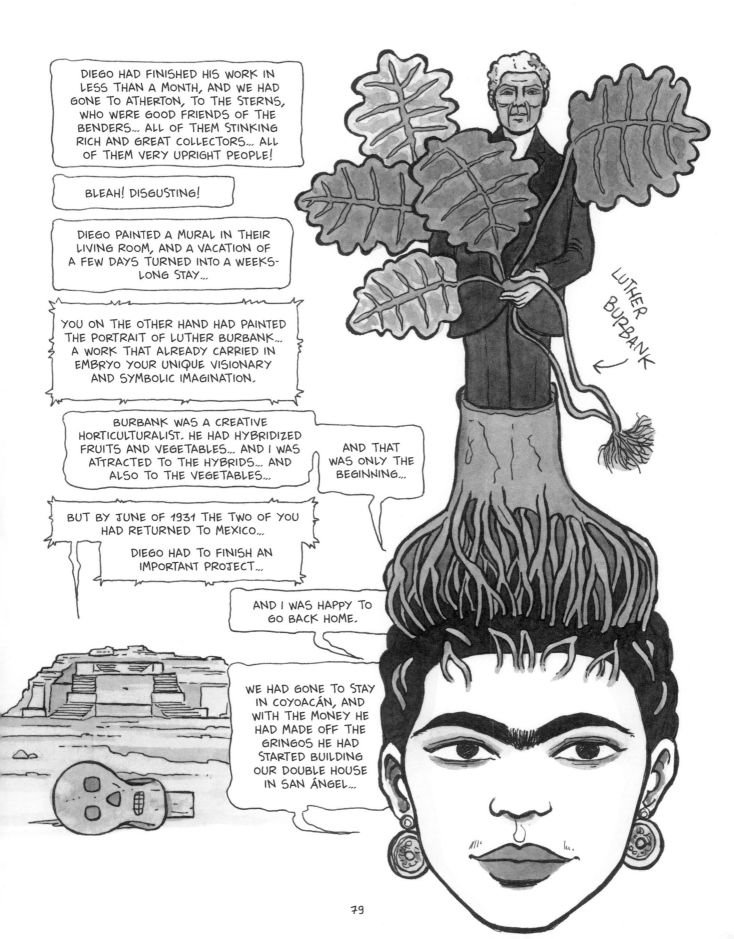

DIEGO HAD FINISHED HIS WORK IN LESS THAN A MONTH, AND WE HAD GONE TO ATHERTON, TO THE STERNS, WHO WERE GOOD FRIENDS OF THE BENDERS... ALL OF THEM STINKING RICH AND GREAT COLLECTORS... ALL OF THEM VERY UPRIGHT PEOPLE!

BLEAH! DISGUSTING!

DIEGO PAINTED A MURAL IN THEIR LIVING ROOM, AND A VACATION OF A FEW DAYS TURNED INTO A WEEKS-LONG STAY...

YOU ON THE OTHER HAND HAD PAINTED THE PORTRAIT OF LUTHER BURBANK... A WORK THAT ALREADY CARRIED IN EMBRYO YOUR UNIQUE VISIONARY AND SYMBOLIC IMAGINATION.

BURBANK WAS A CREATIVE HORTICULTURALIST. HE HAD HYBRIDIZED FRUITS AND VEGETABLES... AND I WAS ATTRACTED TO THE HYBRIDS... AND ALSO TO THE VEGETABLES...

AND THAT WAS ONLY THE BEGINNING...

BUT BY JUNE OF 1931 THE TWO OF YOU HAD RETURNED TO MEXICO...

DIEGO HAD TO FINISH AN IMPORTANT PROJECT...

AND I WAS HAPPY TO GO BACK HOME.

WE HAD GONE TO STAY IN COYOACÁN, AND WITH THE MONEY HE HAD MADE OFF THE GRINGOS HE HAD STARTED BUILDING OUR DOUBLE HOUSE IN SAN ÁNGEL...

LUTHER BURBANK

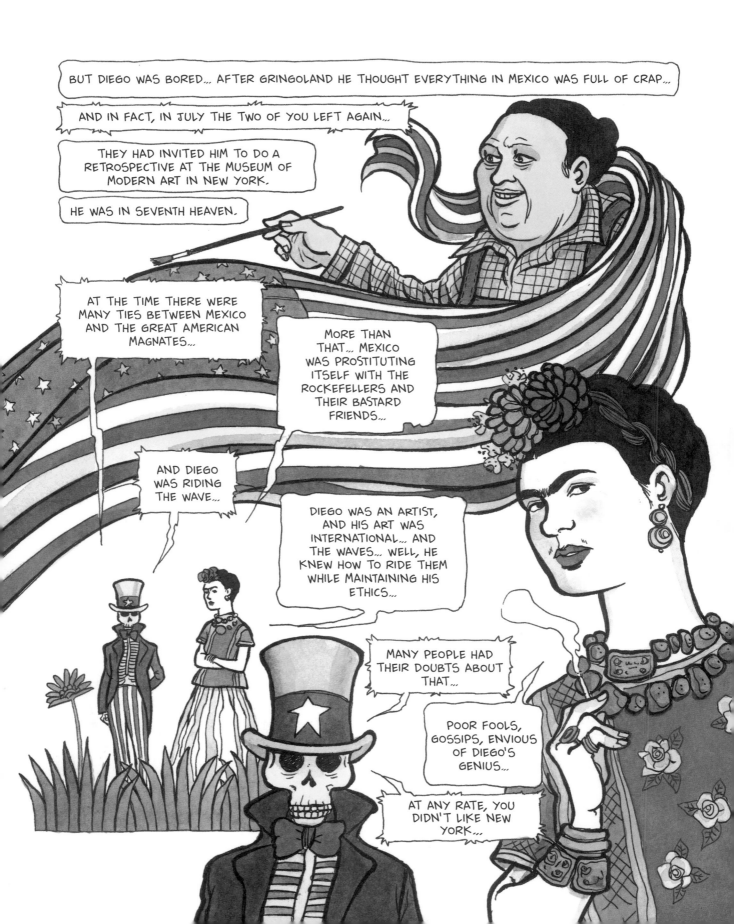

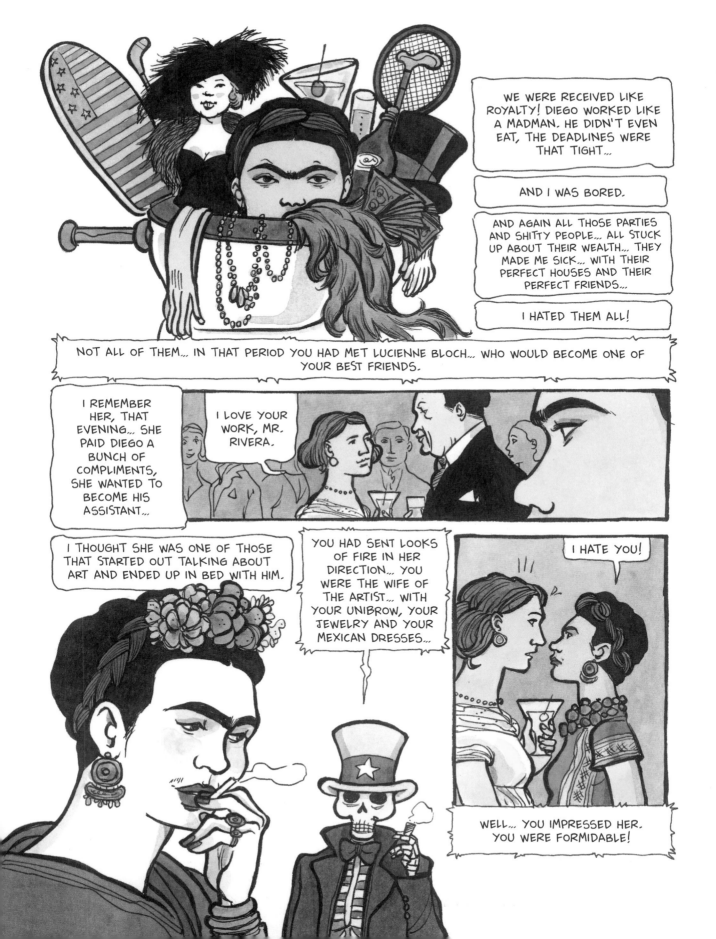

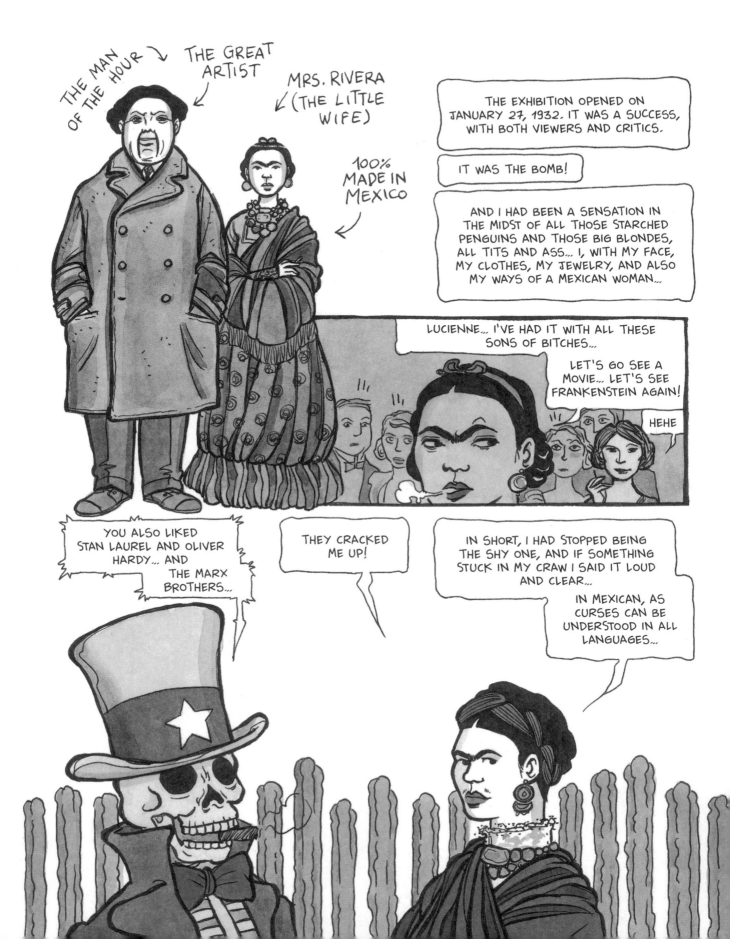

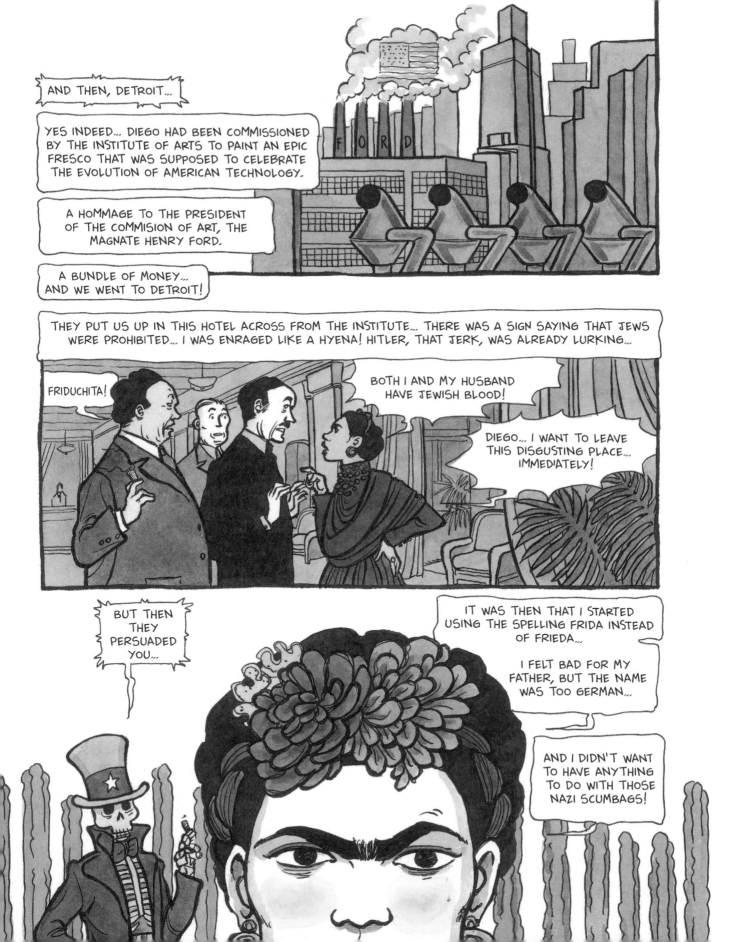

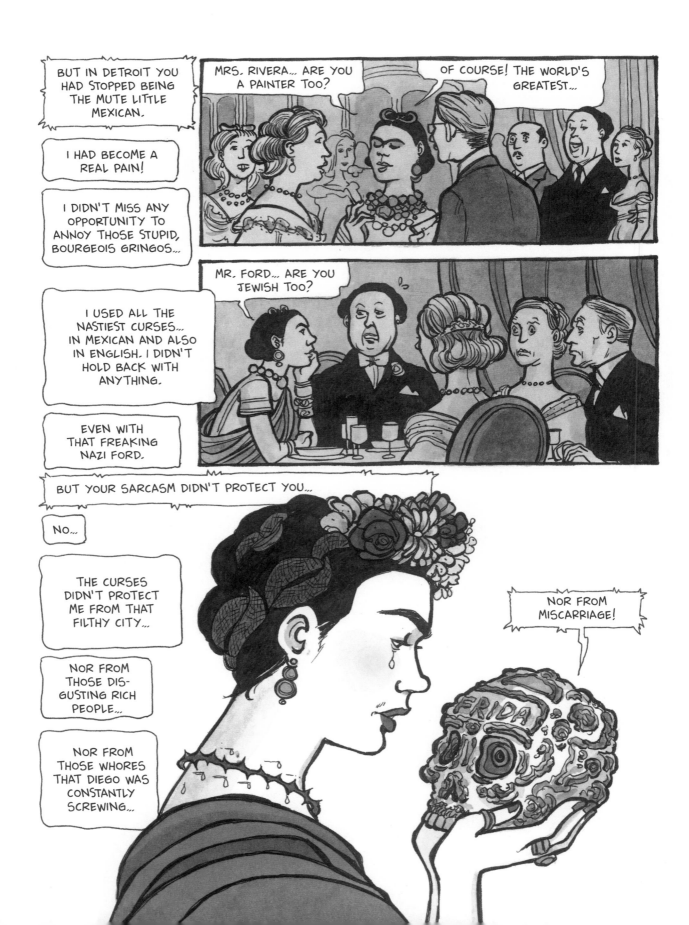

IN 1932 I BECAME PREGNANT FOR THE SECOND TIME... I DIDN'T KNOW WHAT THE HELL TO DO...

I WANTED THE BABY A LITTLE, BUT A LITTLE NOT...

Dear Doctorcito,

I am in Detroit. I don't like it at all here. It seems like a run-down village. But I am glad that Diego is happy and is working hard. About me, what can I say... nothing very good.

I went to see Dr. Pratt, who already knew about everything, and he gave me bad news about my right paw. He said I might have a trophic ulcer. I have no idea what that is, but the idea does not fill me with joy. But now I must tell you about something more important. I am two months pregnant. I saw Dr. Pratt and told him that perhaps, given my physical condition, it would be better to terminate the pregnancy. He gave me a dose of quinine and castor oil. I lost a little blood and thought I had aborted. But no, and Pratt told me that at this point it would be better to keep the baby. He says I can give birth without any problem with a cesarean. I am writing to you because I don't know what to do and I need to think of my health. Diego is of the same opinion. Last time I aborted surgically in the third month. Now, in only the second month, it ought to be more simple. I am afraid that a pregnancy could greatly weaken me, if indeed I were to succeed in carrying it to term. Among other things, if I give birth here, I don't have anyone to assist me. I could go back to Mexico, but it would mean leaving Diego behind, and I don't want to do that. I don't think he is the least bit interested in having a kid. The only thing he cares about is work, understandably, and I don't want to be far away from him for any reason. That's why I would like to know your opinion, to have a better idea of what would be best for me. Because having an abortion is against the law, and if Dr. Pratt pulls back I don't know what I'll do.

I have no appetite, I am eating very little and always throwing up. I am weak also because of my leg, which is giving me a lot of problems. But I'm not disappointed in life and there are lots of things I want to do. I have Diego and my family, whom I love very much. So please, I beg of you, let me know what you think. Pratt told me that an abortion is against nature, that it damages the nervous system and that I would do better to keep the baby. I don't know if that's something doctors say to all pregnant women, but I would like to know exactly what these words mean. Please forgive me if I am putting you under pressure and bothering you, but I don't know what to do and I trust only you.

Frida

THEN YOU DECIDED TO KEEP IT...

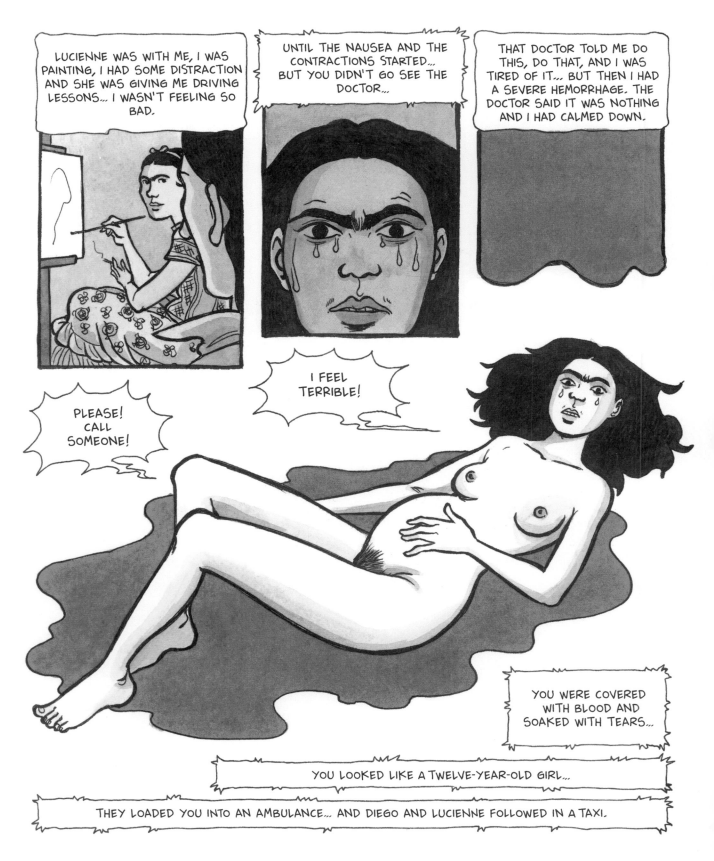

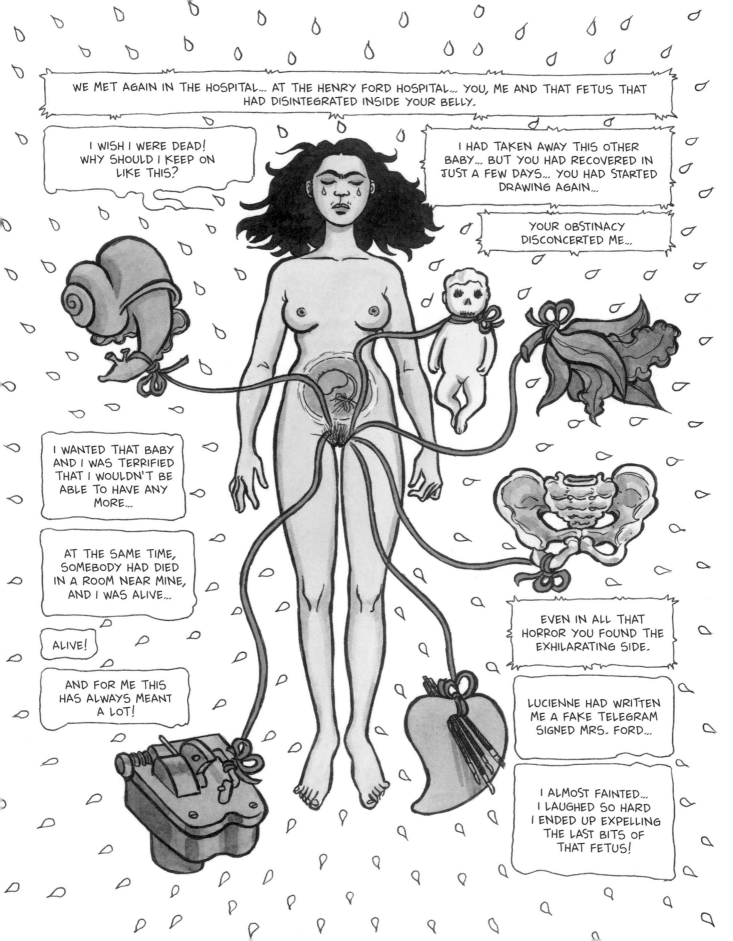

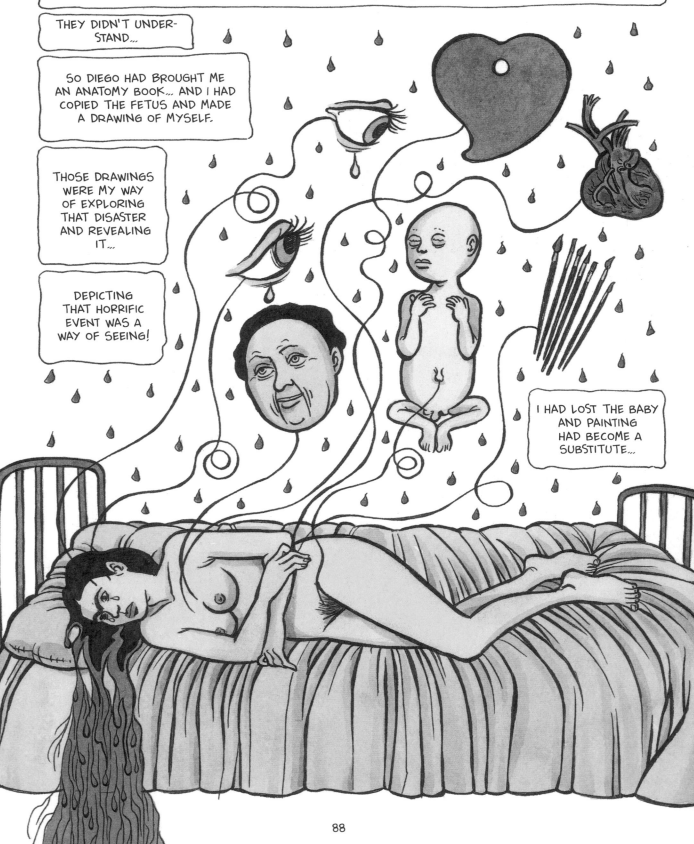

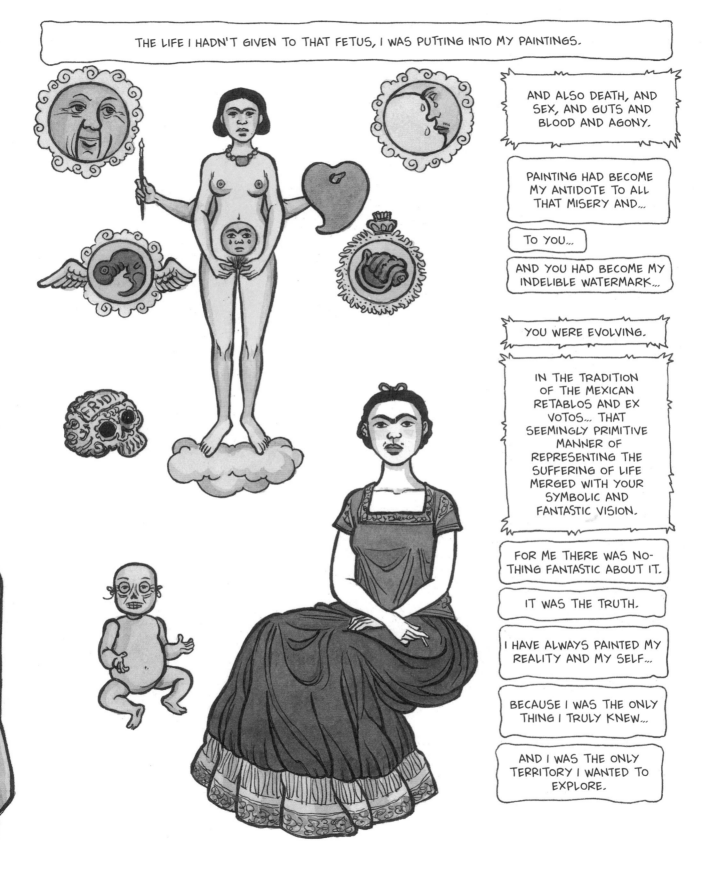

THE LIFE I HADN'T GIVEN TO THAT FETUS, I WAS PUTTING INTO MY PAINTINGS.

AND ALSO DEATH, AND SEX, AND GUTS AND BLOOD AND AGONY.

PAINTING HAD BECOME MY ANTIDOTE TO ALL THAT MISERY AND...

TO YOU...

AND YOU HAD BECOME MY INDELIBLE WATERMARK...

YOU WERE EVOLVING.

IN THE TRADITION OF THE MEXICAN RETABLOS AND EX VOTOS... THAT SEEMINGLY PRIMITIVE MANNER OF REPRESENTING THE SUFFERING OF LIFE MERGED WITH YOUR SYMBOLIC AND FANTASTIC VISION.

FOR ME THERE WAS NO-THING FANTASTIC ABOUT IT.

IT WAS THE TRUTH.

I HAVE ALWAYS PAINTED MY REALITY AND MY SELF...

BECAUSE I WAS THE ONLY THING I TRULY KNEW...

AND I WAS THE ONLY TERRITORY I WANTED TO EXPLORE.

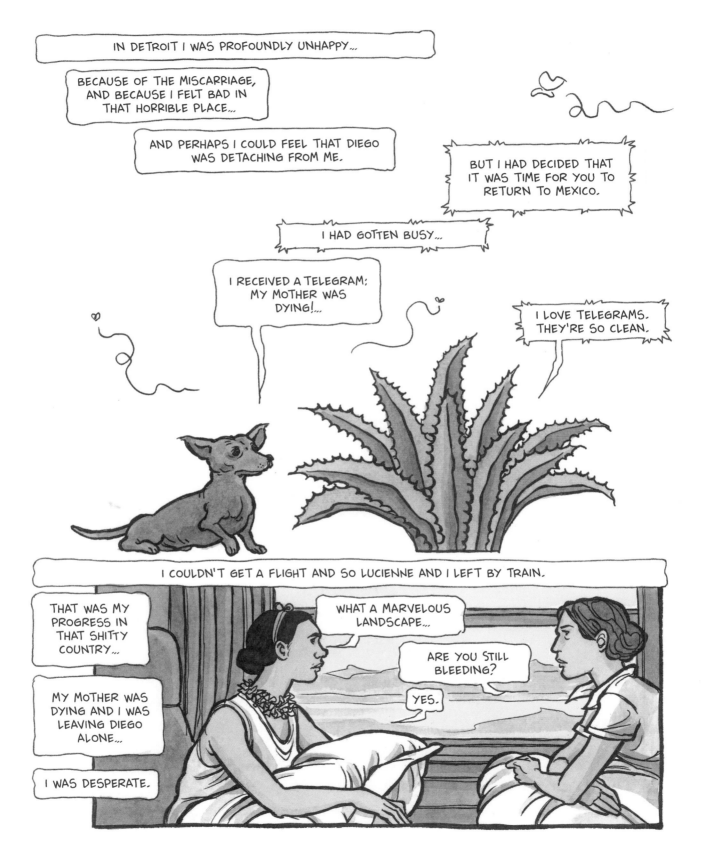

IN DETROIT I WAS PROFOUNDLY UNHAPPY...

BECAUSE OF THE MISCARRIAGE, AND BECAUSE I FELT BAD IN THAT HORRIBLE PLACE...

AND PERHAPS I COULD FEEL THAT DIEGO WAS DETACHING FROM ME.

BUT I HAD DECIDED THAT IT WAS TIME FOR YOU TO RETURN TO MEXICO.

I HAD GOTTEN BUSY...

I RECEIVED A TELEGRAM; MY MOTHER WAS DYING!...

I LOVE TELEGRAMS. THEY'RE SO CLEAN.

I COULDN'T GET A FLIGHT AND SO LUCIENNE AND I LEFT BY TRAIN.

THAT WAS MY PROGRESS IN THAT SHITTY COUNTRY...

MY MOTHER WAS DYING AND I WAS LEAVING DIEGO ALONE...

I WAS DESPERATE.

WHAT A MARVELOUS LANDSCAPE...

ARE YOU STILL BLEEDING?

YES.

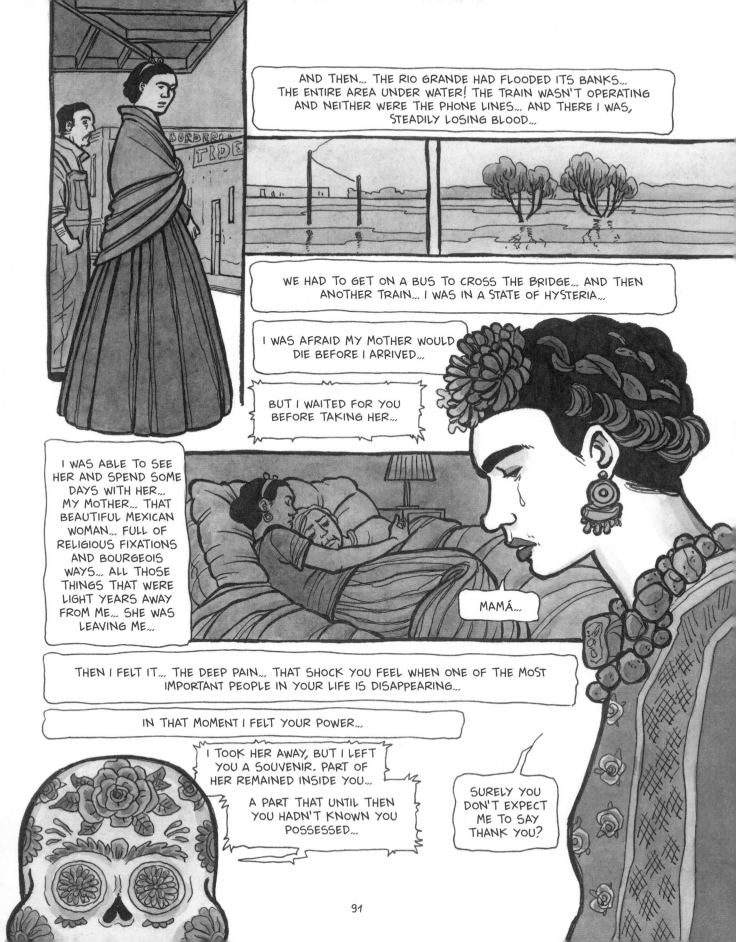

AND THEN... THE RIO GRANDE HAD FLOODED ITS BANKS... THE ENTIRE AREA UNDER WATER! THE TRAIN WASN'T OPERATING AND NEITHER WERE THE PHONE LINES... AND THERE I WAS, STEADILY LOSING BLOOD...

WE HAD TO GET ON A BUS TO CROSS THE BRIDGE... AND THEN ANOTHER TRAIN... I WAS IN A STATE OF HYSTERIA...

I WAS AFRAID MY MOTHER WOULD DIE BEFORE I ARRIVED...

BUT I WAITED FOR YOU BEFORE TAKING HER...

I WAS ABLE TO SEE HER AND SPEND SOME DAYS WITH HER... MY MOTHER... THAT BEAUTIFUL MEXICAN WOMAN... FULL OF RELIGIOUS FIXATIONS AND BOURGEOIS WAYS... ALL THOSE THINGS THAT WERE LIGHT YEARS AWAY FROM ME... SHE WAS LEAVING ME...

MAMÁ...

THEN I FELT IT... THE DEEP PAIN... THAT SHOCK YOU FEEL WHEN ONE OF THE MOST IMPORTANT PEOPLE IN YOUR LIFE IS DISAPPEARING...

IN THAT MOMENT I FELT YOUR POWER...

I TOOK HER AWAY, BUT I LEFT YOU A SOUVENIR. PART OF HER REMAINED INSIDE YOU...

A PART THAT UNTIL THEN YOU HADN'T KNOWN YOU POSSESSED...

SURELY YOU DON'T EXPECT ME TO SAY THANK YOU?

91

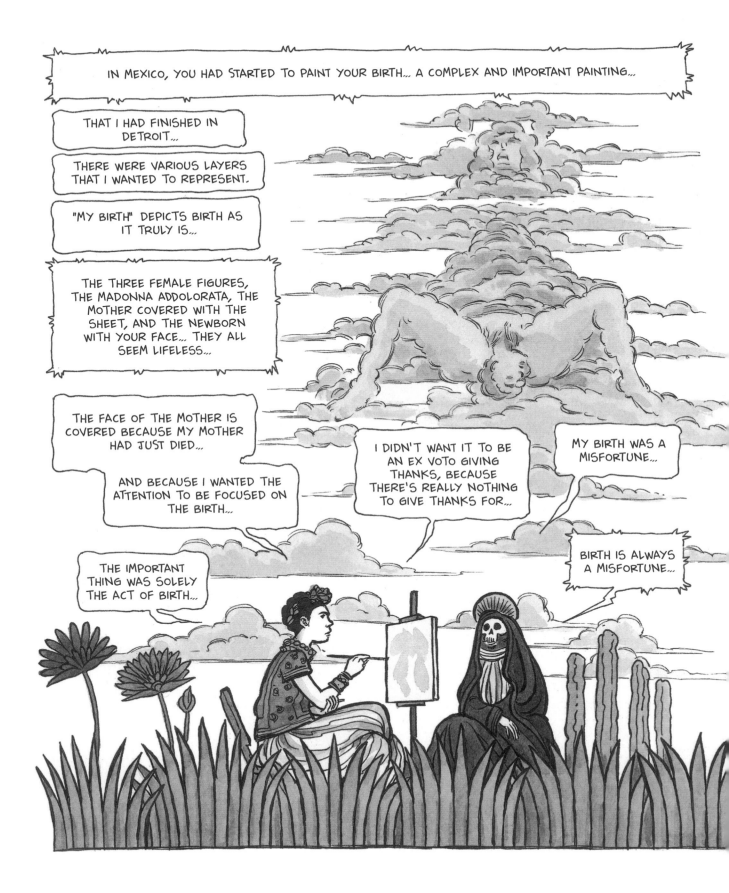

IN MEXICO, YOU HAD STARTED TO PAINT YOUR BIRTH... A COMPLEX AND IMPORTANT PAINTING...

THAT I HAD FINISHED IN DETROIT...

THERE WERE VARIOUS LAYERS THAT I WANTED TO REPRESENT.

"MY BIRTH" DEPICTS BIRTH AS IT TRULY IS...

THE THREE FEMALE FIGURES, THE MADONNA ADDOLORATA, THE MOTHER COVERED WITH THE SHEET, AND THE NEWBORN WITH YOUR FACE... THEY ALL SEEM LIFELESS...

THE FACE OF THE MOTHER IS COVERED BECAUSE MY MOTHER HAD JUST DIED...

AND BECAUSE I WANTED THE ATTENTION TO BE FOCUSED ON THE BIRTH...

I DIDN'T WANT IT TO BE AN EX VOTO GIVING THANKS, BECAUSE THERE'S REALLY NOTHING TO GIVE THANKS FOR...

MY BIRTH WAS A MISFORTUNE...

BIRTH IS ALWAYS A MISFORTUNE...

THE IMPORTANT THING WAS SOLELY THE ACT OF BIRTH...

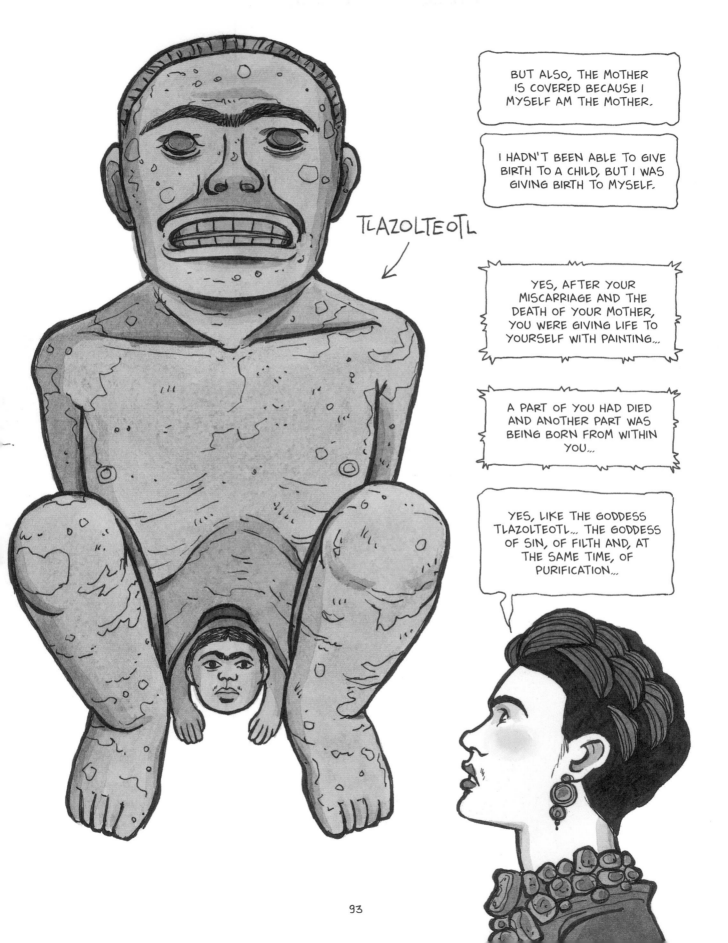

93

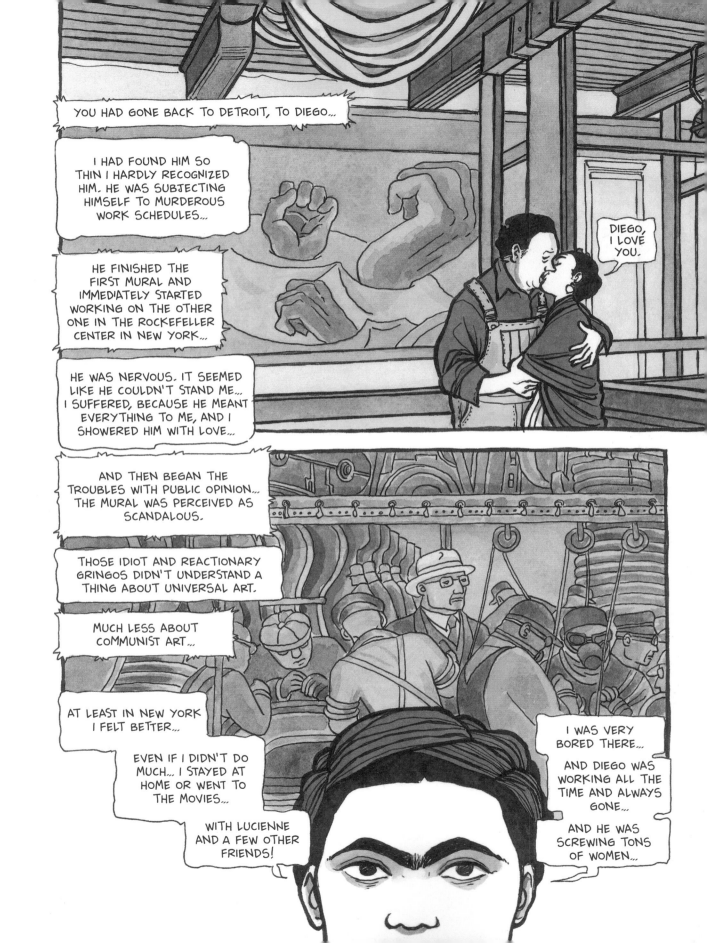

YOU HAD GONE BACK TO DETROIT, TO DIEGO...

I HAD FOUND HIM SO THIN I HARDLY RECOGNIZED HIM. HE WAS SUBJECTING HIMSELF TO MURDEROUS WORK SCHEDULES...

HE FINISHED THE FIRST MURAL AND IMMEDIATELY STARTED WORKING ON THE OTHER ONE IN THE ROCKEFELLER CENTER IN NEW YORK...

HE WAS NERVOUS. IT SEEMED LIKE HE COULDN'T STAND ME... I SUFFERED, BECAUSE HE MEANT EVERYTHING TO ME, AND I SHOWERED HIM WITH LOVE...

DIEGO, I LOVE YOU.

AND THEN BEGAN THE TROUBLES WITH PUBLIC OPINION... THE MURAL WAS PERCEIVED AS SCANDALOUS.

THOSE IDIOT AND REACTIONARY GRINGOS DIDN'T UNDERSTAND A THING ABOUT UNIVERSAL ART.

MUCH LESS ABOUT COMMUNIST ART...

AT LEAST IN NEW YORK I FELT BETTER...

EVEN IF I DIDN'T DO MUCH... I STAYED AT HOME OR WENT TO THE MOVIES...

WITH LUCIENNE AND A FEW OTHER FRIENDS!

I WAS VERY BORED THERE...

AND DIEGO WAS WORKING ALL THE TIME AND ALWAYS GONE...

AND HE WAS SCREWING TONS OF WOMEN...

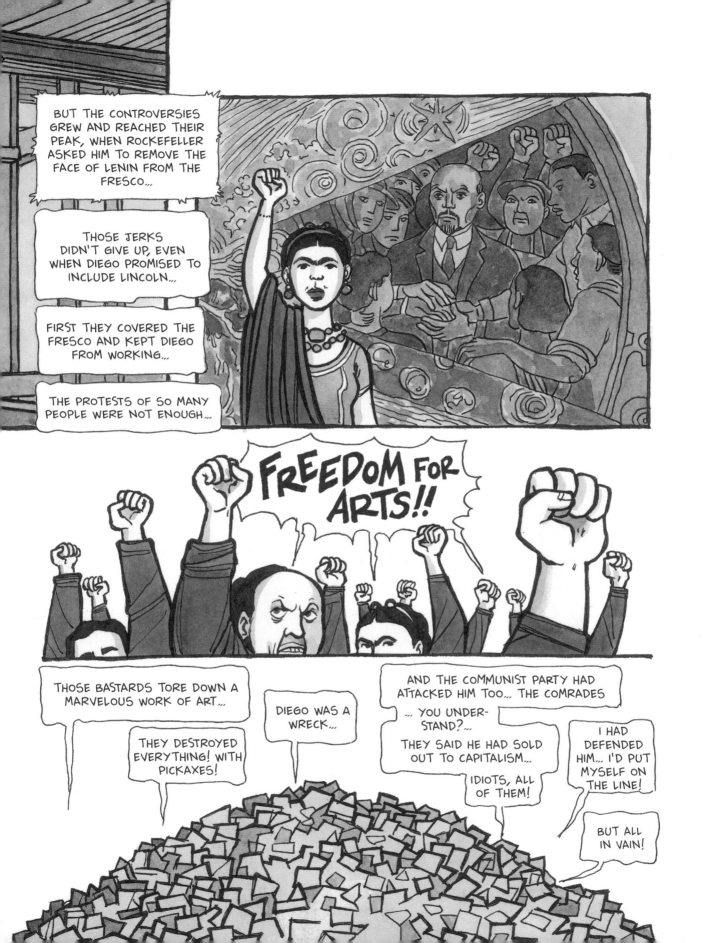

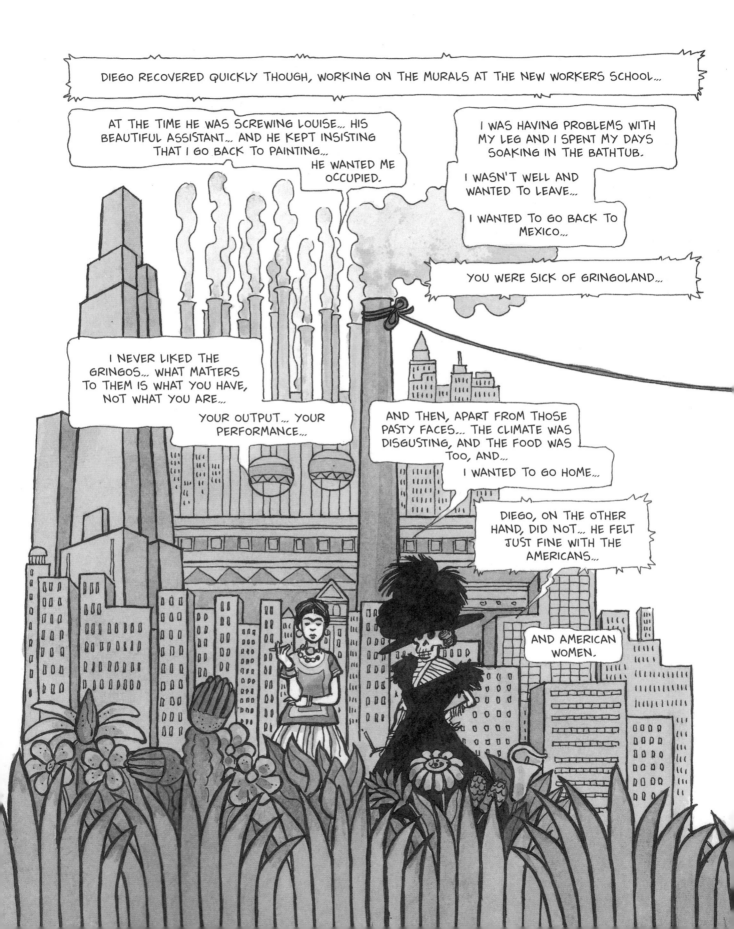

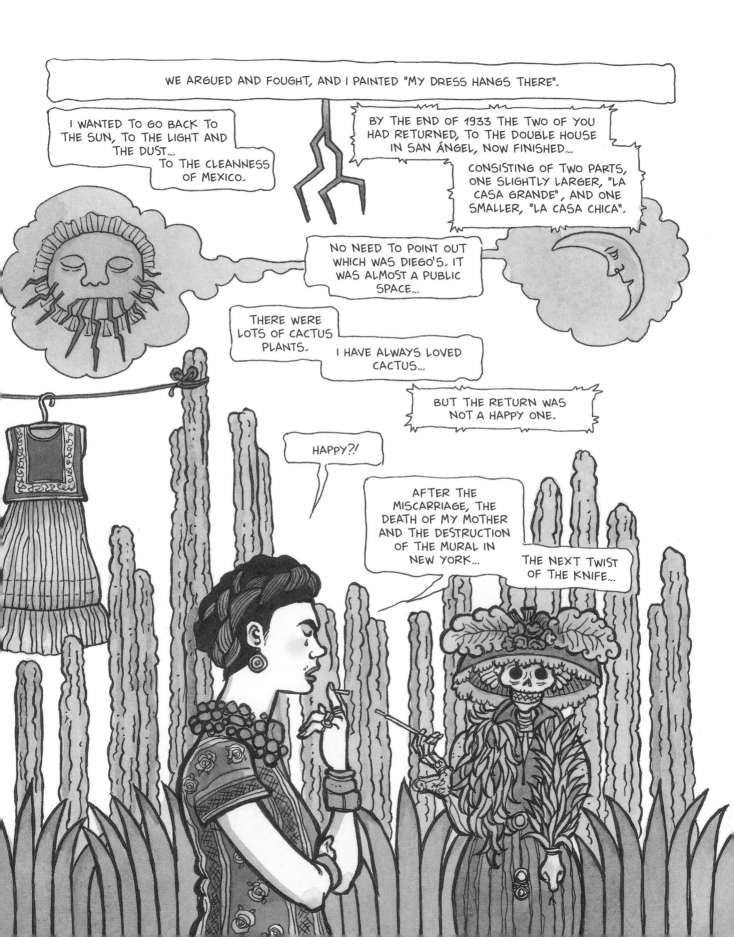

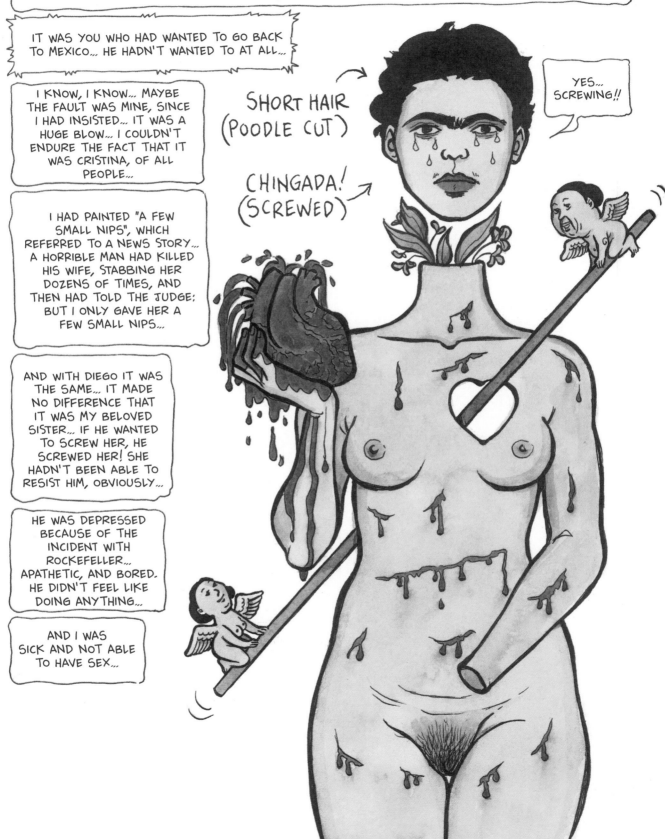

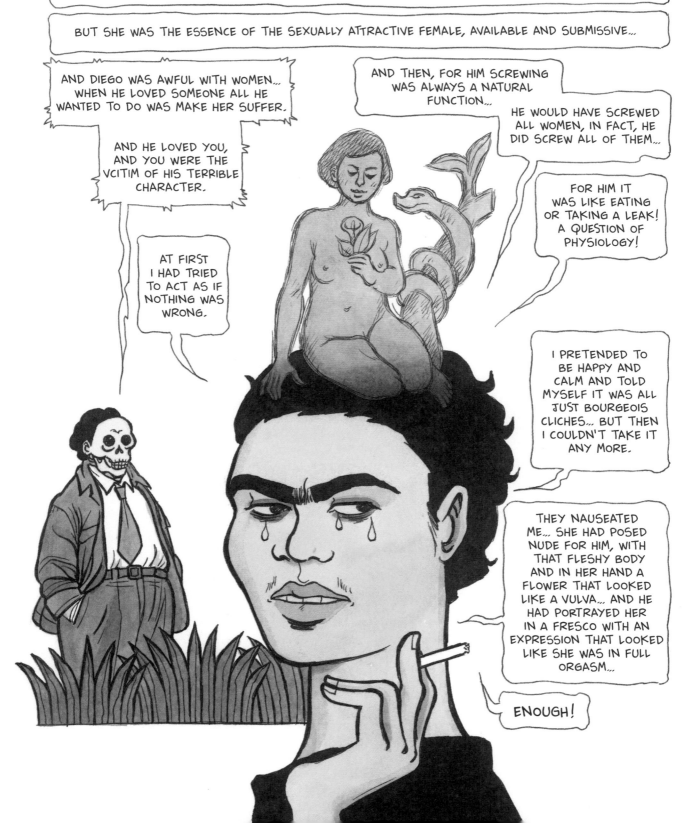

I HAD GONE TO LIVE BY MYSELF AND I HAD CUT MY HAIR... AND STOPPED WEARING THE TEHUANA DRESSES THAT DIEGO LOVED...

I WANTED AN AUTONOMOUS LIFE, ON MY OWN!

IT WAS THE FIRST OF WHAT WOULD BE MANY SEPARATIONS... BUT YOU CONTINUED TO SEE EACH OTHER... FOR ONE REASON OR ANOTHER.

I HAD GONE TO NEW YORK WITH TWO FRIENDS... BUT ON THAT TRIP I HAD REALIZED THE TRUTH; I LOVED DIEGO... AND I HAD WRITTEN TO HIM...

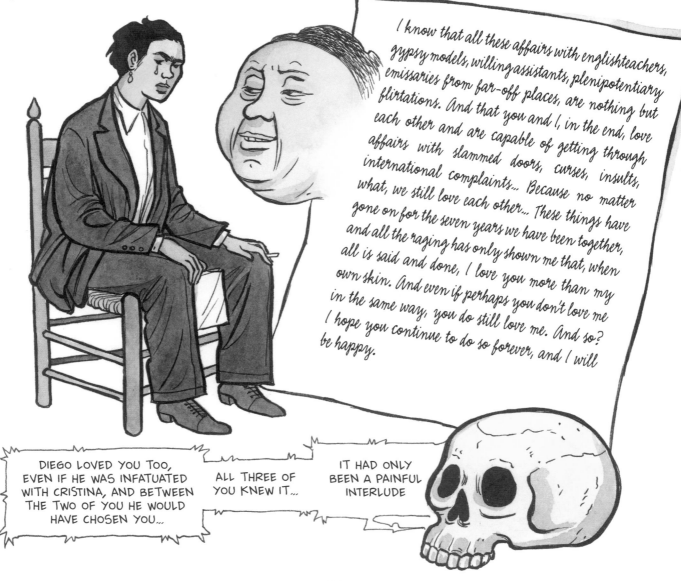

I know that all these affairs with englishteachers, gypsy models, willing assistants, plenipotentiary emissaries from far-off places, are nothing but flirtations. And that you and I, in the end, love each other and are capable of getting through affairs with slammed doors, curses, insults, international complaints... Because no matter what, we still love each other... These things have gone on for the seven years we have been together, and all the raging has only shown me that, when all is said and done, I love you more than my own skin. And even if perhaps you don't love me in the same way, you do still love me. And so? I hope you continue to do so forever, and I will be happy.

DIEGO LOVED YOU TOO, EVEN IF HE WAS INFATUATED WITH CRISTINA, AND BETWEEN THE TWO OF YOU HE WOULD HAVE CHOSEN YOU...

ALL THREE OF YOU KNEW IT...

IT HAD ONLY BEEN A PAINFUL INTERLUDE

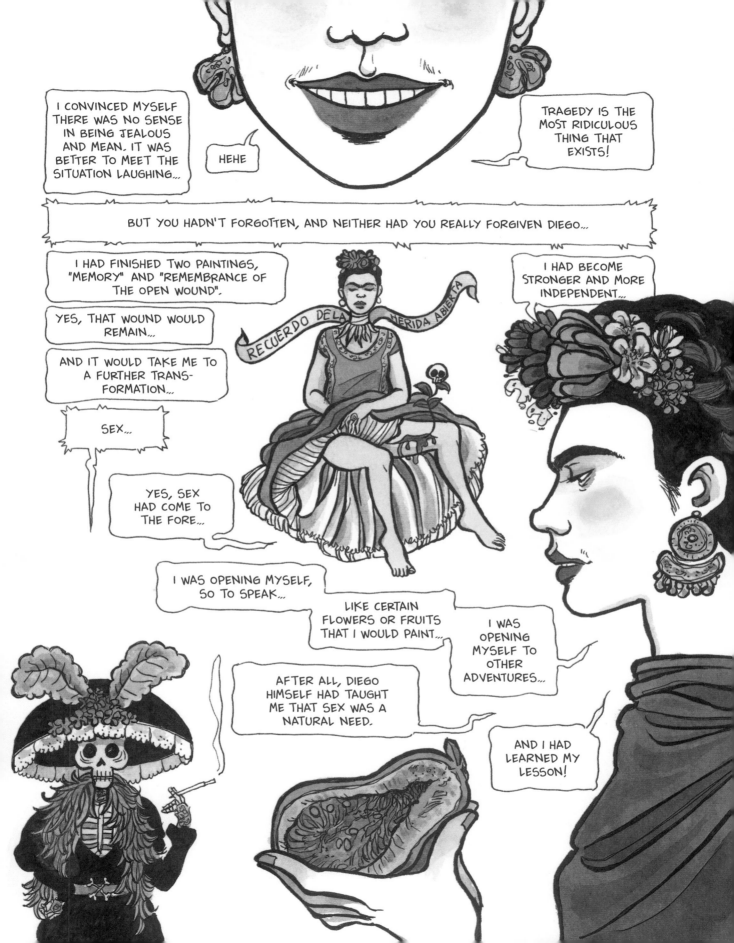

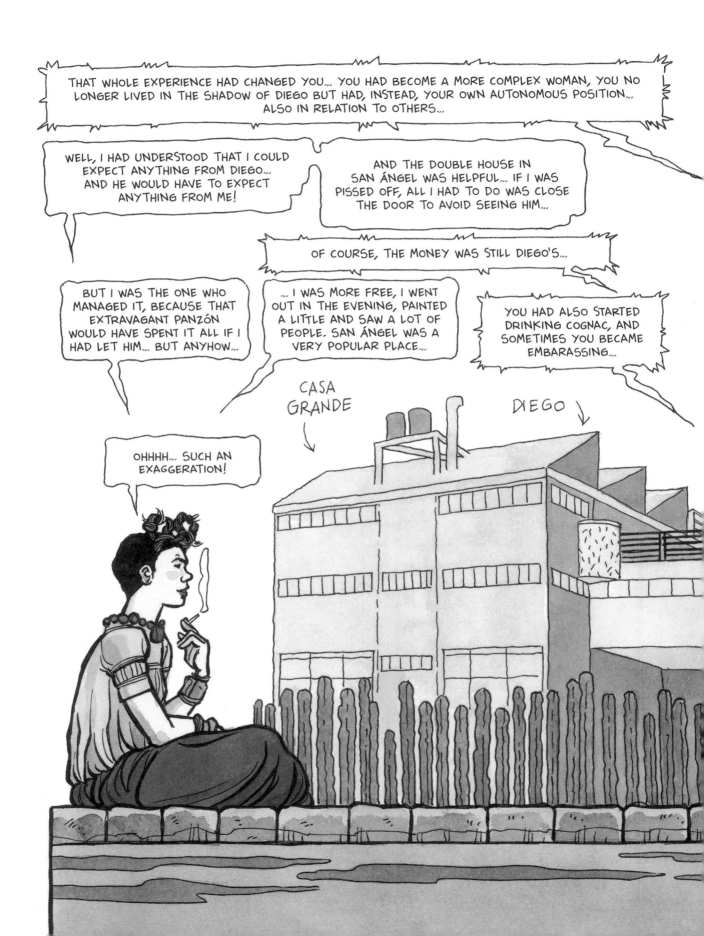

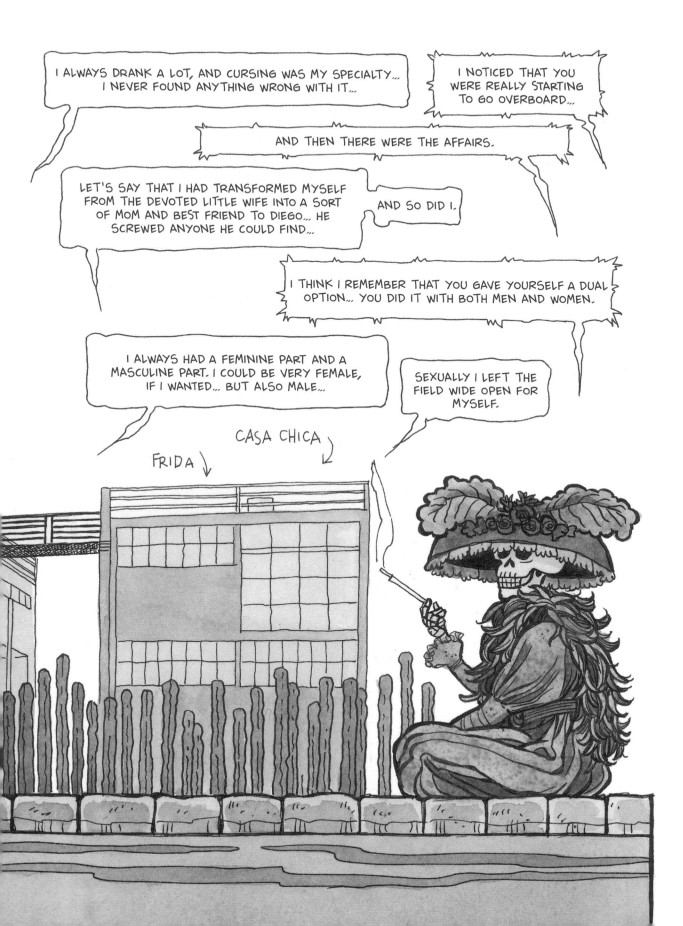

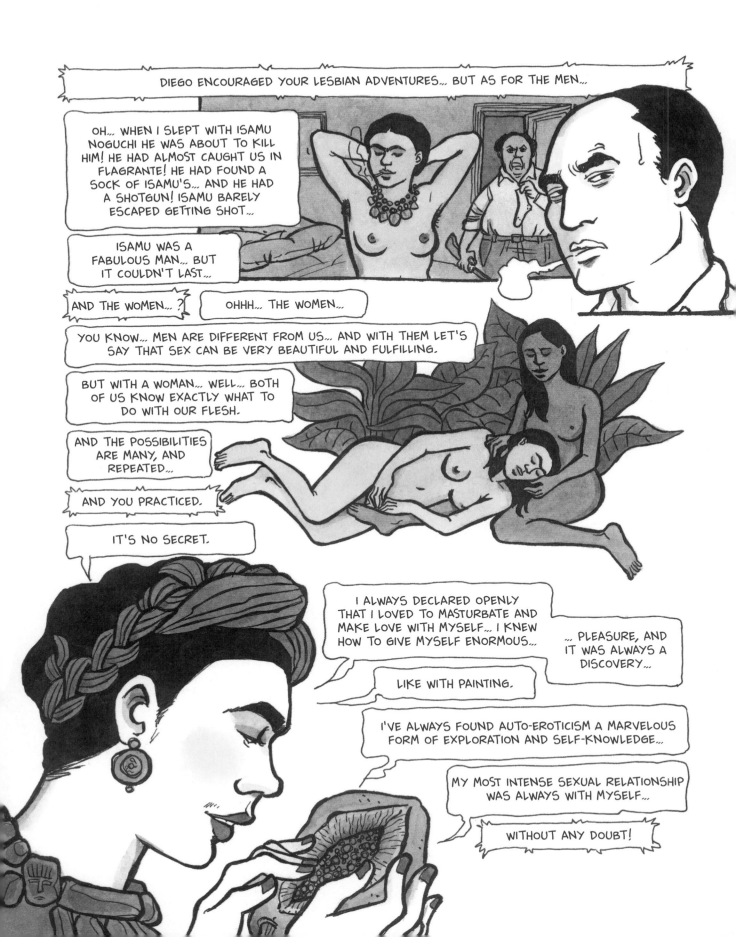

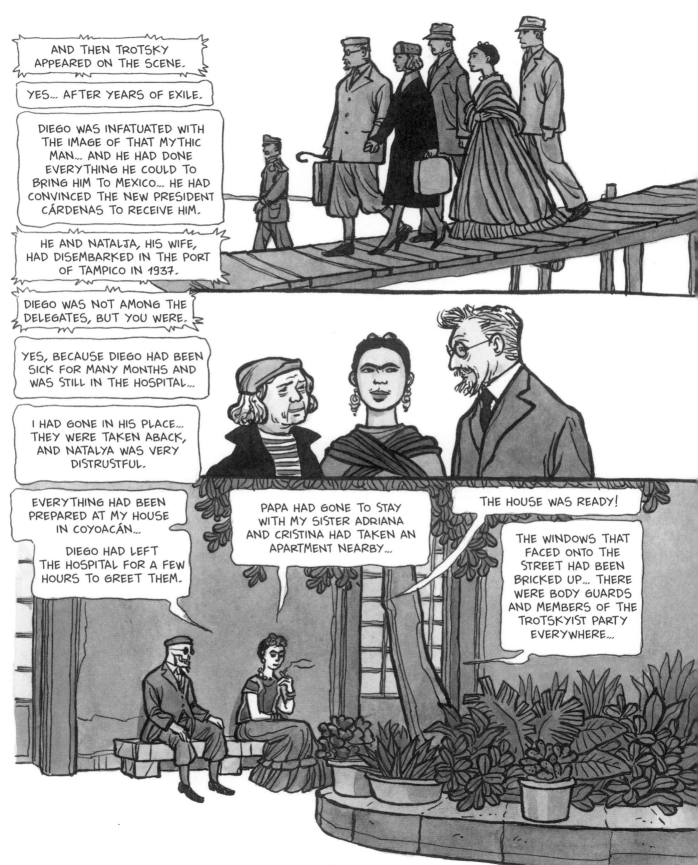

AND THEN TROTSKY APPEARED ON THE SCENE.

YES... AFTER YEARS OF EXILE.

DIEGO WAS INFATUATED WITH THE IMAGE OF THAT MYTHIC MAN... AND HE HAD DONE EVERYTHING HE COULD TO BRING HIM TO MEXICO... HE HAD CONVINCED THE NEW PRESIDENT CÁRDENAS TO RECEIVE HIM.

HE AND NATALJA, HIS WIFE, HAD DISEMBARKED IN THE PORT OF TAMPICO IN 1937.

DIEGO WAS NOT AMONG THE DELEGATES, BUT YOU WERE.

YES, BECAUSE DIEGO HAD BEEN SICK FOR MANY MONTHS AND WAS STILL IN THE HOSPITAL...

I HAD GONE IN HIS PLACE... THEY WERE TAKEN ABACK, AND NATALYA WAS VERY DISTRUSTFUL.

EVERYTHING HAD BEEN PREPARED AT MY HOUSE IN COYOACÁN...

DIEGO HAD LEFT THE HOSPITAL FOR A FEW HOURS TO GREET THEM.

PAPA HAD GONE TO STAY WITH MY SISTER ADRIANA AND CRISTINA HAD TAKEN AN APARTMENT NEARBY...

THE HOUSE WAS READY!

THE WINDOWS THAT FACED ONTO THE STREET HAD BEEN BRICKED UP... THERE WERE BODY GUARDS AND MEMBERS OF THE TROTSKYIST PARTY EVERYWHERE...

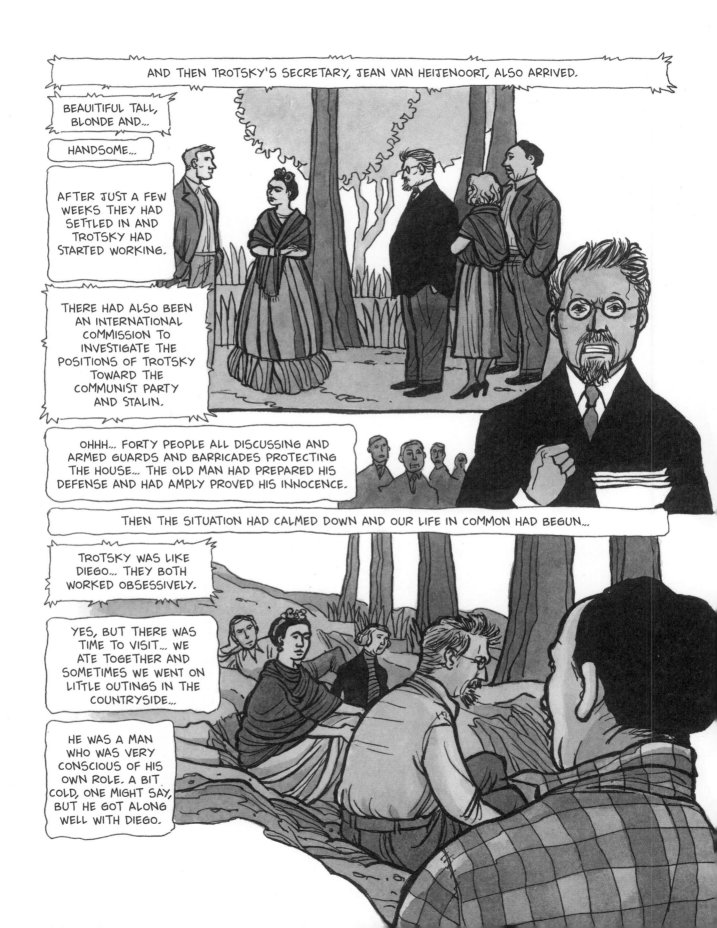

AND THEN TROTSKY'S SECRETARY, JEAN VAN HEIJENOORT, ALSO ARRIVED.

BEAUITFUL TALL, BLONDE AND...

HANDSOME...

AFTER JUST A FEW WEEKS THEY HAD SETTLED IN AND TROTSKY HAD STARTED WORKING.

THERE HAD ALSO BEEN AN INTERNATIONAL COMMISSION TO INVESTIGATE THE POSITIONS OF TROTSKY TOWARD THE COMMUNIST PARTY AND STALIN.

OHHH... FORTY PEOPLE ALL DISCUSSING AND ARMED GUARDS AND BARRICADES PROTECTING THE HOUSE... THE OLD MAN HAD PREPARED HIS DEFENSE AND HAD AMPLY PROVED HIS INNOCENCE.

THEN THE SITUATION HAD CALMED DOWN AND OUR LIFE IN COMMON HAD BEGUN...

TROTSKY WAS LIKE DIEGO... THEY BOTH WORKED OBSESSIVELY.

YES, BUT THERE WAS TIME TO VISIT... WE ATE TOGETHER AND SOMETIMES WE WENT ON LITTLE OUTINGS IN THE COUNTRYSIDE...

HE WAS A MAN WHO WAS VERY CONSCIOUS OF HIS OWN ROLE. A BIT COLD, ONE MIGHT SAY, BUT HE GOT ALONG WELL WITH DIEGO.

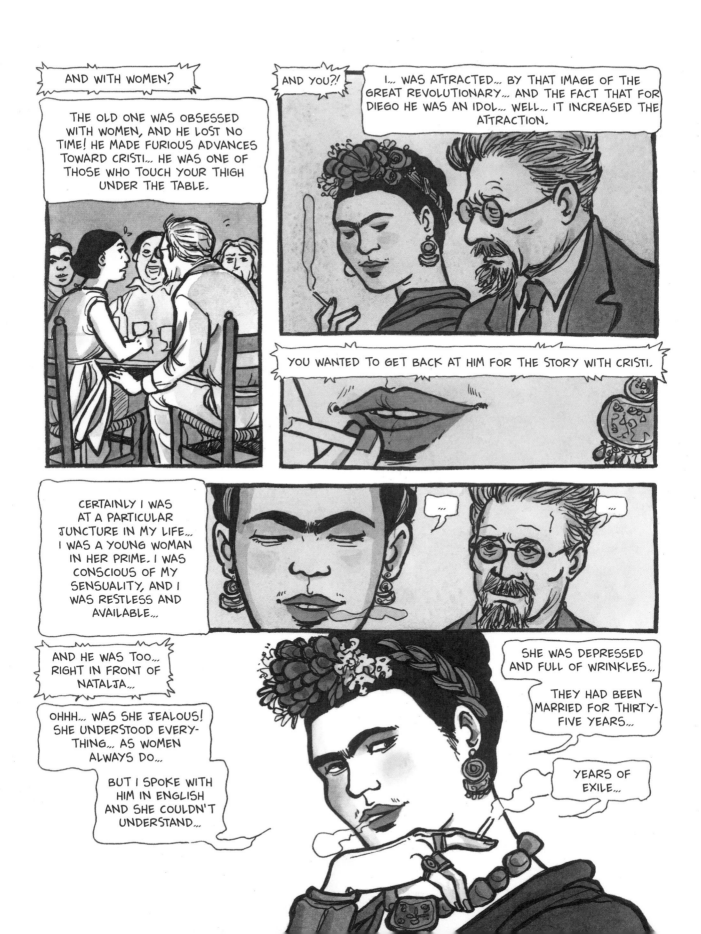

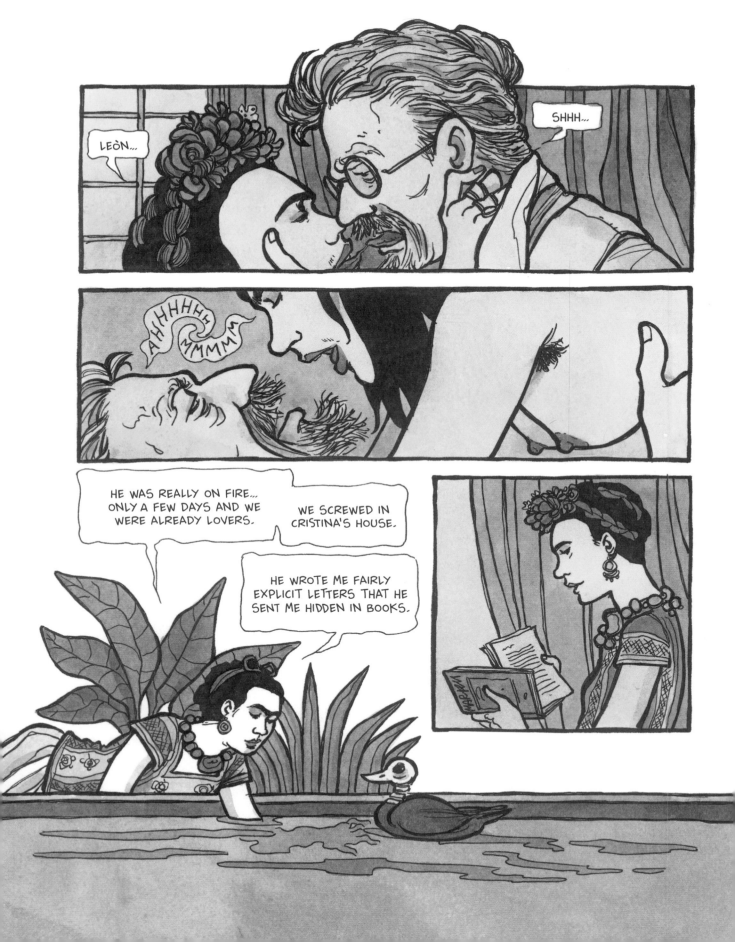

THEN HE HAD GONE TO STAY FOR AWHILE AT A FARM JUST OUTSIDE MÉXICO CITY... BY HIMSELF... AND I HAD GONE TO SEE HIM A FEW TIMES WITHOUT NATALJA... BUT IT WAS ALREADY OVER...

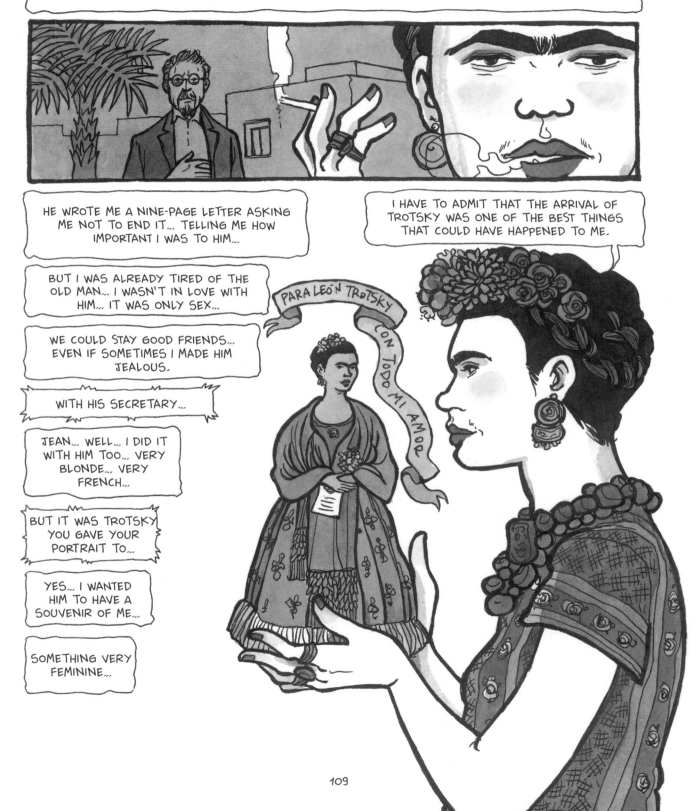

HE WROTE ME A NINE-PAGE LETTER ASKING ME NOT TO END IT... TELLING ME HOW IMPORTANT I WAS TO HIM...

BUT I WAS ALREADY TIRED OF THE OLD MAN... I WASN'T IN LOVE WITH HIM... IT WAS ONLY SEX...

WE COULD STAY GOOD FRIENDS... EVEN IF SOMETIMES I MADE HIM JEALOUS.

WITH HIS SECRETARY...

JEAN... WELL... I DID IT WITH HIM TOO... VERY BLONDE... VERY FRENCH...

BUT IT WAS TROTSKY YOU GAVE YOUR PORTRAIT TO...

YES... I WANTED HIM TO HAVE A SOUVENIR OF ME...

SOMETHING VERY FEMININE...

I HAVE TO ADMIT THAT THE ARRIVAL OF TROTSKY WAS ONE OF THE BEST THINGS THAT COULD HAVE HAPPENED TO ME.

PARA LEÓN TROTSKY CON TODO MI AMOR

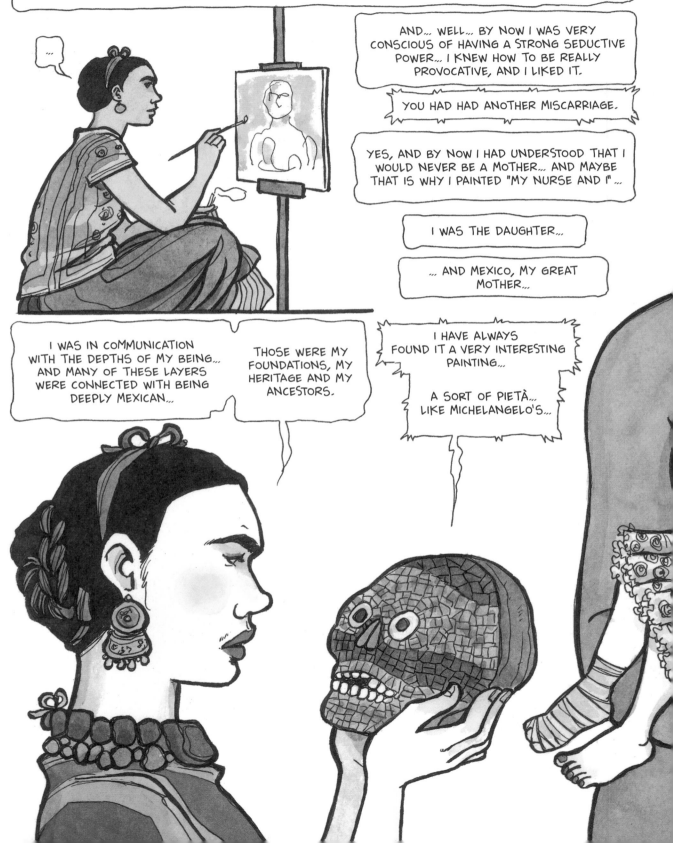

FROM 1938 ON I HAD STARTED FEELING MORE SURE OF MYSELF IN ALL WAYS... I WAS PAINTING MORE SERIOUSLY AND I LAUGHED AT DIEGO'S FLIRTATIONS...

AND... WELL... BY NOW I WAS VERY CONSCIOUS OF HAVING A STRONG SEDUCTIVE POWER... I KNEW HOW TO BE REALLY PROVOCATIVE, AND I LIKED IT.

YOU HAD HAD ANOTHER MISCARRIAGE.

YES, AND BY NOW I HAD UNDERSTOOD THAT I WOULD NEVER BE A MOTHER... AND MAYBE THAT IS WHY I PAINTED "MY NURSE AND I"...

I WAS THE DAUGHTER...

... AND MEXICO, MY GREAT MOTHER...

I WAS IN COMMUNICATION WITH THE DEPTHS OF MY BEING... AND MANY OF THESE LAYERS WERE CONNECTED WITH BEING DEEPLY MEXICAN...

THOSE WERE MY FOUNDATIONS, MY HERITAGE AND MY ANCESTORS.

I HAVE ALWAYS FOUND IT A VERY INTERESTING PAINTING...

A SORT OF PIETÀ... LIKE MICHELANGELO'S...

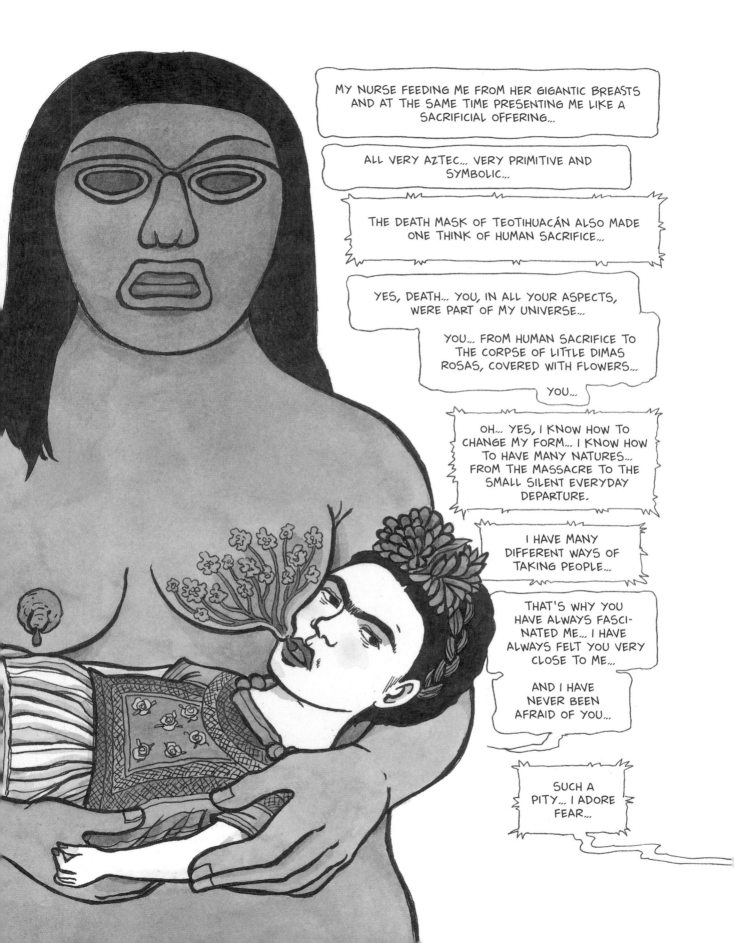

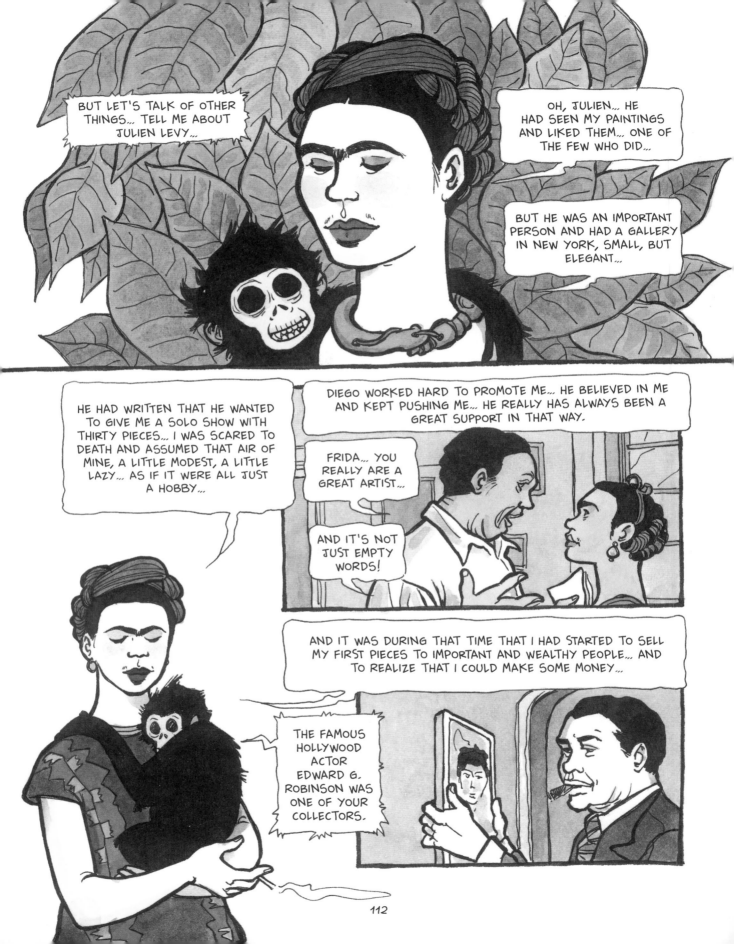

BUT LET'S TALK OF OTHER THINGS... TELL ME ABOUT JULIEN LEVY...

OH, JULIEN... HE HAD SEEN MY PAINTINGS AND LIKED THEM... ONE OF THE FEW WHO DID...

BUT HE WAS AN IMPORTANT PERSON AND HAD A GALLERY IN NEW YORK, SMALL, BUT ELEGANT...

HE HAD WRITTEN THAT HE WANTED TO GIVE ME A SOLO SHOW WITH THIRTY PIECES... I WAS SCARED TO DEATH AND ASSUMED THAT AIR OF MINE, A LITTLE MODEST, A LITTLE LAZY... AS IF IT WERE ALL JUST A HOBBY...

DIEGO WORKED HARD TO PROMOTE ME... HE BELIEVED IN ME AND KEPT PUSHING ME... HE REALLY HAS ALWAYS BEEN A GREAT SUPPORT IN THAT WAY.

FRIDA... YOU REALLY ARE A GREAT ARTIST...

AND IT'S NOT JUST EMPTY WORDS!

AND IT WAS DURING THAT TIME THAT I HAD STARTED TO SELL MY FIRST PIECES TO IMPORTANT AND WEALTHY PEOPLE... AND TO REALIZE THAT I COULD MAKE SOME MONEY...

THE FAMOUS HOLLYWOOD ACTOR EDWARD G. ROBINSON WAS ONE OF YOUR COLLECTORS.

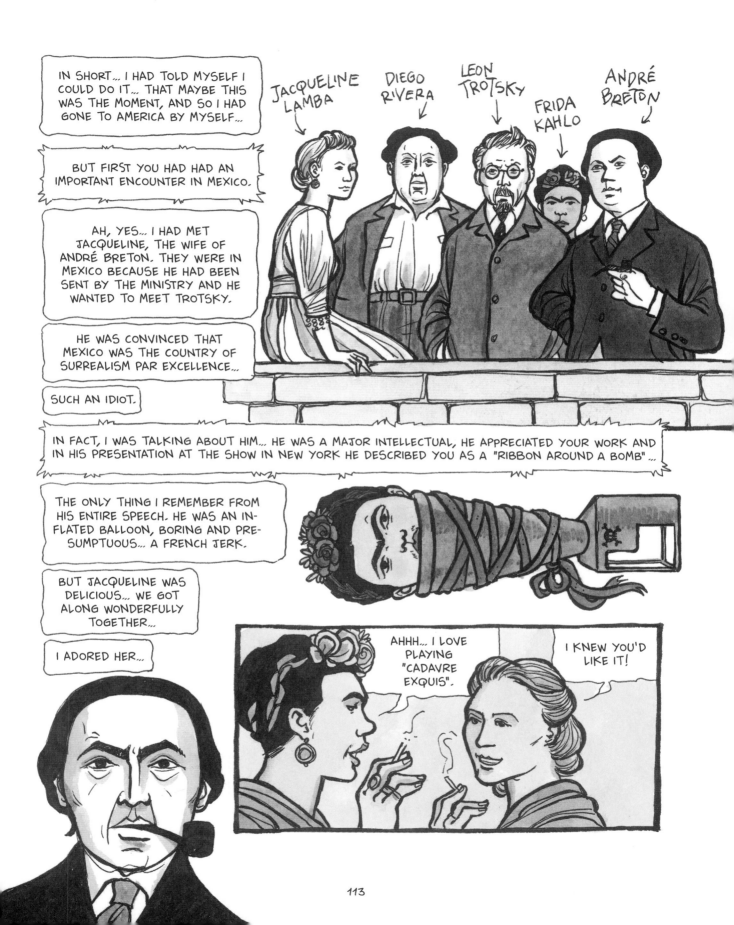

IN SHORT... I HAD TOLD MYSELF I COULD DO IT... THAT MAYBE THIS WAS THE MOMENT, AND SO I HAD GONE TO AMERICA BY MYSELF...

BUT FIRST YOU HAD HAD AN IMPORTANT ENCOUNTER IN MEXICO.

AH, YES... I HAD MET JACQUELINE, THE WIFE OF ANDRÉ BRETON. THEY WERE IN MEXICO BECAUSE HE HAD BEEN SENT BY THE MINISTRY AND HE WANTED TO MEET TROTSKY.

HE WAS CONVINCED THAT MEXICO WAS THE COUNTRY OF SURREALISM PAR EXCELLENCE...

SUCH AN IDIOT.

IN FACT, I WAS TALKING ABOUT HIM... HE WAS A MAJOR INTELLECTUAL, HE APPRECIATED YOUR WORK AND IN HIS PRESENTATION AT THE SHOW IN NEW YORK HE DESCRIBED YOU AS A "RIBBON AROUND A BOMB"...

THE ONLY THING I REMEMBER FROM HIS ENTIRE SPEECH. HE WAS AN IN- FLATED BALLOON, BORING AND PRE- SUMPTUOUS... A FRENCH JERK.

BUT JACQUELINE WAS DELICIOUS... WE GOT ALONG WONDERFULLY TOGETHER...

I ADORED HER...

JACQUELINE LAMBA

DIEGO RIVERA

LEON TROTSKY

FRIDA KAHLO

ANDRÉ BRETON

AHHH... I LOVE PLAYING "CADAVRE EXQUIS".

I KNEW YOU'D LIKE IT!

113

AND SO, IN NEW YORK...?

I WAS FABULOUS! I PRESENTED MYSELF AS A WOMAN WHO WAS FREE AND INDEPENDENT...
I SPOKE BADLY OF DIEGO AND WANTED TO SHOW THAT I NO LONGER LOVED HIM.

IN 1938 THE SHOW HAD OPENED ON NOVEMBER 4! ISAMU NOGUCHI WAS THERE, ALSO CLARE BOOTHE
LUCE FROM VANITY FAIR, AND A BUNCH OF IMPORTANT PEOPLE LIKE GEORGIA O'KEEFE AND HER HUSBAND...

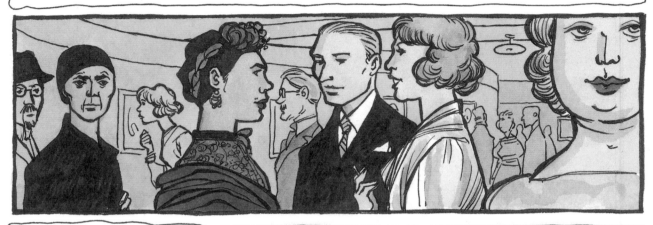

I EVEN FLIRTED A LITTLE
WITH HER... SHE WAS ONE OF
THE GREAT ONES!

I, WEARING THE DRESS OF A REAL MEXICAN WOMAN, ENCHANTED THEM ALL,
EVEN IF UNDERNEATH I FELT PRETTY INTIMIDATED...

BUT YOU WERE HAPPY AND YOU SOLD
HALF THE PIECES...

IT'S TRUE, IT WAS A GOOD PERIOD,
EVEN IF MY RIGHT FOOT WAS HURTING
A LOT AND I TIRED RAPIDLY...

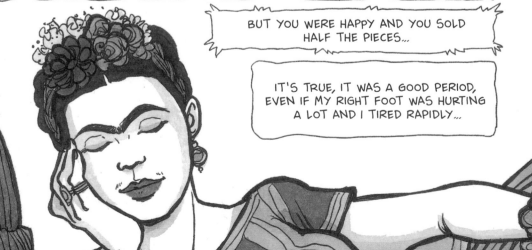

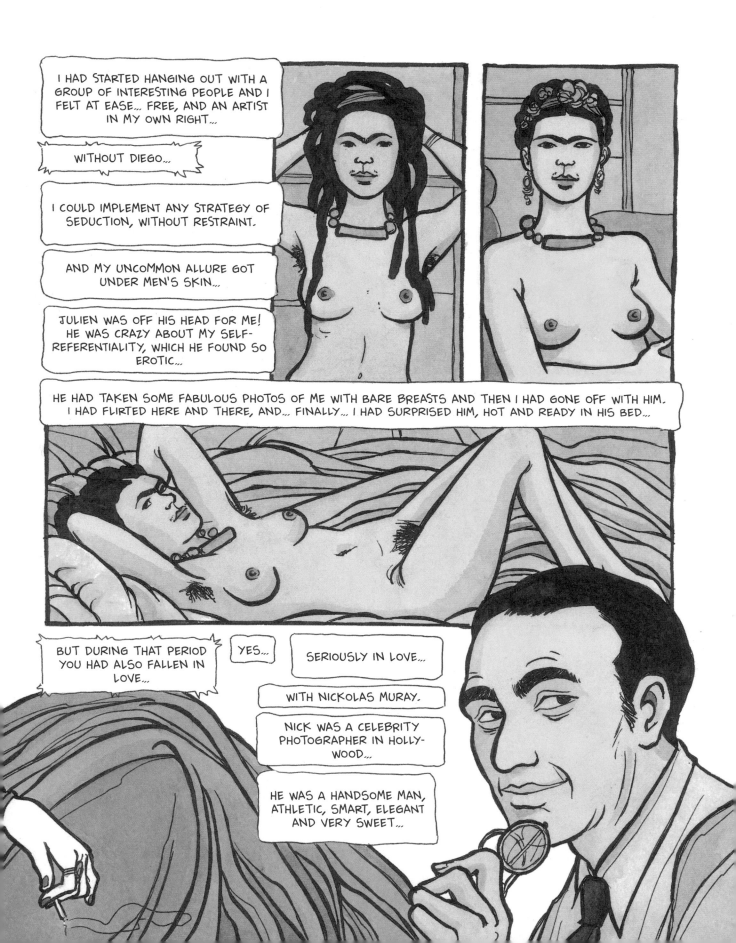

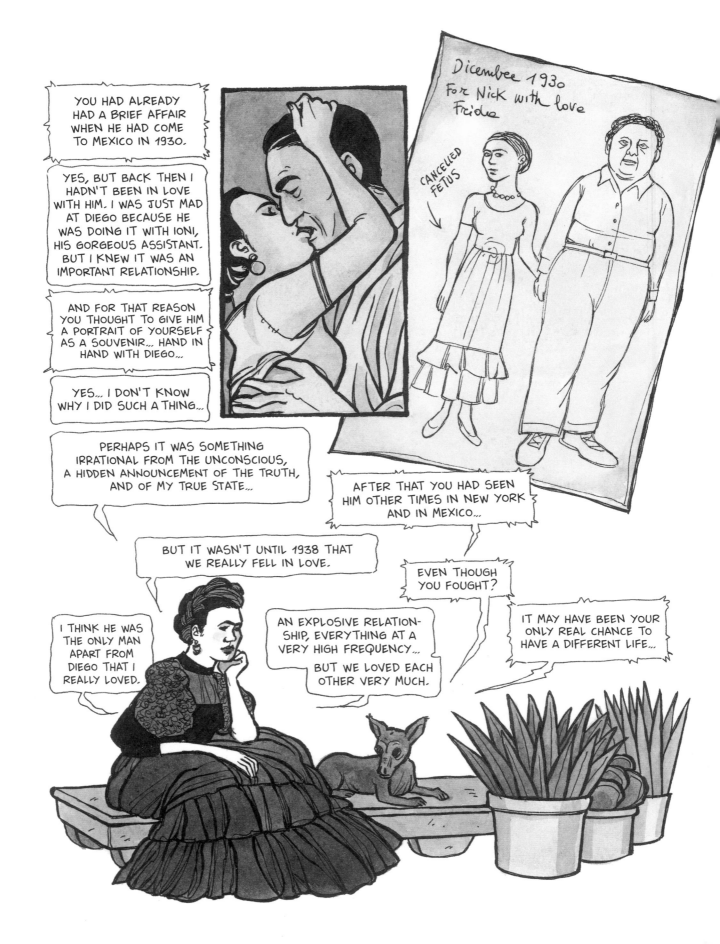

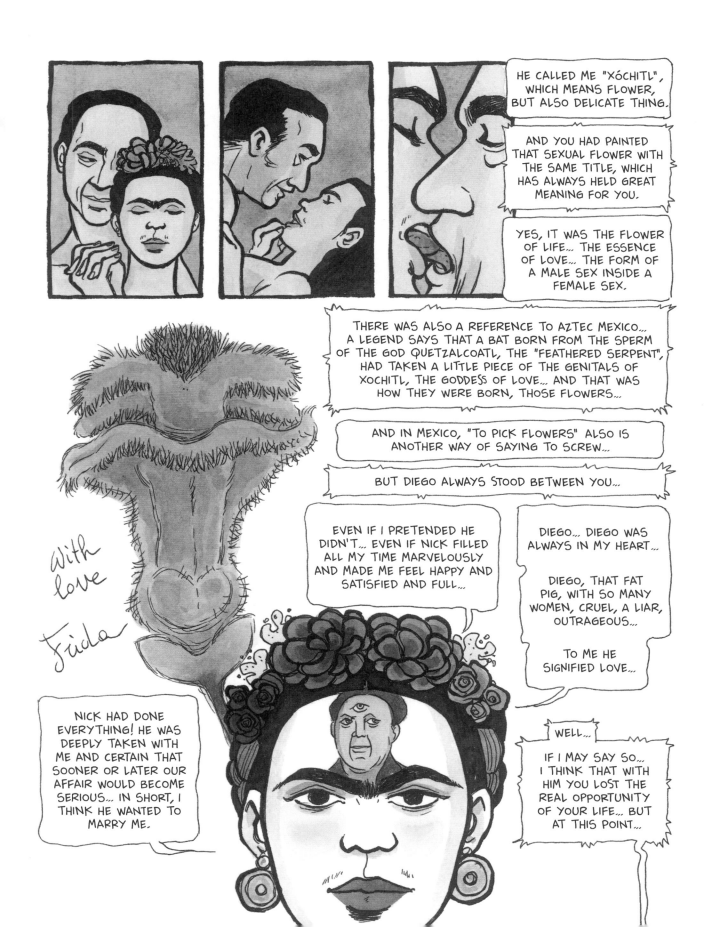

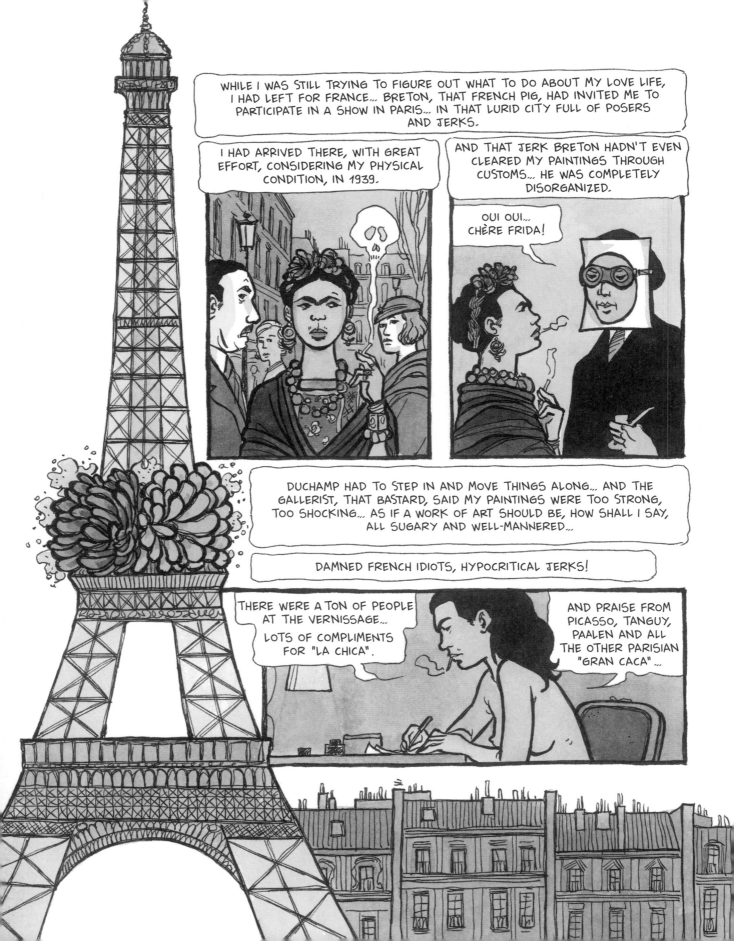

AND AT BRETON'S HOUSE I HAD CAUGHT A NASTY COLI BACTERIA INFECTION AND HAD ENDED UP IN THE HOSPITAL...

I WAS SICK AS A DOG AND I WAS ALL BY MYSELF...

AFRAID OF WAR AND THE NAZIS, WHO WERE ALREADY RAGING...

AHHH... THE NAZIS... ONE OF MY MOST BRILLIANT IDEAS! THAT'S WHEN THEY WERE SERIOUSLY BEGINNING TO MOBILIZE... AHHH... I WAS SO BUSY BACK THEN...

I WAS AFRAID, BUT ALSO HAD OTHER THINGS TO THINK ABOUT. MY INTESTINES WERE IN SUCH BAD SHAPE THAT I THOUGHT YOU WOULD TAKE ME AWAY...

EHHH... IMAGINE! FOR A LITTLE DIARRHEA!

COME ON... I WAS A WRECK...

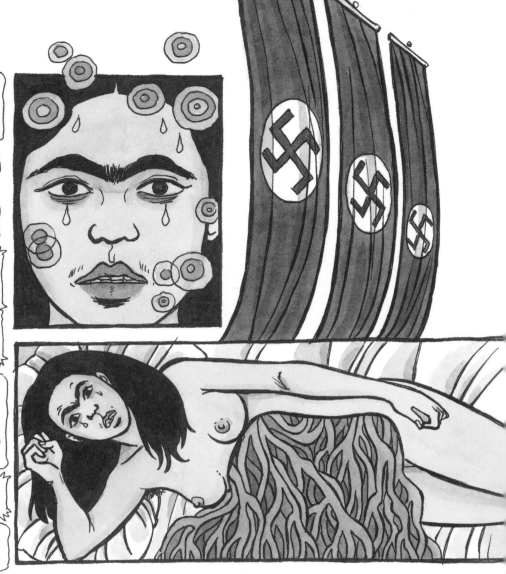

IN THAT DISGUSTING PLACE... THE PARISIANS ARE SOME OF THE FILTHIEST PEOPLE I'VE EVER SEEN!

AND THEN, AFTER DAYS OF AGONY, IN THE END I MANAGED...

... TO BURP!

I LET OUT A HUGE BURP AND FELT BETTER RIGHT AWAY!

I SAVED MYSELF BY BURPING!

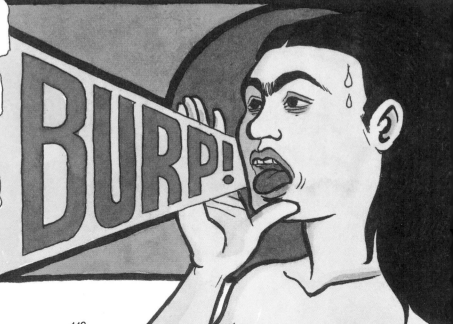

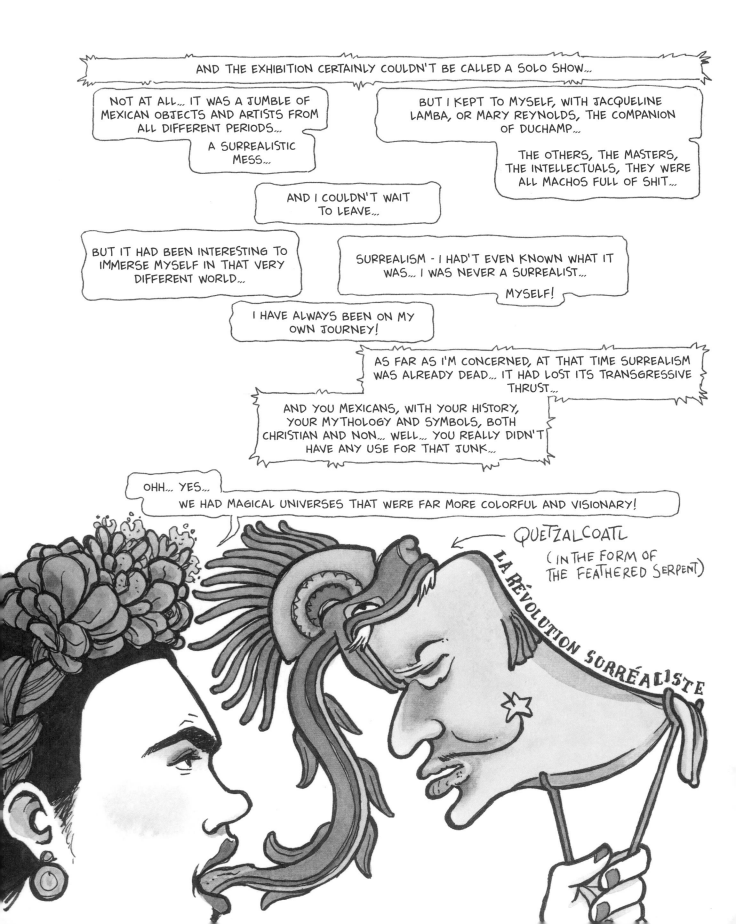

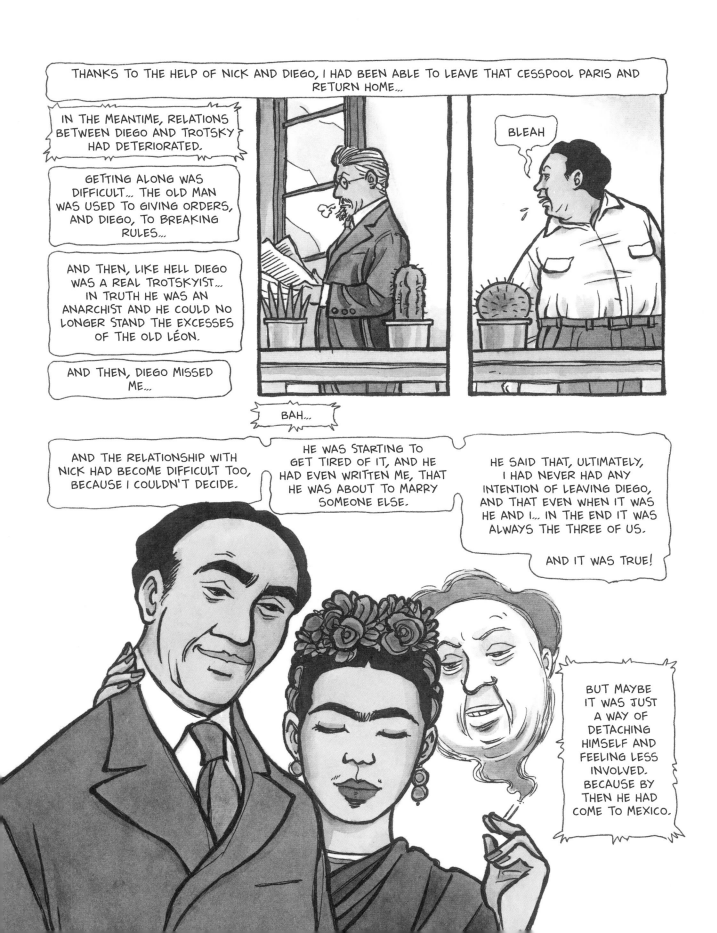

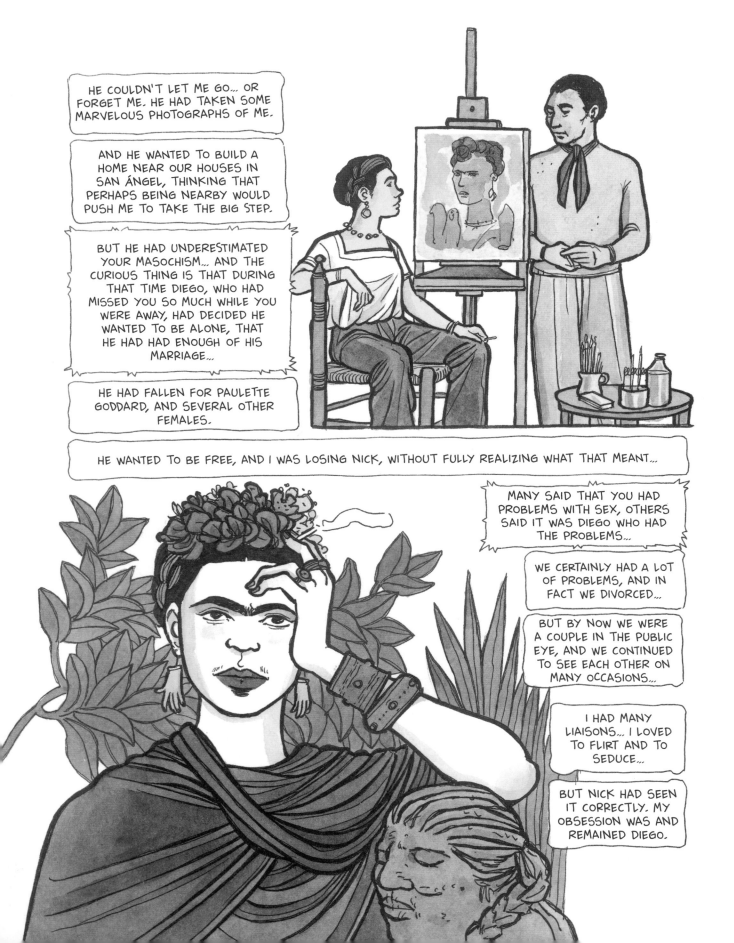

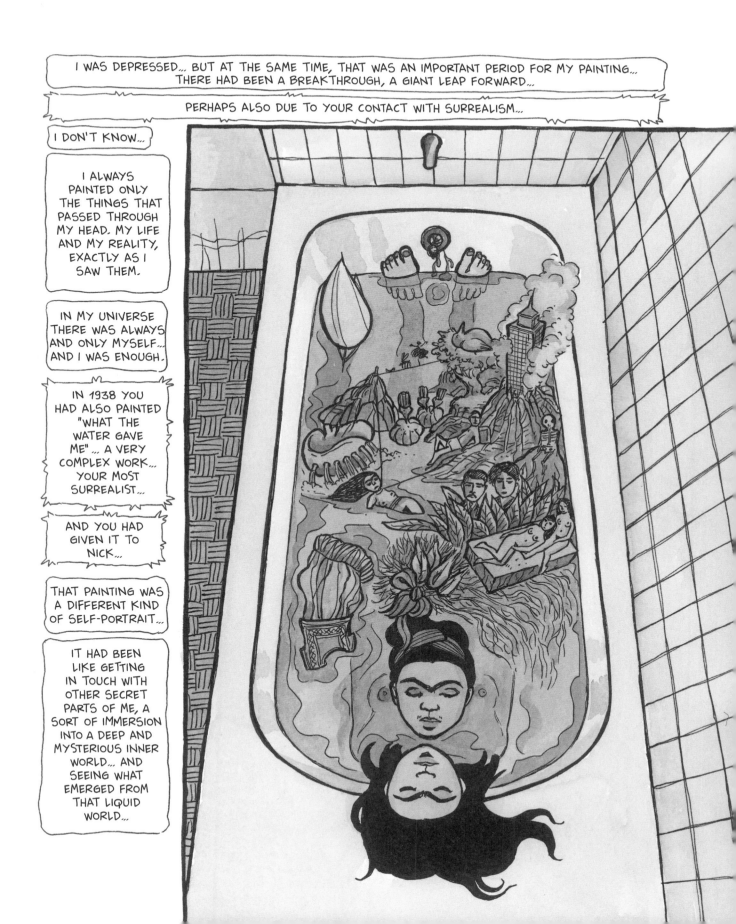

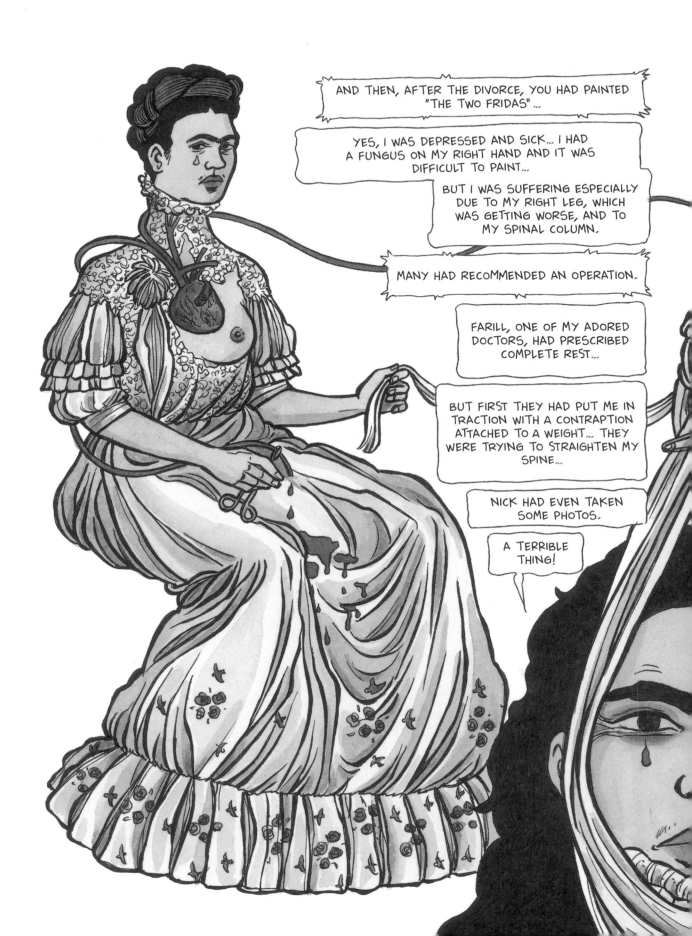

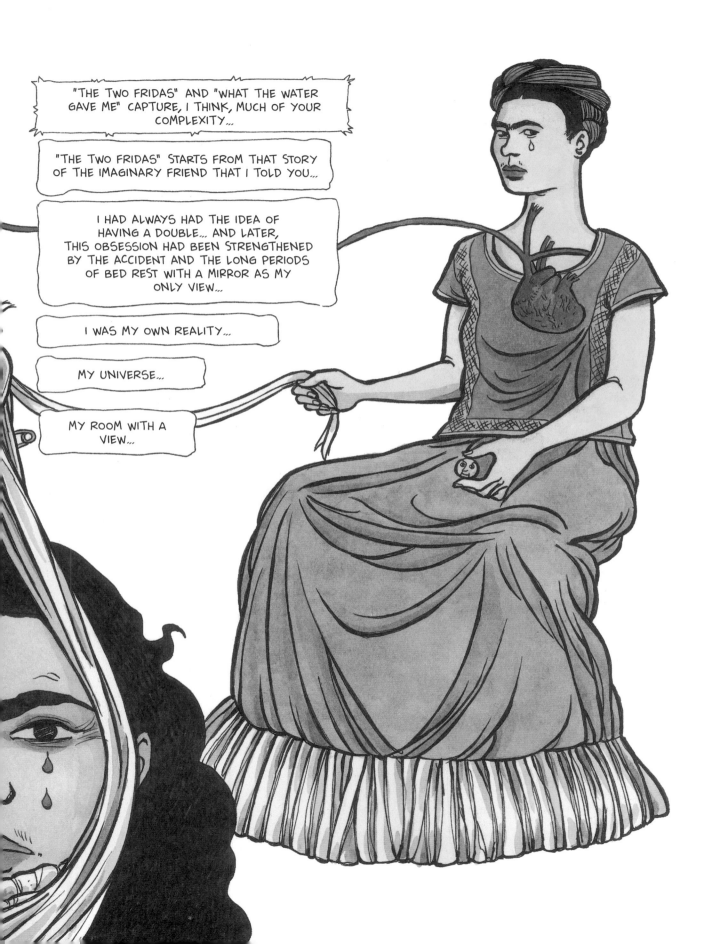

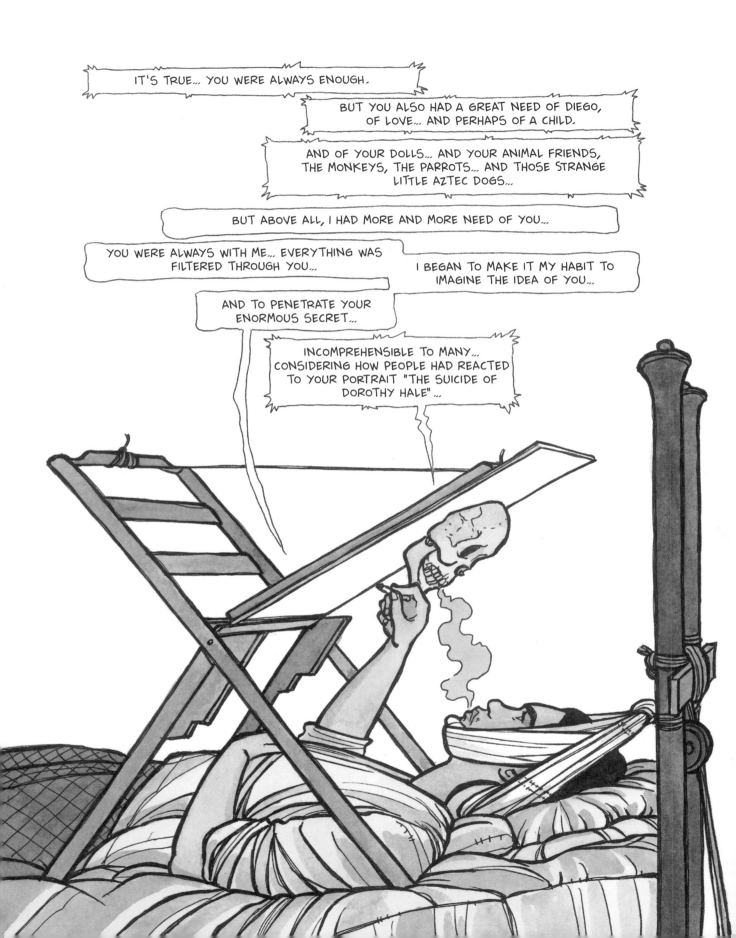

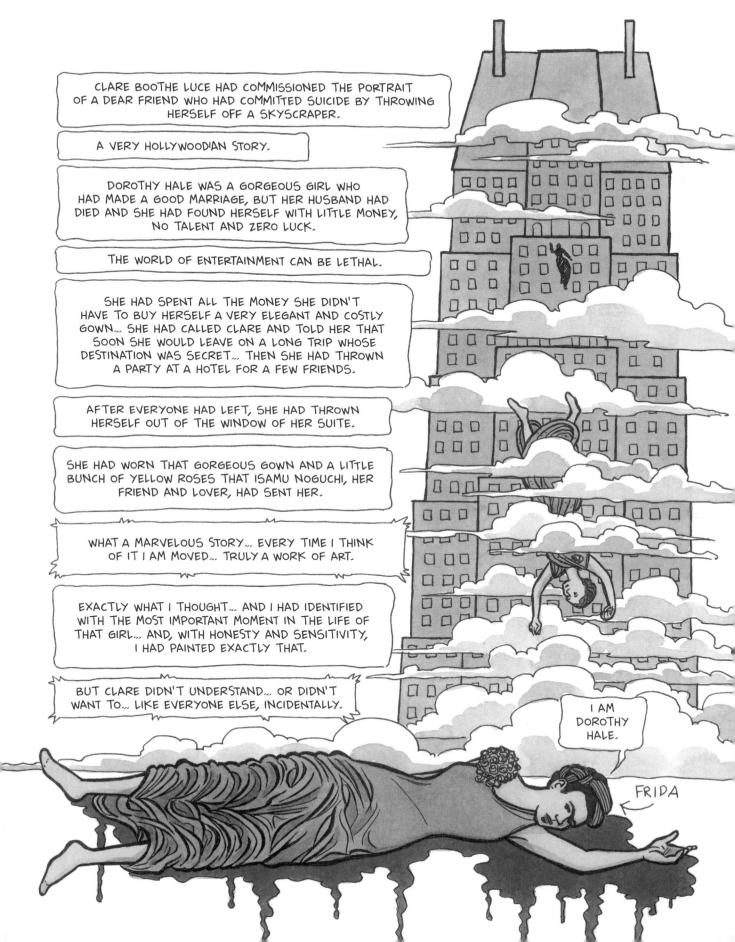

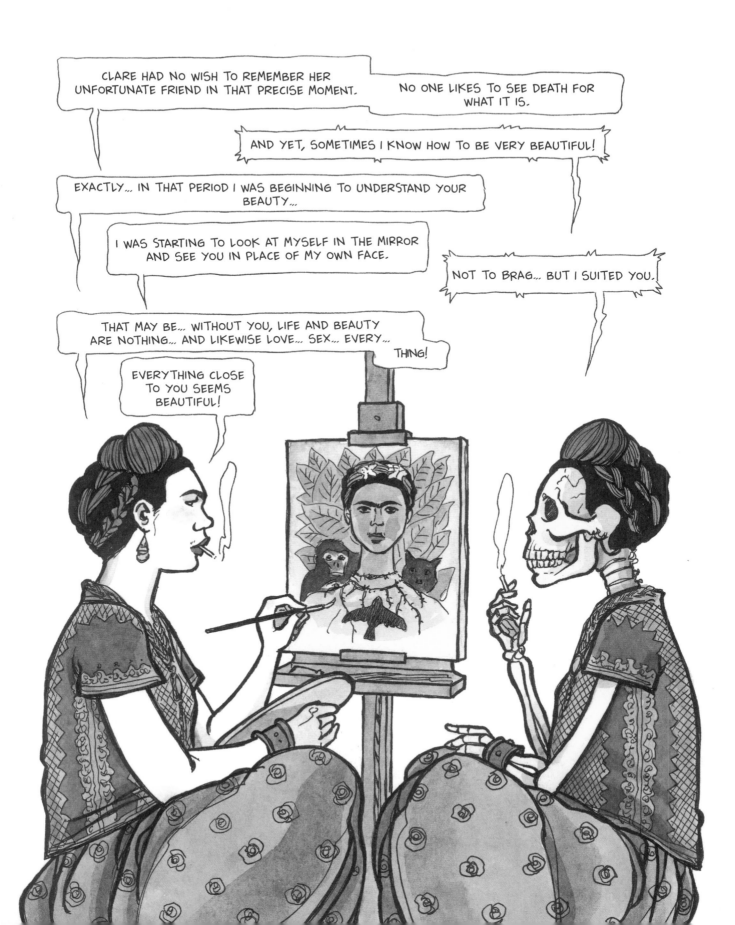

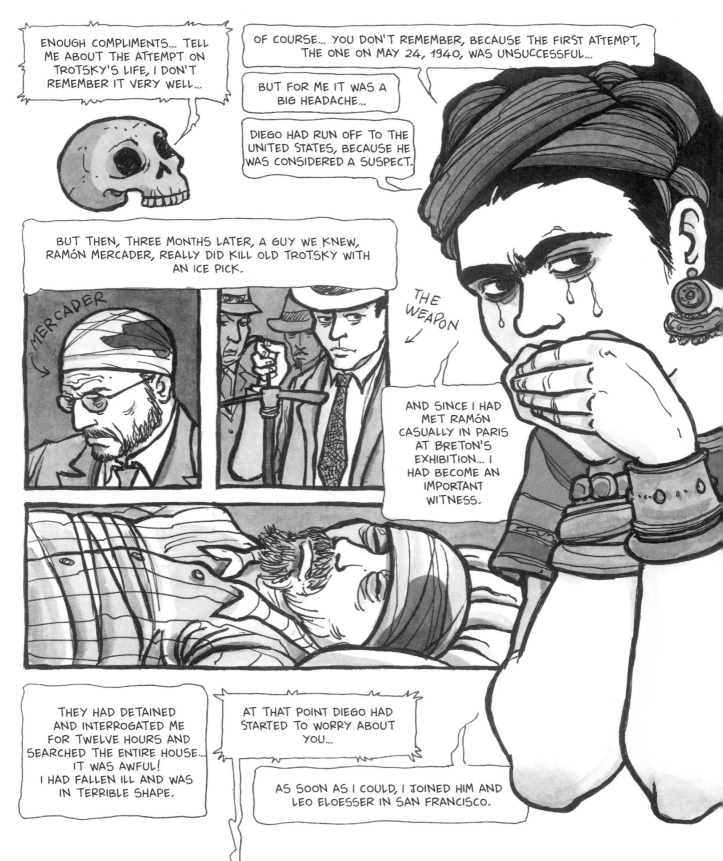

THEY HAD ME ADMITTED TO THE HOSPITAL. LEO HAD PRESCRIBED COMPLETE BED REST AND VARIOUS THERAPIES, BUT ABOVE ALL, ZERO ALCOHOL. THEN, AFTER LOTS OF TESTS AND EXAMS, HE HAD DECIDED THAT I DIDN'T NEED SURGERY...

AND I WAS THINKING ABOUT GETTING MARRIED TO DIEGO AGAIN, ALSO ON LEO'S ADVICE...

YES... BUT THEN YOU HAD THAT FLING WITH A YOUNG GERMAN WHO HAD ESCAPED FROM THE NAZIS...

DIEGO HAD BROUGHT HIM TO VISIT.

OHH... HEINZ! HE HAD COME TO THE HOSPITAL WITH DIEGO...

HE WAS SO YOUNG AND CUTE. I FELT IT CLICK RIGHT AWAY!

FRIDA WILL SUCK YOU DRY... YOU'LL SEE.

...

THERE WAS SOMETHING DIABOLICAL ABOUT DIEGO... PROBABLY HE HAD ALREADY SENSED WHAT WOULD HAPPEN... OR MAYBE HE EVEN WANTED IT TO HAPPEN...

I STAYED IN THE HOSPITAL FOR A MONTH... AND HE CAME EVERY DAY... IT WAS MARVELOUS... WE DID IT RIGHT THERE... WITH THE RISK OF BEING CAUGHT AT EVERY MOMENT... THAT SENSATION EXCITED ME TREMENDOUSLY...

NO PRIVACY, AND YOU WERE SO WILD AND PASSIONATE.

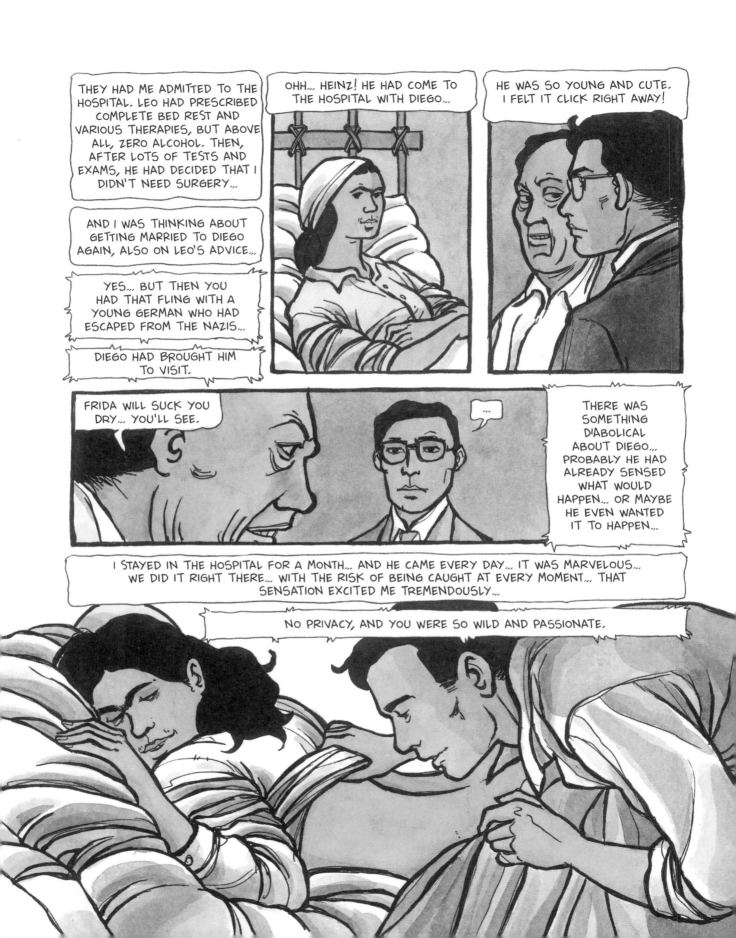

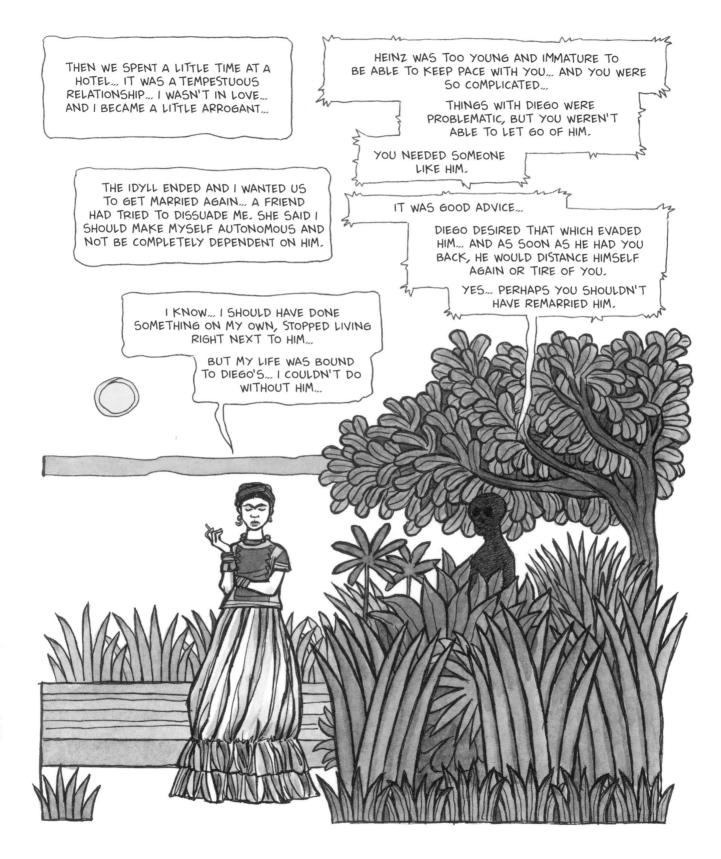

THEN WE SPENT A LITTLE TIME AT A HOTEL... IT WAS A TEMPESTUOUS RELATIONSHIP... I WASN'T IN LOVE... AND I BECAME A LITTLE ARROGANT...

HEINZ WAS TOO YOUNG AND IMMATURE TO BE ABLE TO KEEP PACE WITH YOU... AND YOU WERE SO COMPLICATED...

THINGS WITH DIEGO WERE PROBLEMATIC, BUT YOU WEREN'T ABLE TO LET GO OF HIM.

YOU NEEDED SOMEONE LIKE HIM.

THE IDYLL ENDED AND I WANTED US TO GET MARRIED AGAIN... A FRIEND HAD TRIED TO DISSUADE ME. SHE SAID I SHOULD MAKE MYSELF AUTONOMOUS AND NOT BE COMPLETELY DEPENDENT ON HIM.

IT WAS GOOD ADVICE...

DIEGO DESIRED THAT WHICH EVADED HIM... AND AS SOON AS HE HAD YOU BACK, HE WOULD DISTANCE HIMSELF AGAIN OR TIRE OF YOU.

YES... PERHAPS YOU SHOULDN'T HAVE REMARRIED HIM.

I KNOW... I SHOULD HAVE DONE SOMETHING ON MY OWN, STOPPED LIVING RIGHT NEXT TO HIM...

BUT MY LIFE WAS BOUND TO DIEGO'S... I COULDN'T DO WITHOUT HIM...

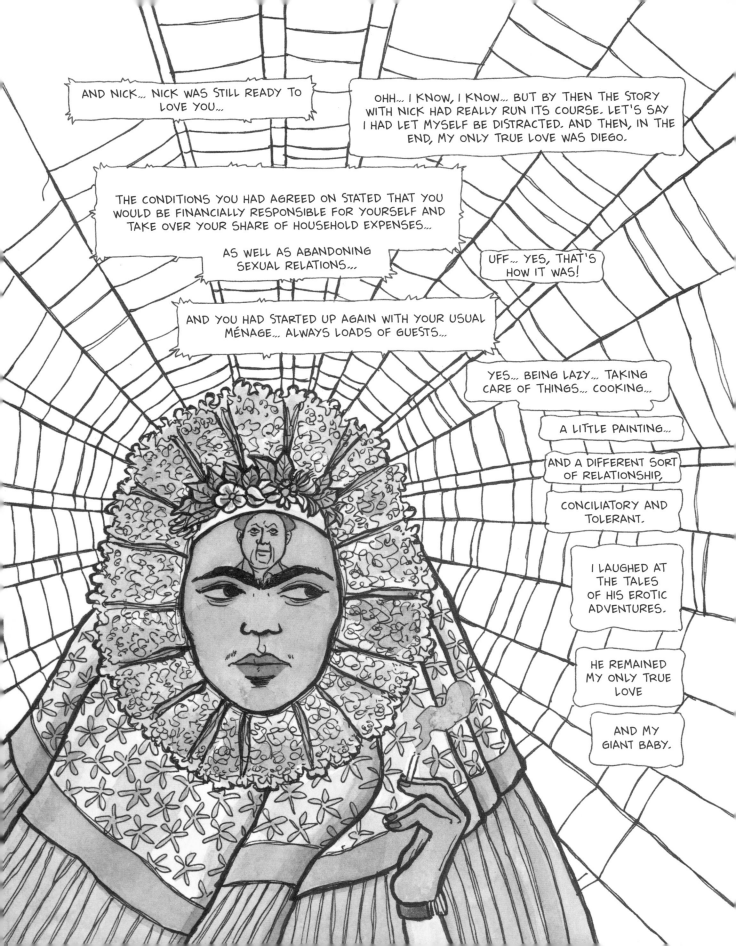

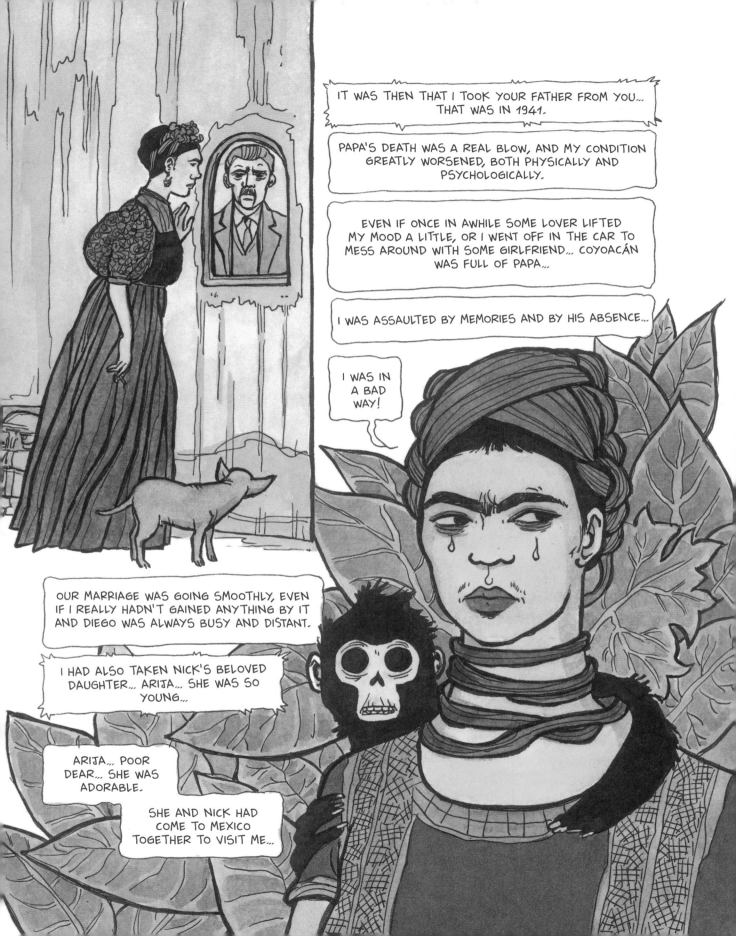

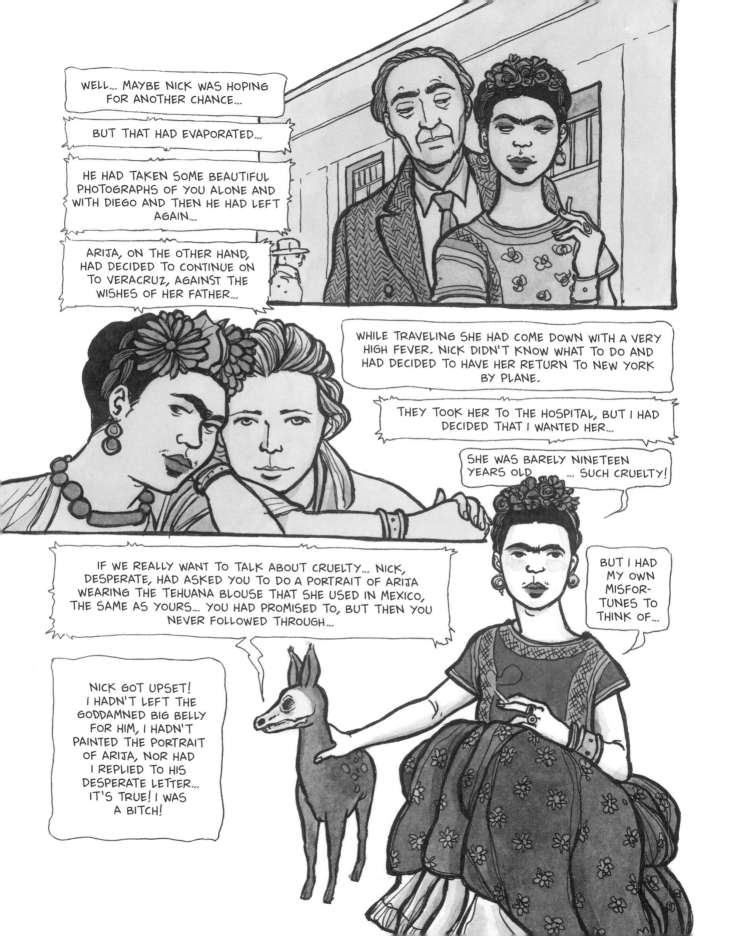

BUT FROM 1940 ON, YOUR STANDING AS AN ARTIST HAD STARTED TO INCREASE... YOU WERE VERY FOCUSED ON YOURSELF AND YOUR PAINTING.

I HAD PARTICIPATED IN A LOT OF GROUP SHOWS, AND BASICALLY I ALREADY HAD A NAME IN THE UNITED STATES... I TOOK MYSELF A LITTLE MORE SERIOUSLY, EVEN IF IT WAS HARD TO PRESENT MYSELF AS A REAL ARTIST... I HAD ALSO STARTED PAINTING LARGER CANVASES... BUT I WASN'T LOOKING FOR SUCCESS AND I HAD NO AMBITIONS!

EVERYTHING I DID WAS RELATED ONLY TO THE EXPRESSION OF MYSELF! FOR ME PAINTING WAS A VITAL NEED, A WAY OF ENTERING DEEPLY INTO CONTACT WITH MY INTERIORITY...

I HAD PARTICIPATED IN A SHOW ABOUT FLOWERS AND FRUITS, LEAVING EVERYBODY BEWILDERED...

MY FLOWERS AND MY FRUITS LOOKED LIKE GENITALS... THEY WERE FLOWERS OF SEX! BECAUSE, FOR ME, SEX WAS LINKED TO NATURE.

I HAD ALSO HAD ANOTHER MISCARRIAGE... BUT THE CHILD WAS NOT DIEGO'S...

AND IT WAS IN 1942 THAT I BEGAN WRITING MY DIARY...

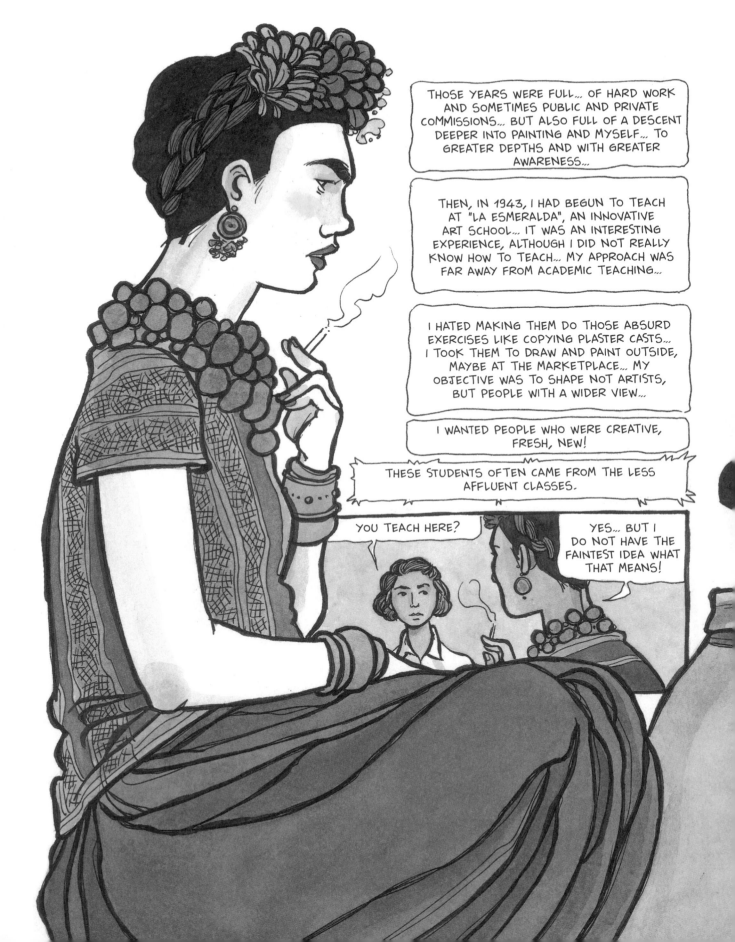

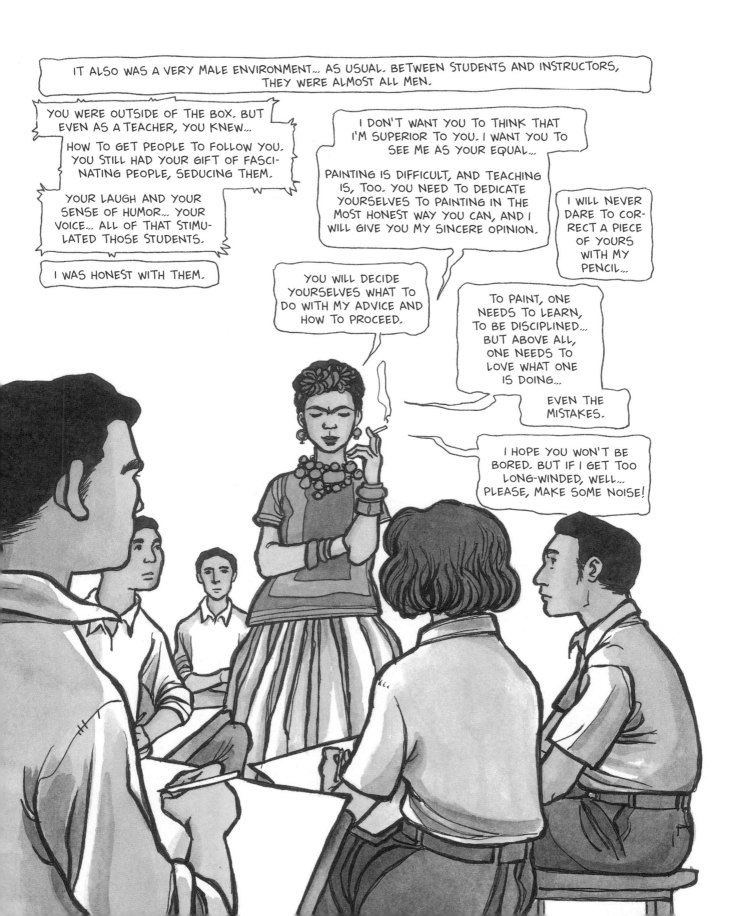

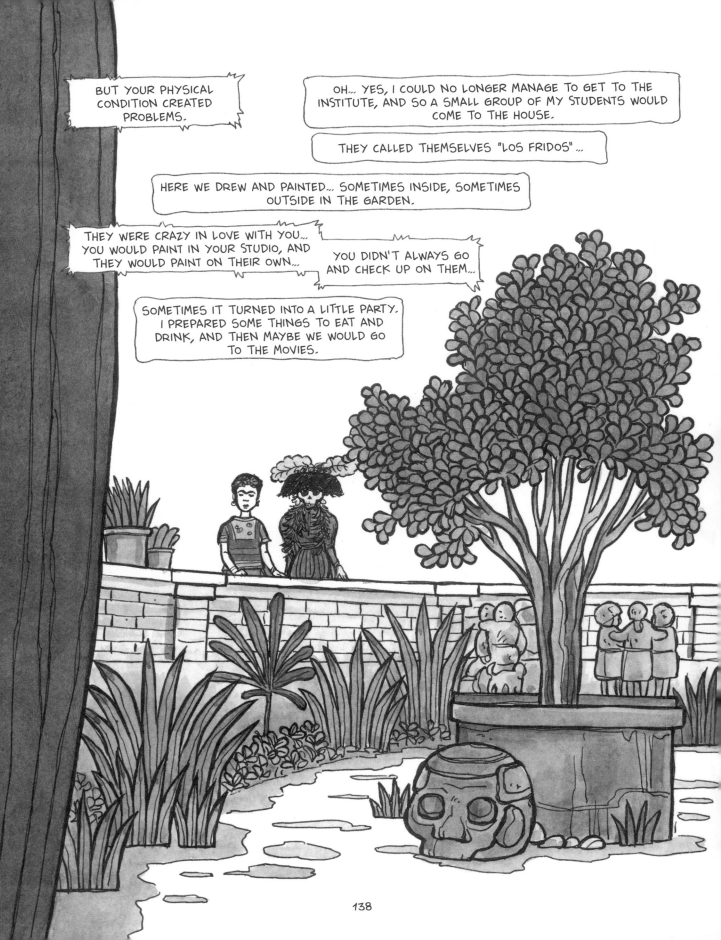

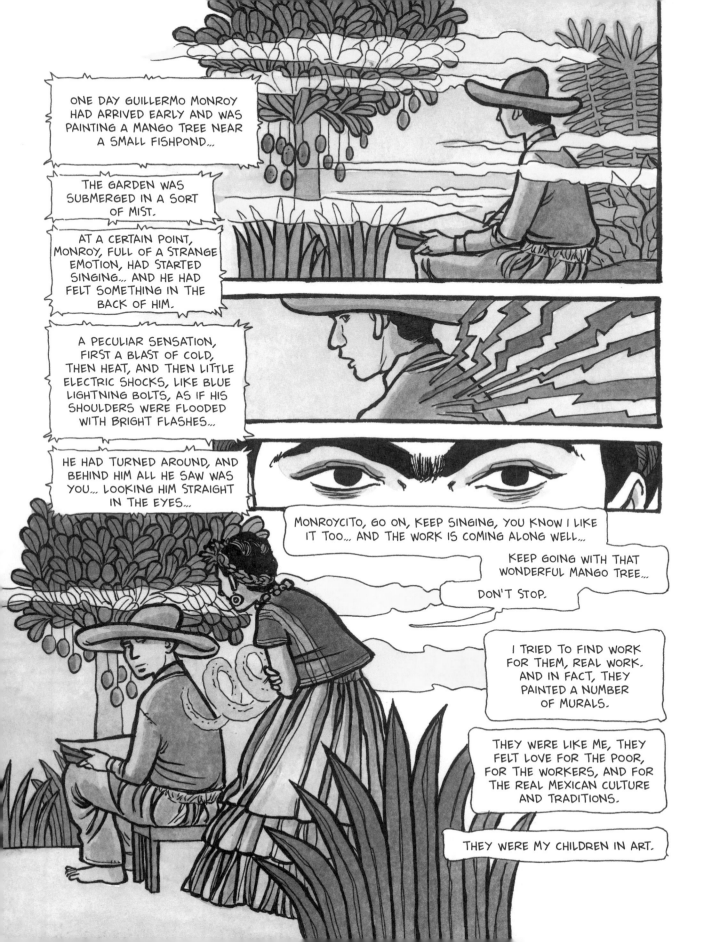

IN 1944, YOU NEEDED TO START TAKING IT EASY... THE PAIN IN YOUR BACK AND YOUR FOOT HAD GREATLY INCREASED...

ANOTHER DOCTOR, A CERTAIN ZIMBRÓN, HAD PRESCRIBED A CORSET MADE OF METAL... IT WAS TORTURE. I COULD NEITHER SIT DOWN NOR STAND... I HAD LOST A LOT OF WEIGHT AND WAS ALWAYS IN BED.

I WORE IT FOR FIVE MONTHS, THAT CORSET...

IN 1945 YOU HAD TO WEAR A DIFFERENT CORSET, THIS ONE MADE OF PLASTER, BUT THEY REMOVED IT AFTER TWO DAYS...

I THINK THEY HAD INJECTED ME WITH LIPIDOL, WHICH HADN'T BEEN ABSORBED AND GAVE ME TREMENDOUS HEADACHES AND BACKACHE.

ONE COULD TELL YOUR STORY BASED ON THE GALLERY OF CASTS YOU WORE THROUGH-OUT YOUR LIFE...

THERE WERE TWENTY-EIGHT IN ALL.

AND THE LIST OF ALL THE PAIN MEDICATIONS, TRANQUILIZERS, AND ALL THE REST... AND A WHOLE COLLECTION OF SUPPORTS AND CRUTCHES.

Dear Leo,

every day it gets worse. At first it was a nightmare getting used to this thing... but you can't imagine how awful I felt before I started wearing it... any movement was impossible. The first days with the corset it seemed like things were going better, but now I feel terrible again. I am DESPERATE! They say my nerves are inflamed. But how is it possible, I ask myself, if this corset and lying immobile were supposed to prevent precisely that... Listen, sweetheart, let me know what the hell I should do so I don't get carried off by my girlfriend Tostada... Many say I should have an operation. But I won't do anything like that without being sure that I absolutely have to... and above all... if it's really necessary, you'll have to be the one to do it...

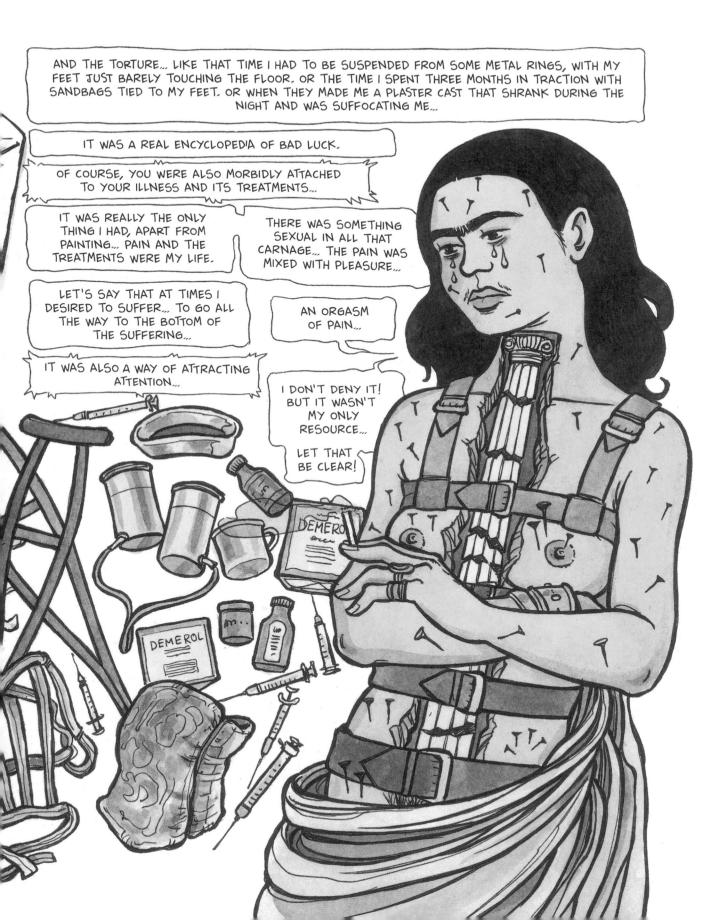

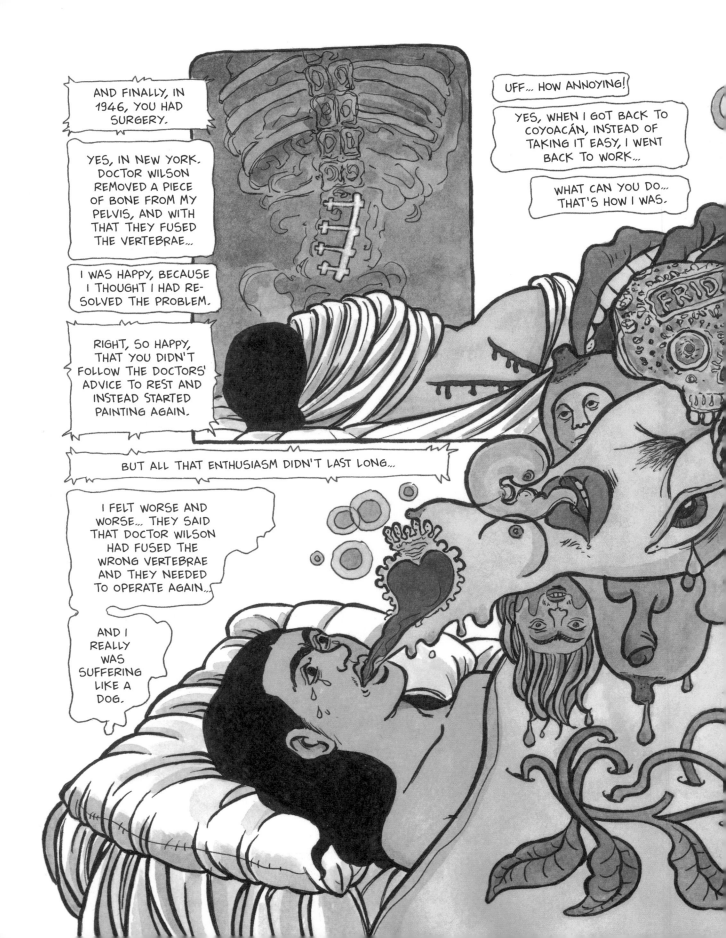

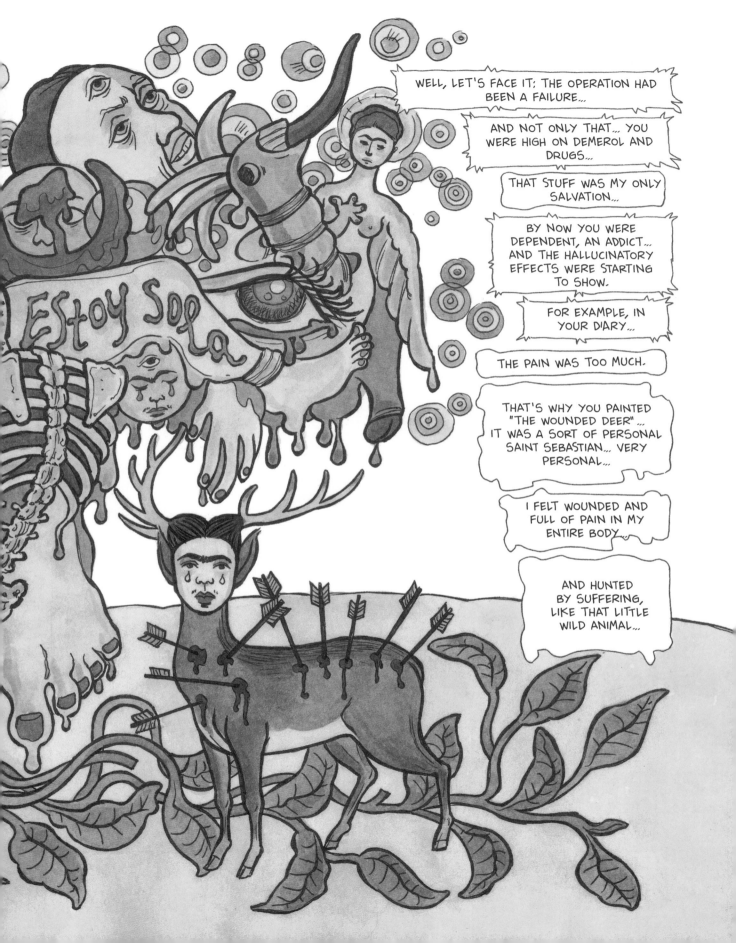

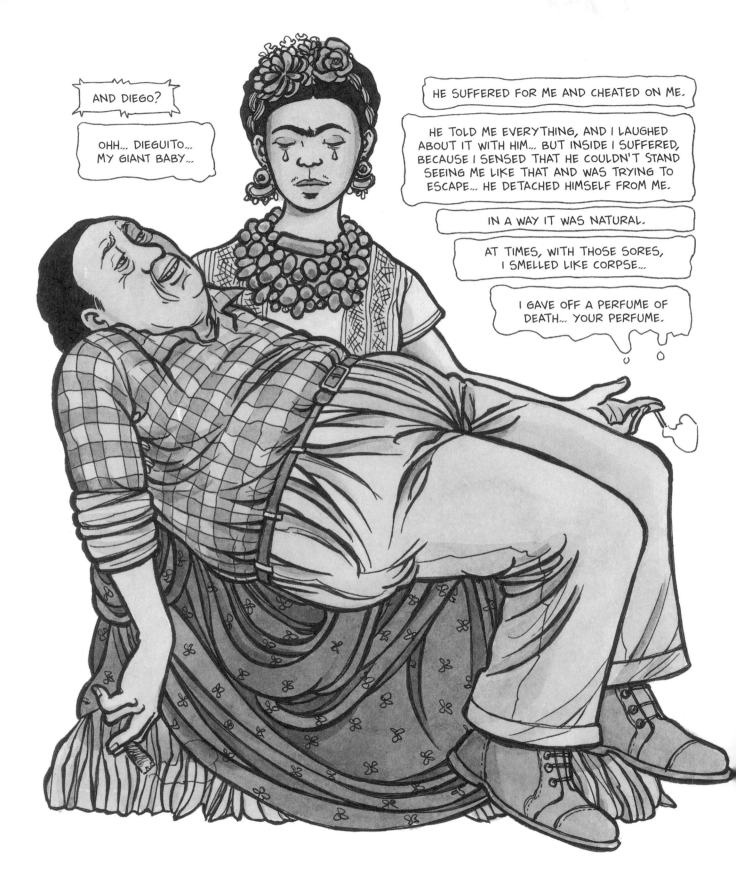

144

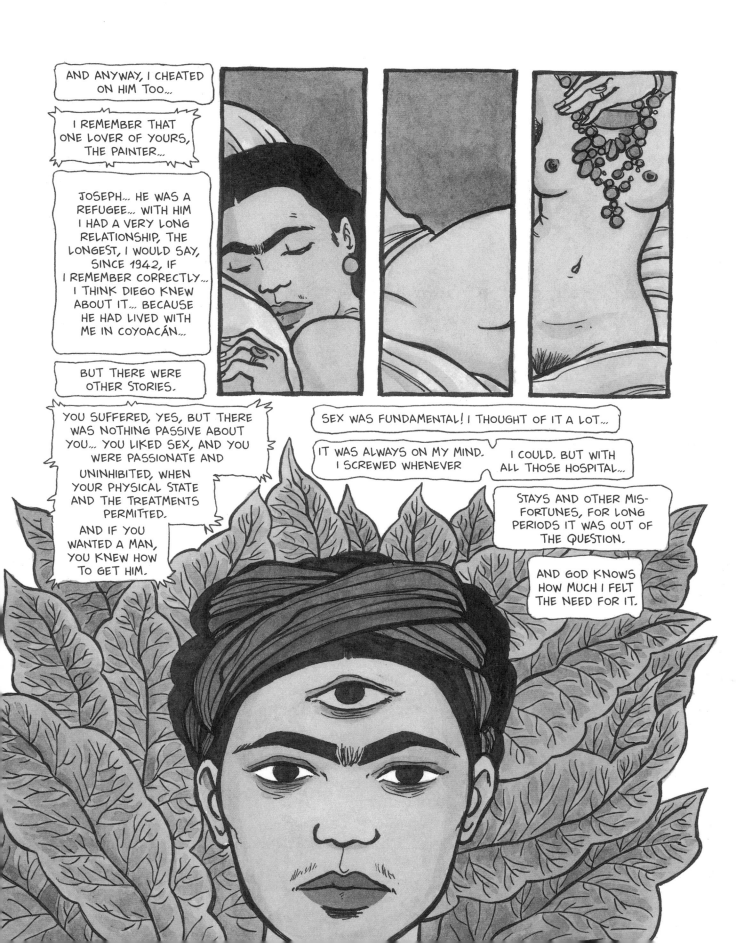

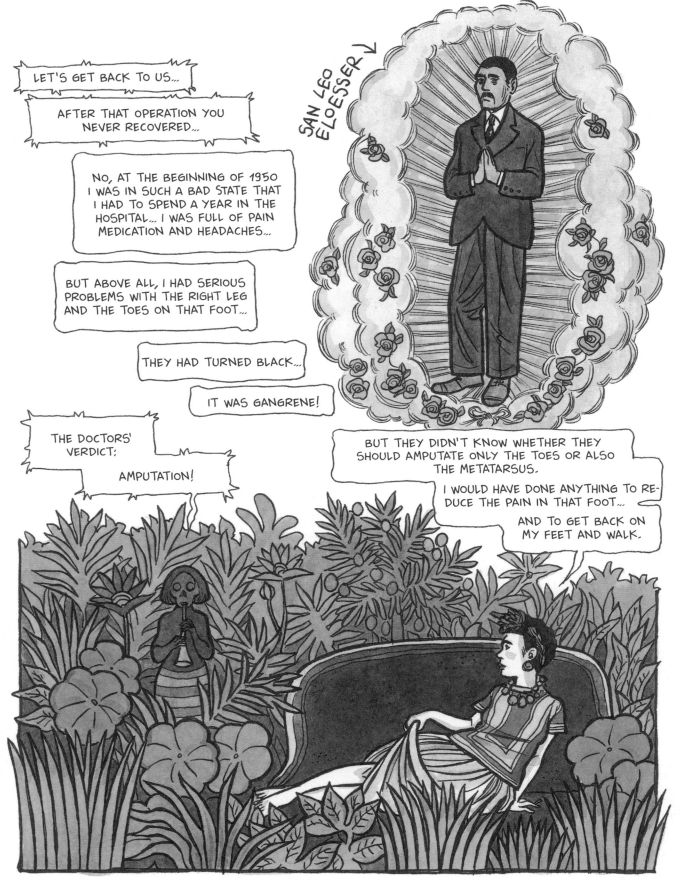

LET'S GET BACK TO US...

AFTER THAT OPERATION YOU NEVER RECOVERED...

NO, AT THE BEGINNING OF 1950 I WAS IN SUCH A BAD STATE THAT I HAD TO SPEND A YEAR IN THE HOSPITAL... I WAS FULL OF PAIN MEDICATION AND HEADACHES...

BUT ABOVE ALL, I HAD SERIOUS PROBLEMS WITH THE RIGHT LEG AND THE TOES ON THAT FOOT...

THEY HAD TURNED BLACK...

IT WAS GANGRENE!

THE DOCTORS' VERDICT:

AMPUTATION!

SAN LEO ELOESSER ↘

BUT THEY DIDN'T KNOW WHETHER THEY SHOULD AMPUTATE ONLY THE TOES OR ALSO THE METATARSUS.

I WOULD HAVE DONE ANYTHING TO REDUCE THE PAIN IN THAT FOOT...

AND TO GET BACK ON MY FEET AND WALK.

I WAS DESPERATE AND WEARY... AND I HAD ASKED FOR LEO'S ADVICE ABOUT THAT GODDAMNED FOOT.

IT WAS A MESS!

BUT THE FOOT WASN'T THE ONLY PROBLEM... THE SPINAL OPERATION HAD GONE BADLY AND THEY NEEDED TO OPEN YOU UP AGAIN...

IT WAS A NIGHTMARE!

THEY OPENED ME UP, SEWED ME TOGETHER, OPENED ME AGAIN, CLOSED ME BACK UP... I DON'T KNOW HOW MANY TIMES...

I SUFFERED LIKE A DOG...

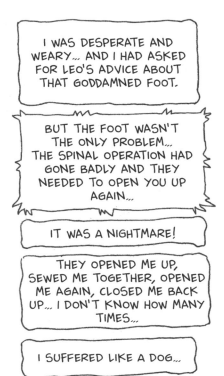

Dear Doctor Eloesser,

I am writing to inform you that there has been no progress. Frida is going through real torture. After the operation she had an intestinal blockage and a very high fever. She was constantly throwing up. Then they put her in a cast and gave her Demerol injections, and it got a little better. They can't use morphine, because she can't tolerate it...
The fever continued, and after a few days I noticed that she was emitting a horrible odor, and in fact, underneath the cast the wound had become infected and was full of pus... So they operated on her again, without any improvement. They put another plaster cast on her which by now is all dirty, and she smells like a dead dog...
I think that the operation has been a failure, even if these doctors say that everything is fine. We will have to wait and see what happens with the third surgery... even if I think it would have been better to do nothing.

Cristina

147

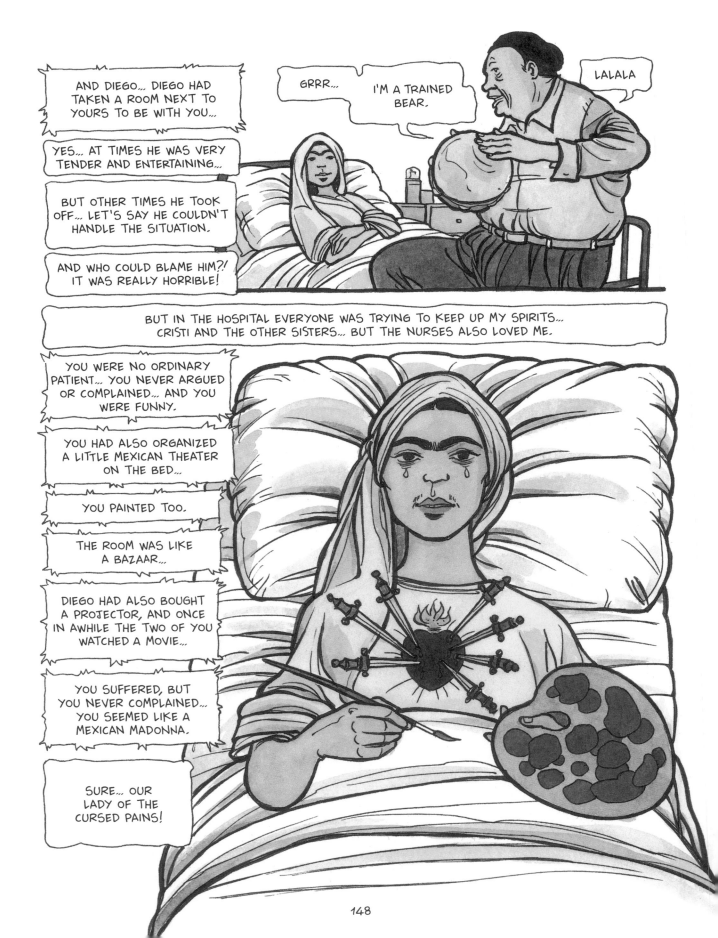

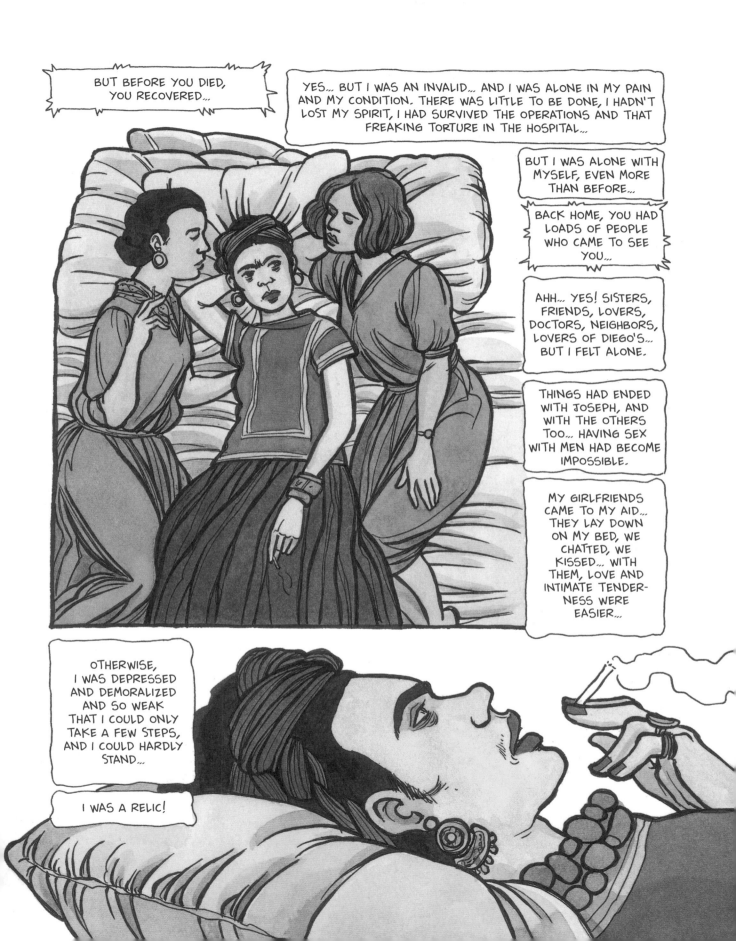

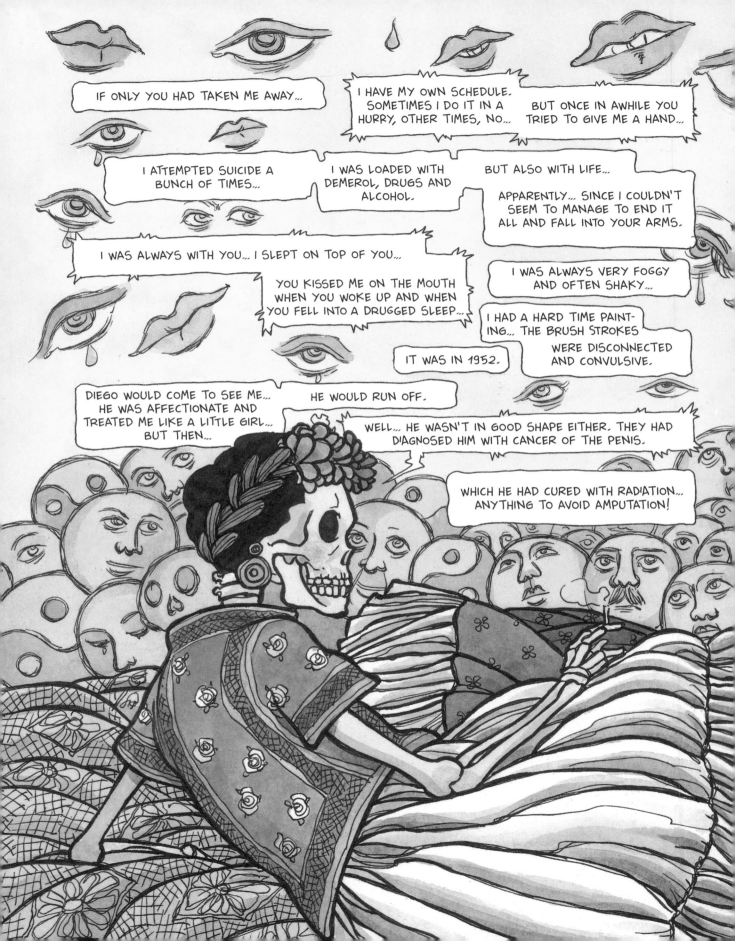

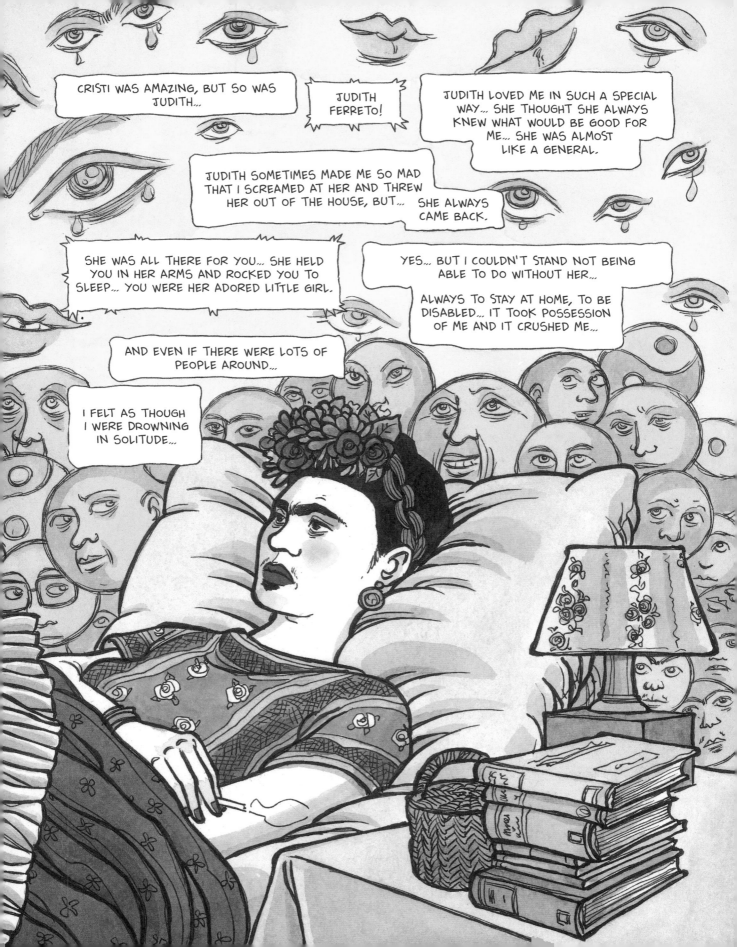

THANK GOD YOU HAD DRUGS TO SPARE!

WHAT WOULD I HAVE DONE WITHOUT THEM, WITH THE CONSTANT PAIN, ANXIETY, DEPRESSION AND BOREDOM...

AND IN 1953, THERE WAS ALSO THE DEATH OF STALIN...

I THOUGHT YOU DIDN'T CARE FOR HIM MUCH...

NO! BUT I HAD RECONSIDERED, AND SINCE I WAS AN ATHEIST, STALIN, THE PARTY AND THE RED FLAGS HAD BECOME MY CULT...

I WAS ALWAYS A COMMUNIST!

BUT IN 1953, FINALLY SOMEONE IN MEXICO HAD TAKEN AN INTEREST IN YOUR WORK AND DECIDED TO ORGANIZE A GREAT EXHIBITION OF YOUR ART...

YES, AT LAST!

AT FIRST IT WAS ONLY DIEGO WHO EXPRESSED APPRECIATION AND GREAT LOVE OF MY WORK, AND CALLED ME A GREAT ARTIST.

IT HAD TAKEN LOLA ÁLVAREZ BRAVO AND HER GALLERY...

I WAS IN TERRIBLE SHAPE! I DIDN'T EVEN KNOW IF I WOULD BE ABLE TO GO TO THE OPENING!

BUT I HAD ALSO WRITTEN AN INVITATION...

AND IN THE END THE SHOW WAS A BIG SUCCESS!

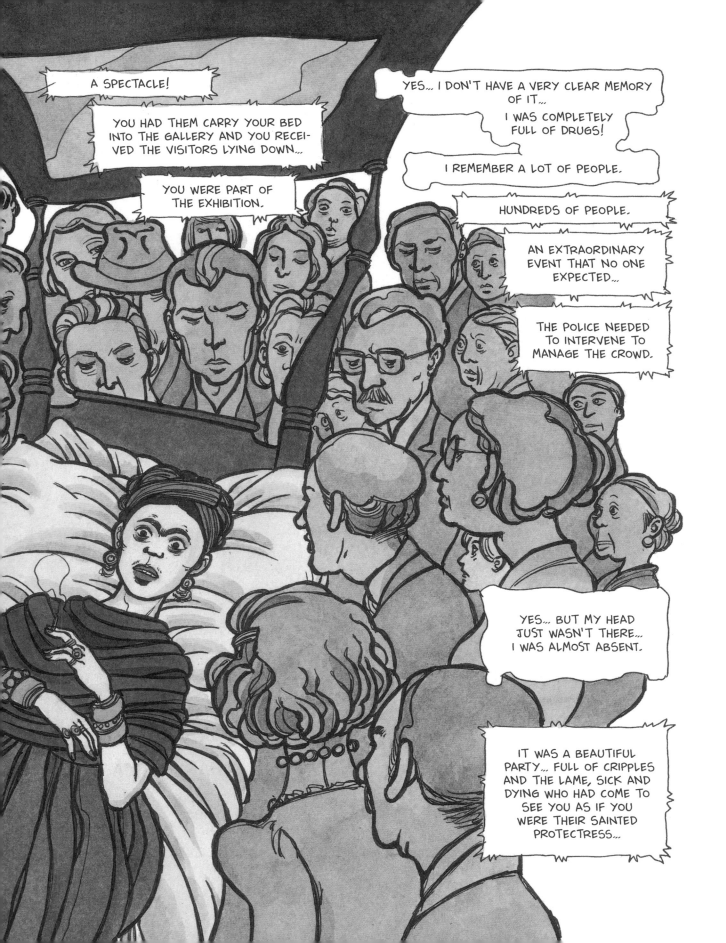

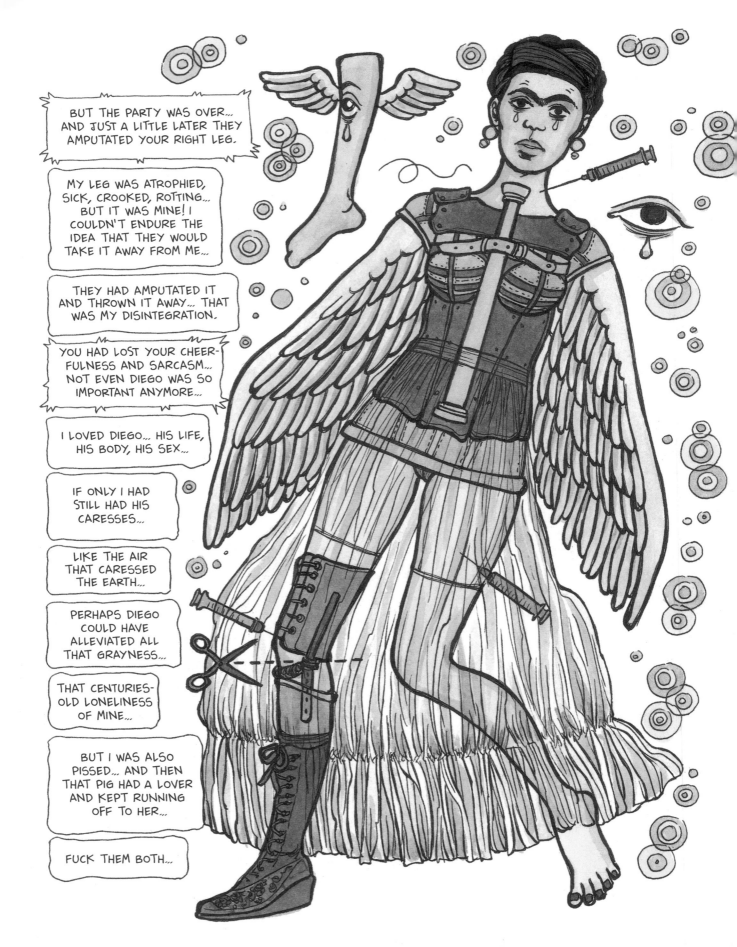

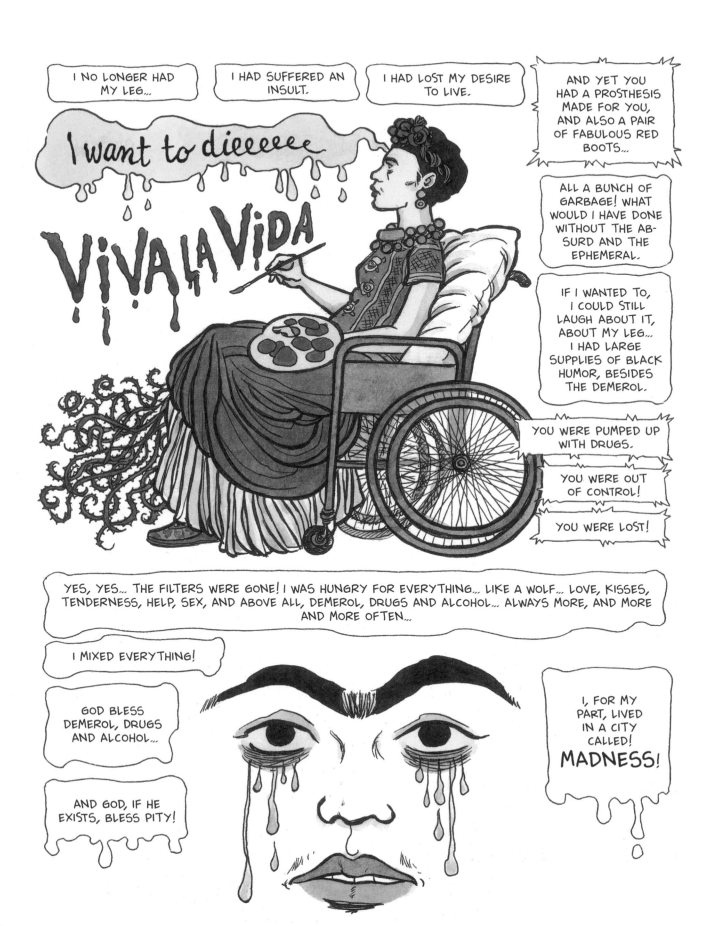

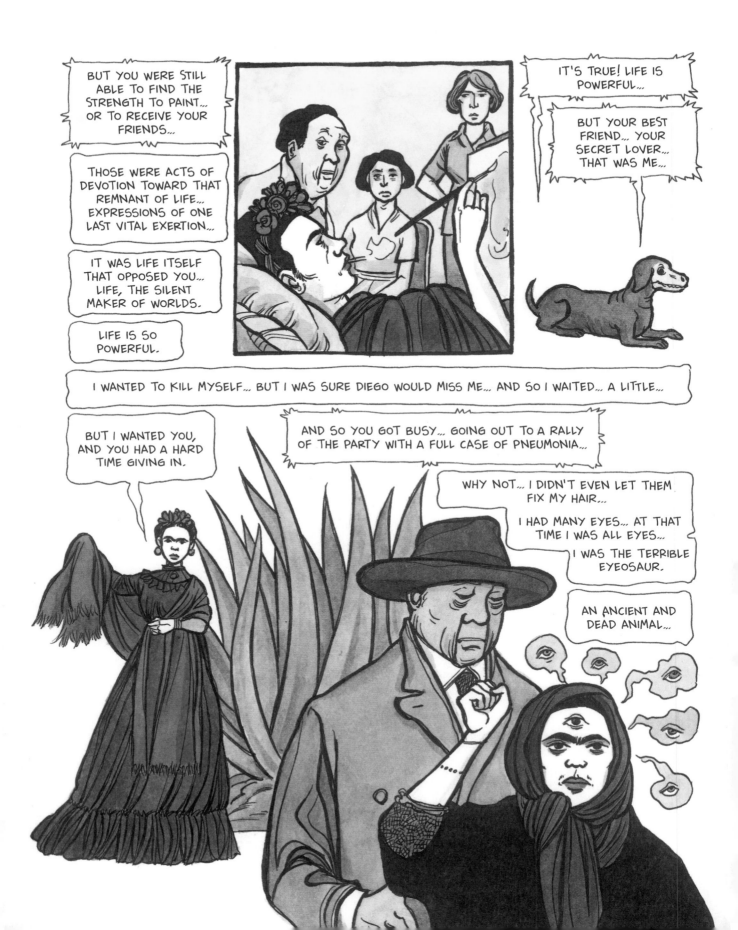

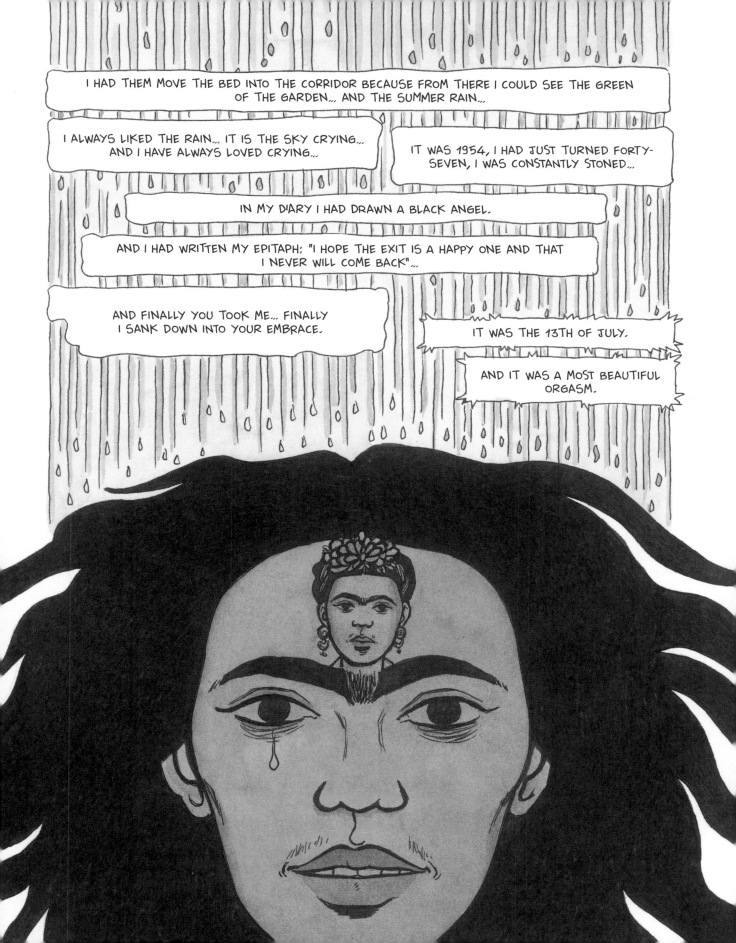

DIEGO HAD BECOME PALE, ASHEN, AGED. LUPE MARIN AND EMMA HURTADO, HIS SECOND WIFE AND HIS LOVER, HAD COME TO SEE YOU. YOU WOULDN'T HAVE BEEN PLEASED, BUT YOU WERE ALREADY SOMEWHERE ELSE... HE COULDN'T BELIEVE THAT YOU HAD REALLY DIED, AND HE HAD SAID TO LUPE'S PHYSICIAN BROTHER THAT HE WAS HORRIFIED AT THE THOUGHT THAT THEY MIGHT CREMATE YOU WHILE THERE WAS STILL BLOOD FLOWING IN YOUR VEINS. SO HE HAD ASKED THAT THEY OPEN A VEIN TO MAKE SURE YOU WERE DEAD. AND THEY HAD DONE IT! THEY HAD CUT YOUR JUGULAR AND TWO RED TEARS HAD FALLEN.

FRIDA, YOU REALLY WERE DEAD!

THEY HAD DRESSED YOU AND ADORNED YOU LIKE A SAINT, AND MANY PEOPLE HAD COME, AS THEY ALWAYS DO AT THESE TIMES. THEN YOU WERE CARRIED IN A COFFIN TO THE PALACIO DE BELLAS ARTES. ANDRÉS IDUARTE, YOUR FRIEND FROM HIGH SCHOOL, WHO AT THE TIME WAS THE DIRECTOR OF THE INSTITUTO NACIONAL DE BELLAS ARTES, HAD GIVEN PERMISSION, PROVIDED THAT POLITICS AND THE PARTY WERE KEPT OUT OF THE CEREMONY. DIEGO HAD ACCEPTED. THEN, HOWEVER, SOMEONE HAD PULLED OUT A RED FLAG WITH THE HAMMER AND SICKLE AND DRAPED IT OVER THE COFFIN. THERE HAD BEEN SOME TENSIONS, AS THERE ARE AT NEARLY ALL FUNERALS. AND THEN CRIES AND SCREAMS AND WORDS AND SONGS AND TOTALLY USELESS HUMAN THINGS.

BUT AT THE CREMATORY, WHAT A SPECTACLE!

DIEGO PARALYZED, CRISTINA HYSTERICAL, EVERYONE CONTRITE, AND YOUR BODY, WHICH AS SOON AS IT ENTERS THE OVEN RISES UP TO A SEATED POSITION WITH YOUR HAIR ON FIRE AND BLAZING LIKE A HALO OR A SUNFLOWER.

NOW YOUR ASHES ARE IN A PRE-COLUMBIAN URN AT YOUR HOUSE, IN COYOACÁN.

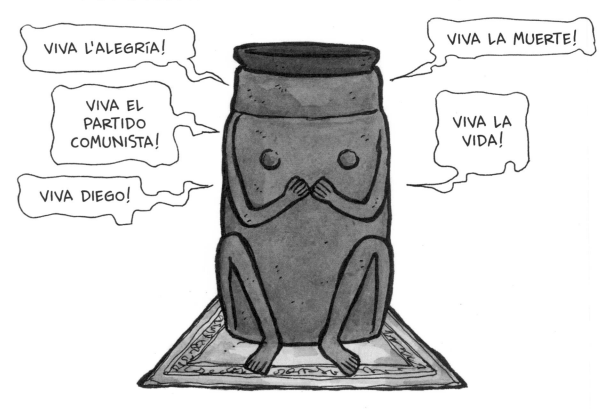

Publisher and author thank Diego Sileo for his valuable contribution during the supervision process.

Special thanks of the author go to Simonetta Scala, Sandra Sisofo, Silvana Manconi and to the people at 24 ORE Cultura.

The original edition was published in October 2016 under the title
Frida. Operetta amorale a fumetti
at 24 ORE Cultura srl, Milan.

Regarding the letter texts, some of them are not original adaptions of letters by Frida Kahlo, but slightly condensed summaries.

Prestel Publishing Ltd.
14-17 Wells Street
London W1T 3PD

Prestel Publishing
900 Broadway, Suite 603
New York, NY 10003

A CIP catalogue record for this book is available from the British Library.

Editorial direction: Claudia Stäuble
Translation: Katharine Cofer, San Francisco
Design and layout: Simonetta Scala / Lizart
Typesetting and copyediting: VerlagsService Dietmar Schmitz GmbH, Heimstetten
Production management: Friederike Schirge
Printing and binding: Mohn Media, Gütersloh
Paper: Tauro Offset

Verlagsgruppe Random House FSC®N001967

Printed in Germany

ISBN 978-3-7913-8388-0

www.prestel.com